annette messager

Translated from the French by David Radzinowicz Howell

Copy-editing: Bernard Wooding
Design: Valérie Gautier
Typesetting: Studio X-Act
Color separation: APS-Chromostyle Tours

Originally published as *Annette Messager*

© 2000 Flammarion
English-language edition
© 2001 Flammarion

ISBN 2-080106-619-8
FA0619-01-VI
Dépôt légal: 09/2001

Printed in France

Flammarion

CATHERINE GRENIER

annette messager

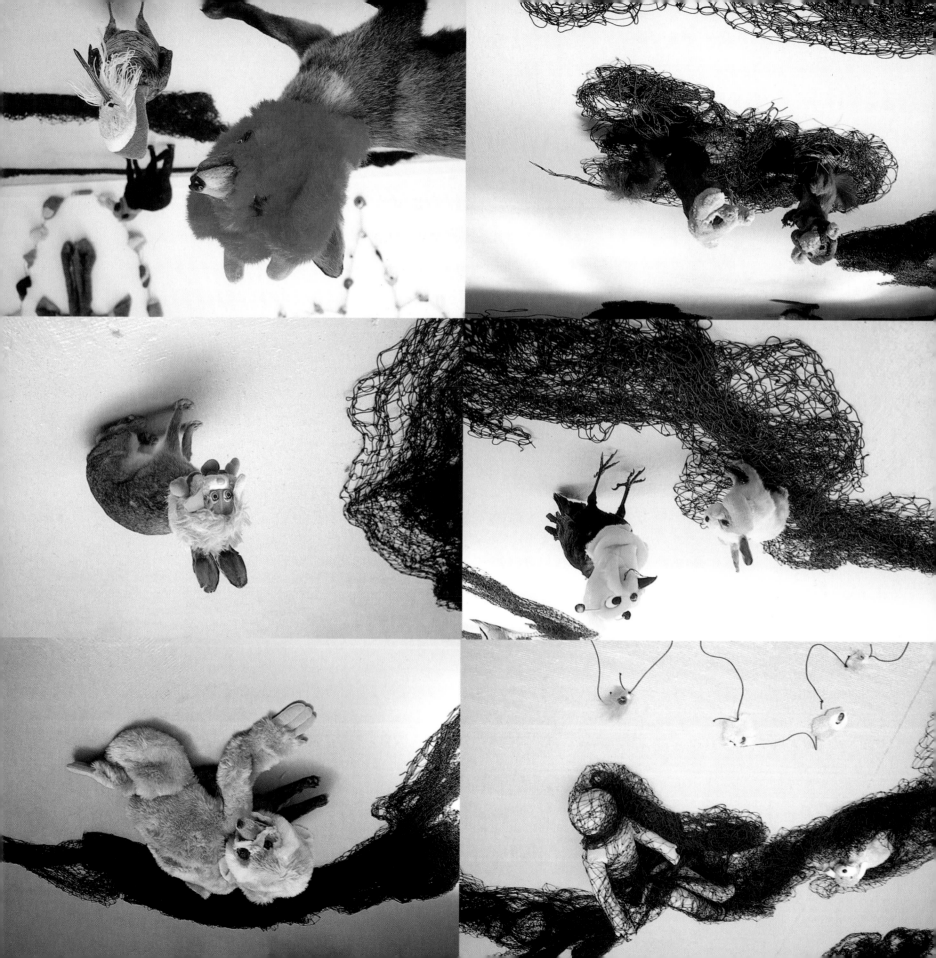

annette messager

Translated from the French by David Radzinowicz Howell
Copy-editing: Bernard Wooding
Design: Valérie Gautier
Typesetting: Studio X-Act
Color separation: APS-Chromostyle Tours

Originally published as *Annette Messager*
© 2000 Flammarion
English-language edition
© 2001 Flammarion

ISBN 2-08010-619-8
FA0619-01-VI
Dépôt légal: 09/2001

Printed in France

annette messager

CATHERINE GRENIER

Flammarion

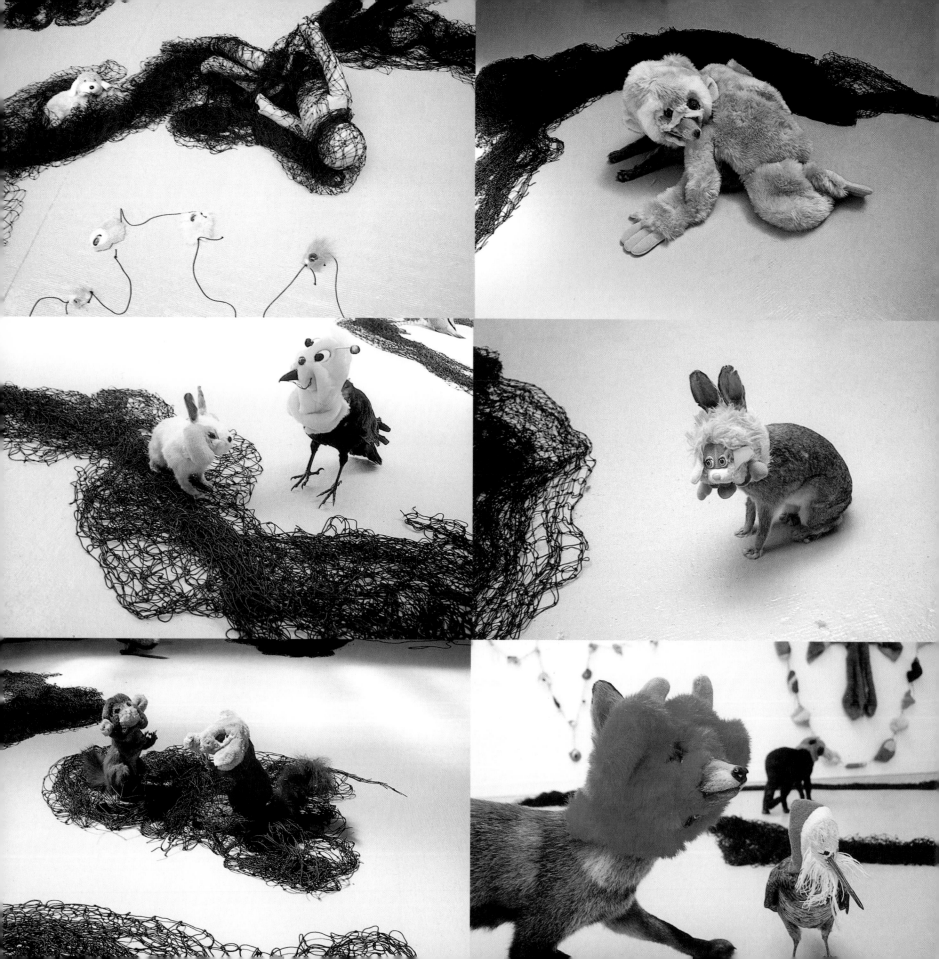

contents

portfolio 7

introduction 41

the dolls 49

a model artist 61

the world pinned 71

image manufacture 83

fairyland and apocalypse 91

topography of the body,
topography of the soul 103

family stories 119

secret societies 137

body and decor 145

realism and the fantastic 167

Details of the exhibition "Les Messagers de l'Été,"
Écuries de Saint-Hugues, Cluny, 1999.

Chimaera Traps (Les Pièges à chimères), 1986, detail.
Painted photographs with painting on wall.

Following pages: "Annette Messager, Collector," *My Collection of Proverbs*
(Ma collection de proverbes), 1974, detail. Embroidery on fabric. 35 × 28 cm.

My Vows (Mes vœux), 1988. Photographs, colored pencils, string.
300 × 300 cm.

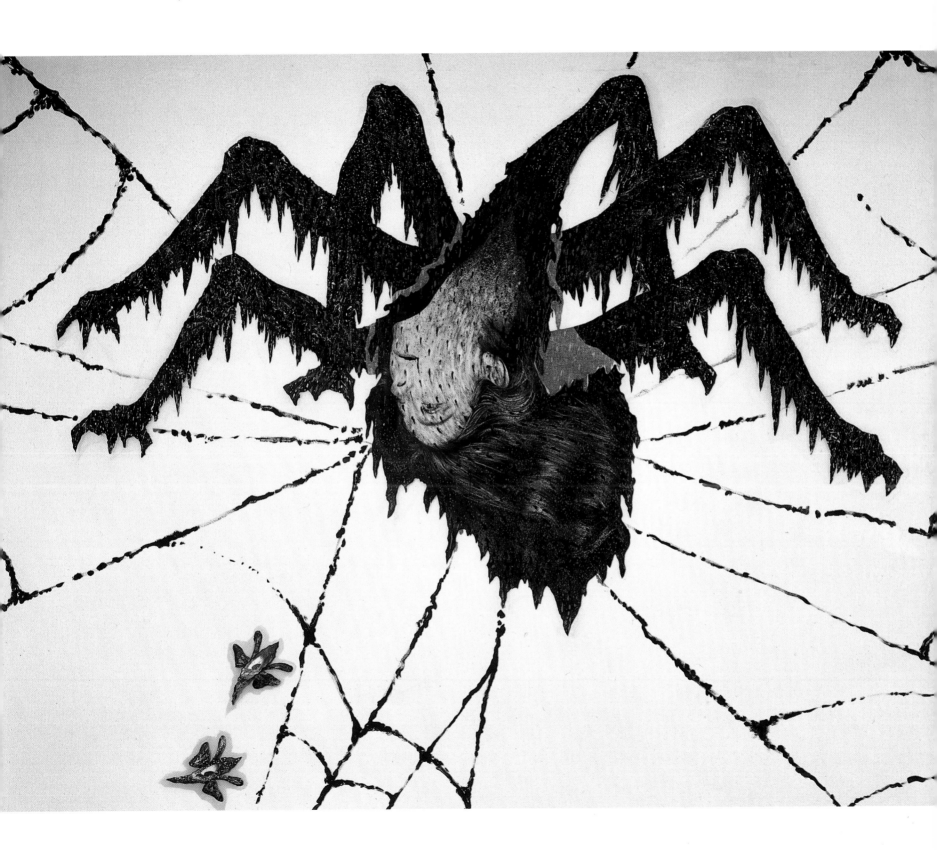

CHEZ LA FEMME
LES DENTS DE SAGESSE NE POUSSENT
QU'APRÈS LA MORT

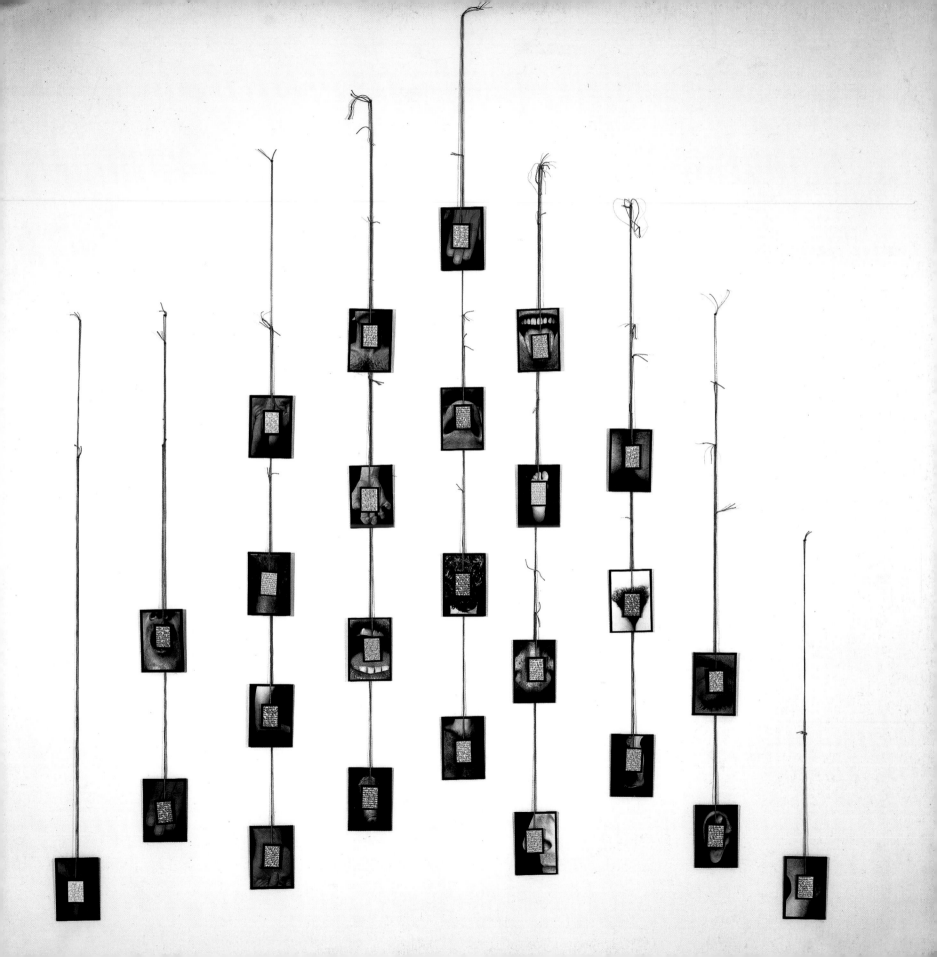

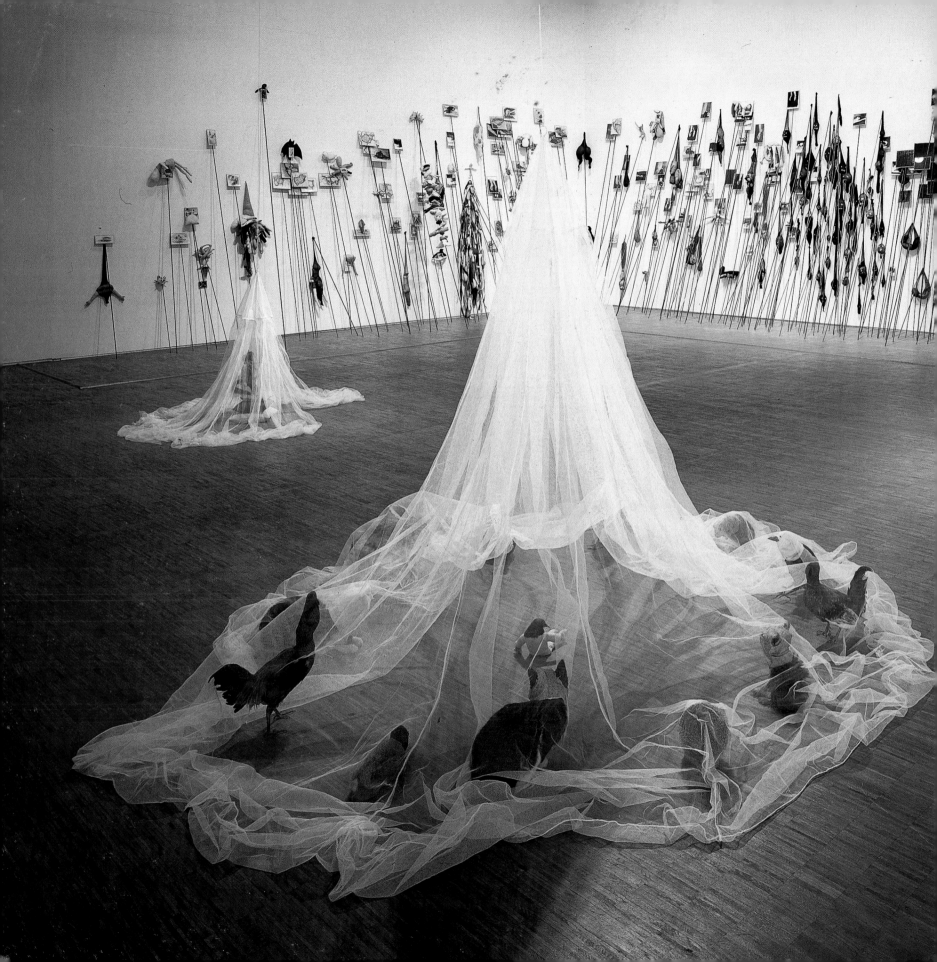

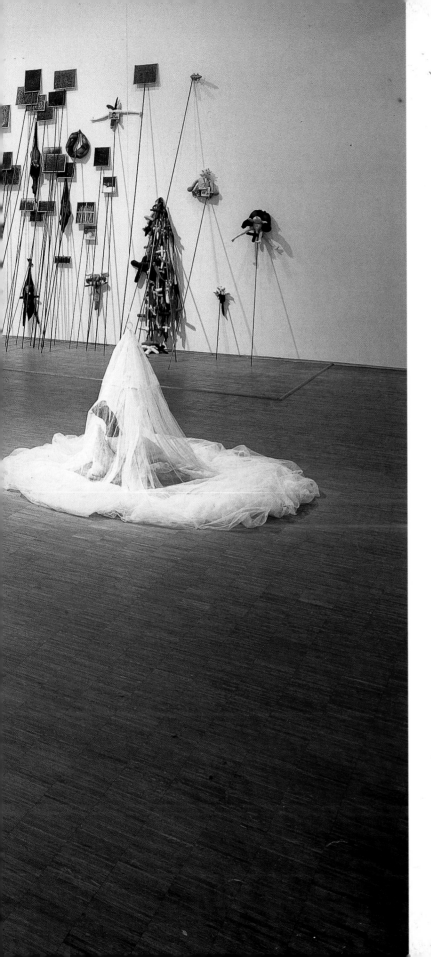

The Pikes (Les Piques), *The Mosquito Nets* (Les Moustiquaires), 1991–93.
Exhibition at the Centre Georges Pompidou, Paris, 1993.

Following pages: *The Pikes*, 1991–93, details.
Exhibition at the Centre Georges Pompidou, Paris, 1993.

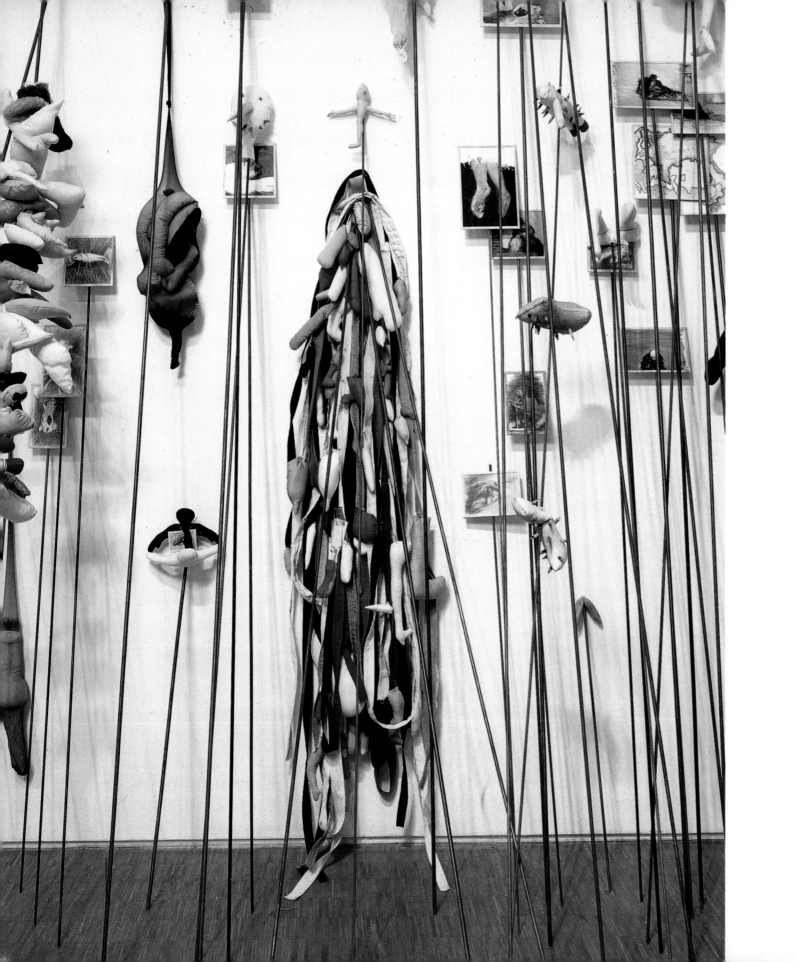

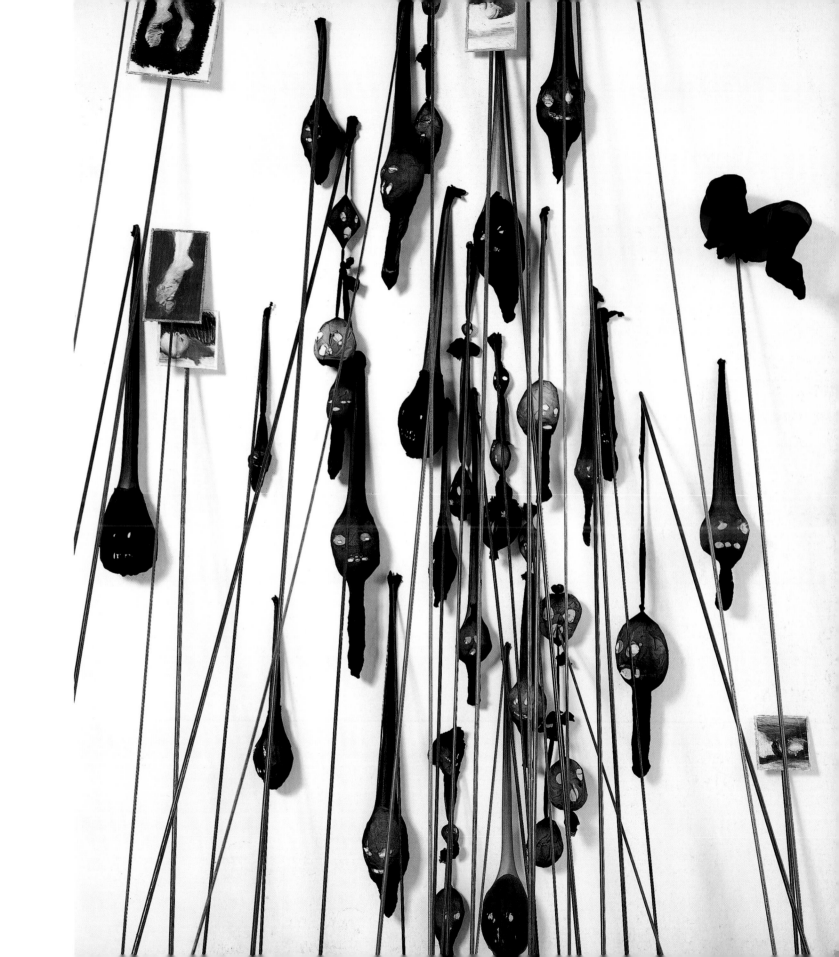

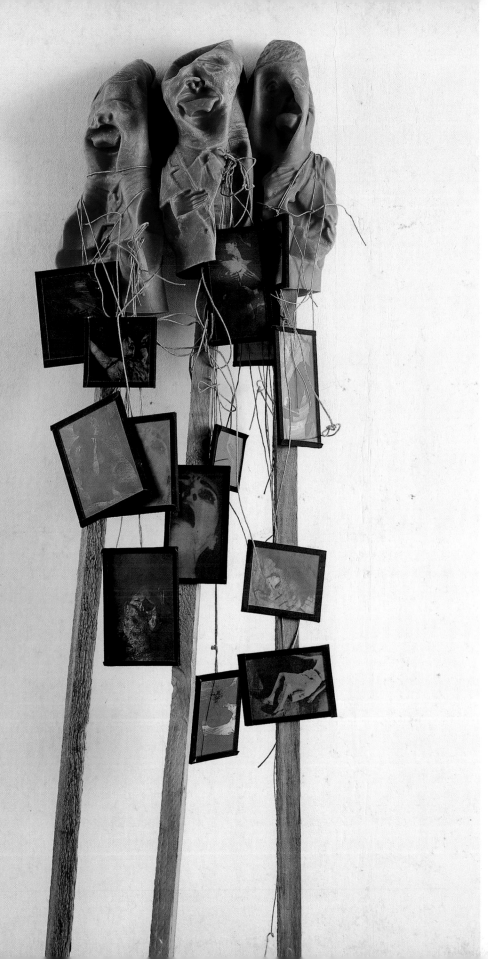

Three Masks (Trois masques), 1996.
Painted framed photographs, three rubber masks,
three wooden poles, string.
200 × 40 cm.

Ensemble (Ensemble), 1998.
Fox fur and soft toy with stuffing removed, string.
150 × 155 cm.

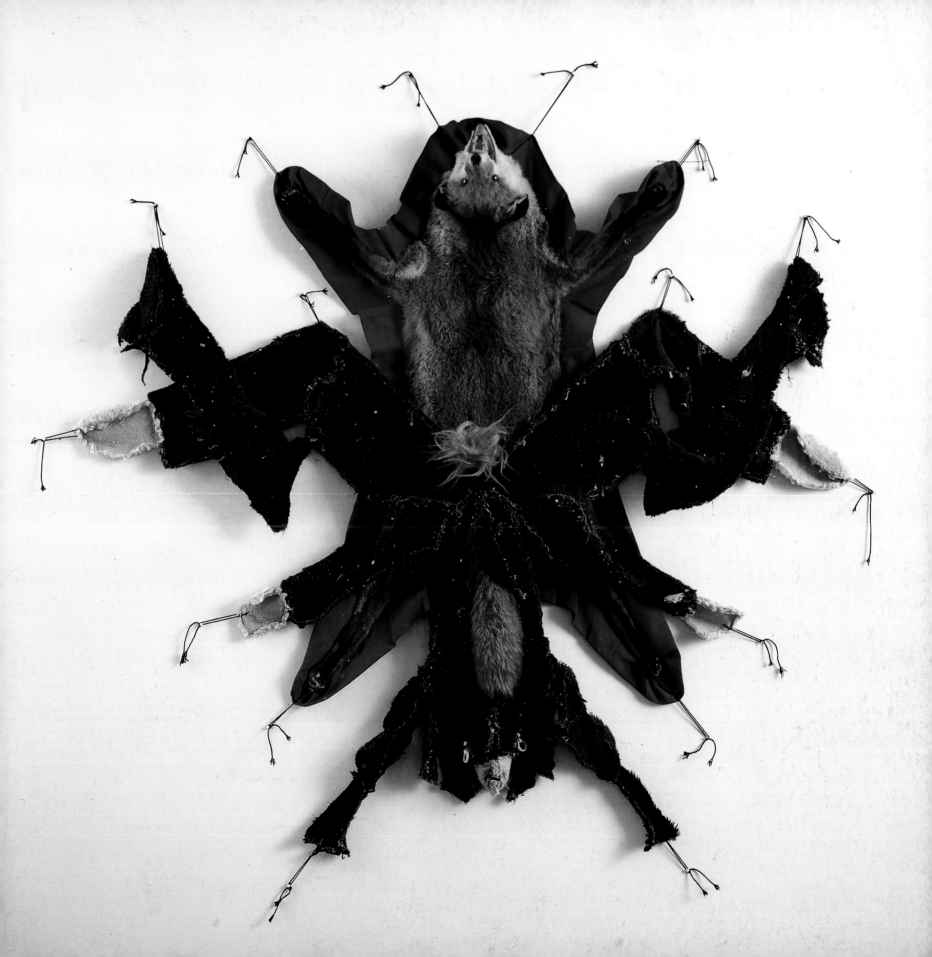

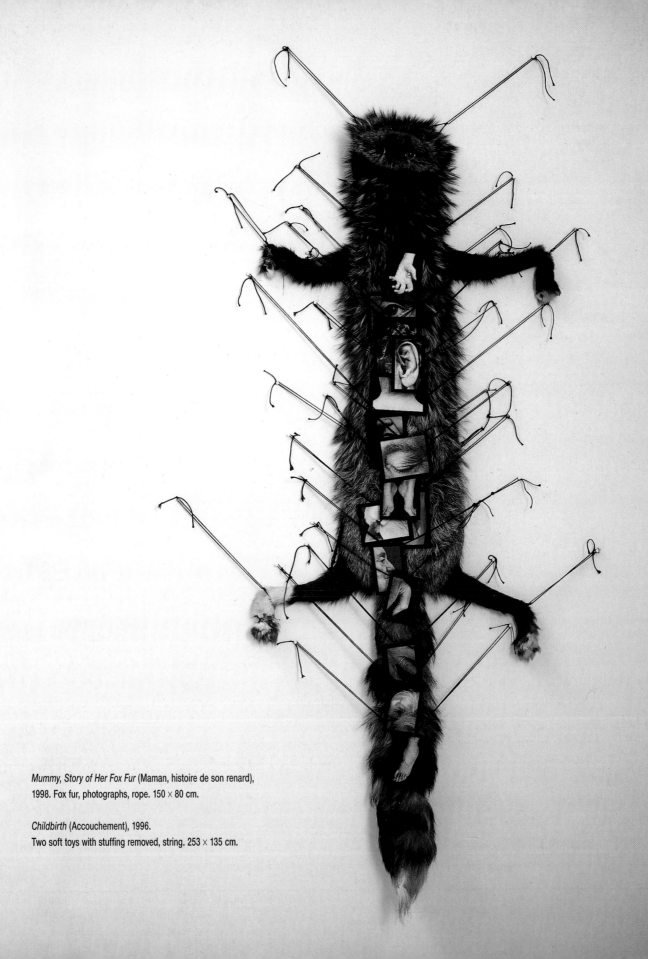

Mummy, Story of Her Fox Fur (Maman, histoire de son renard),
1998. Fox fur, photographs, rope. 150 × 80 cm.

Childbirth (Accouchement), 1996.
Two soft toys with stuffing removed, string. 253 × 135 cm.

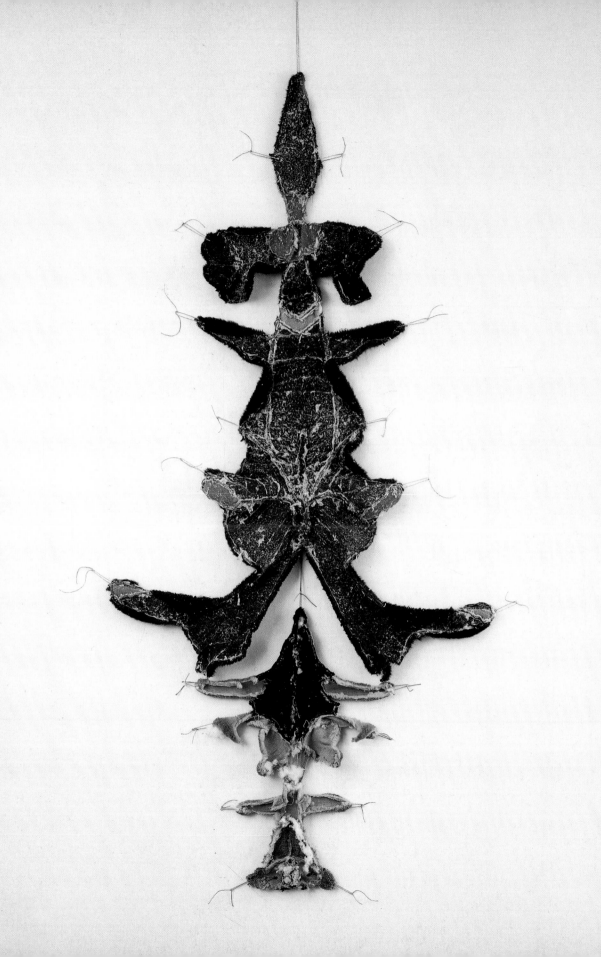

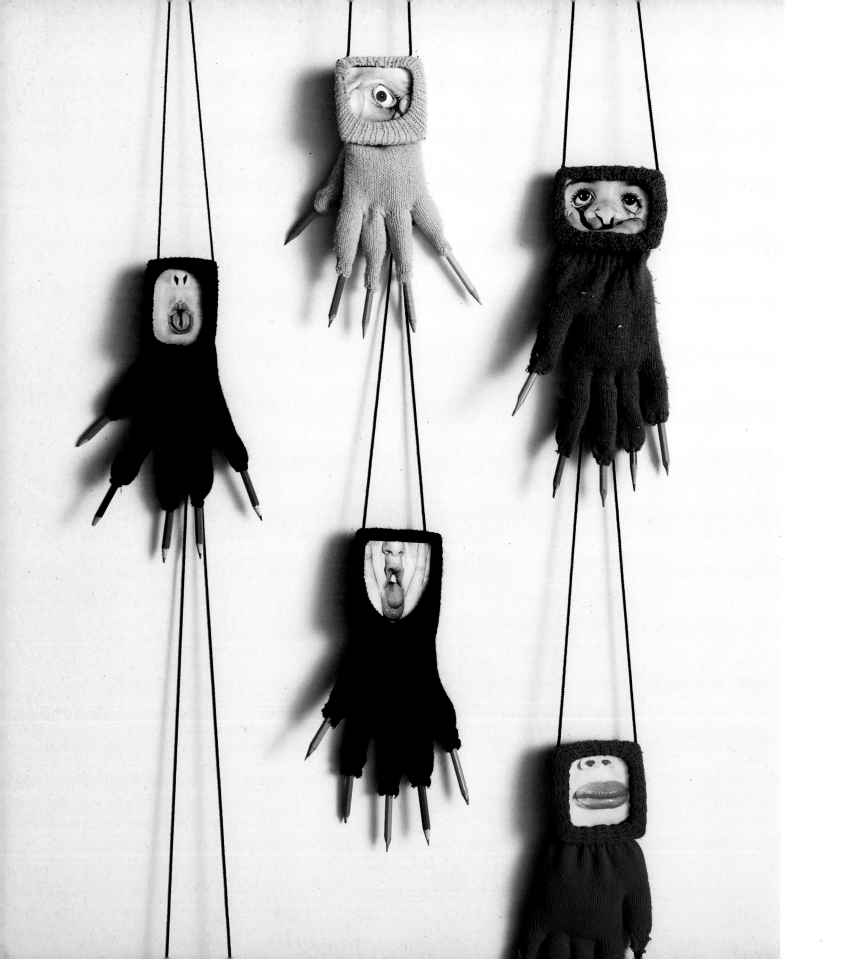

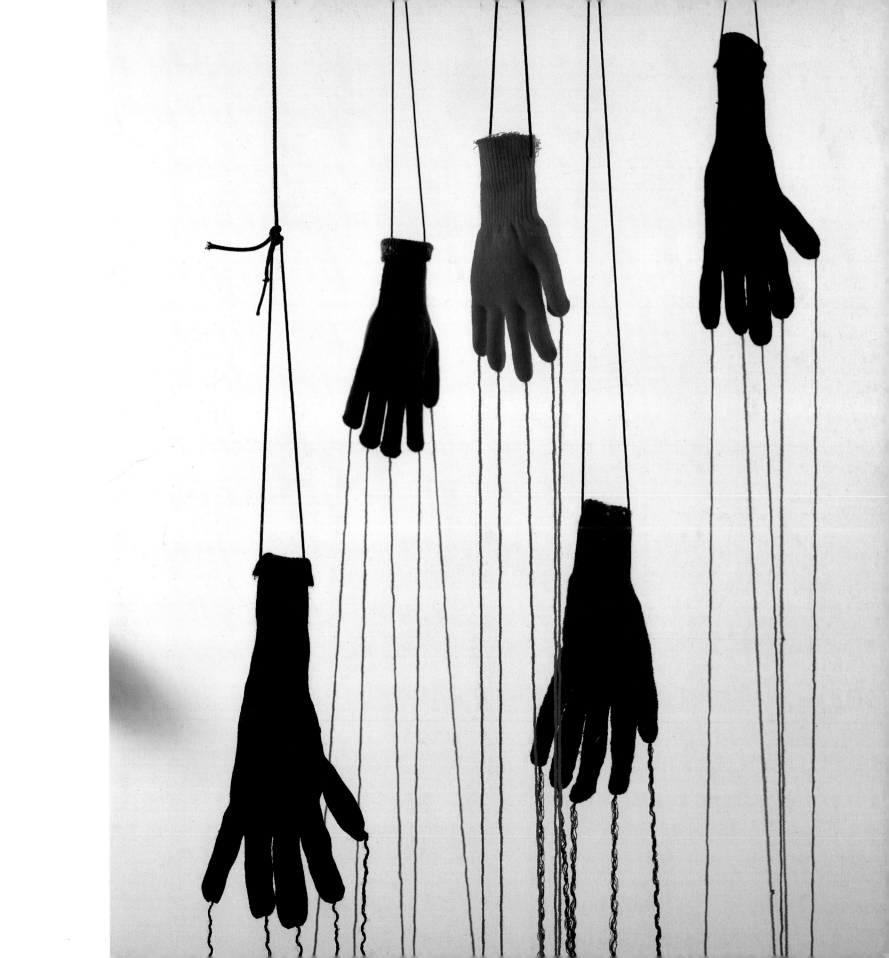

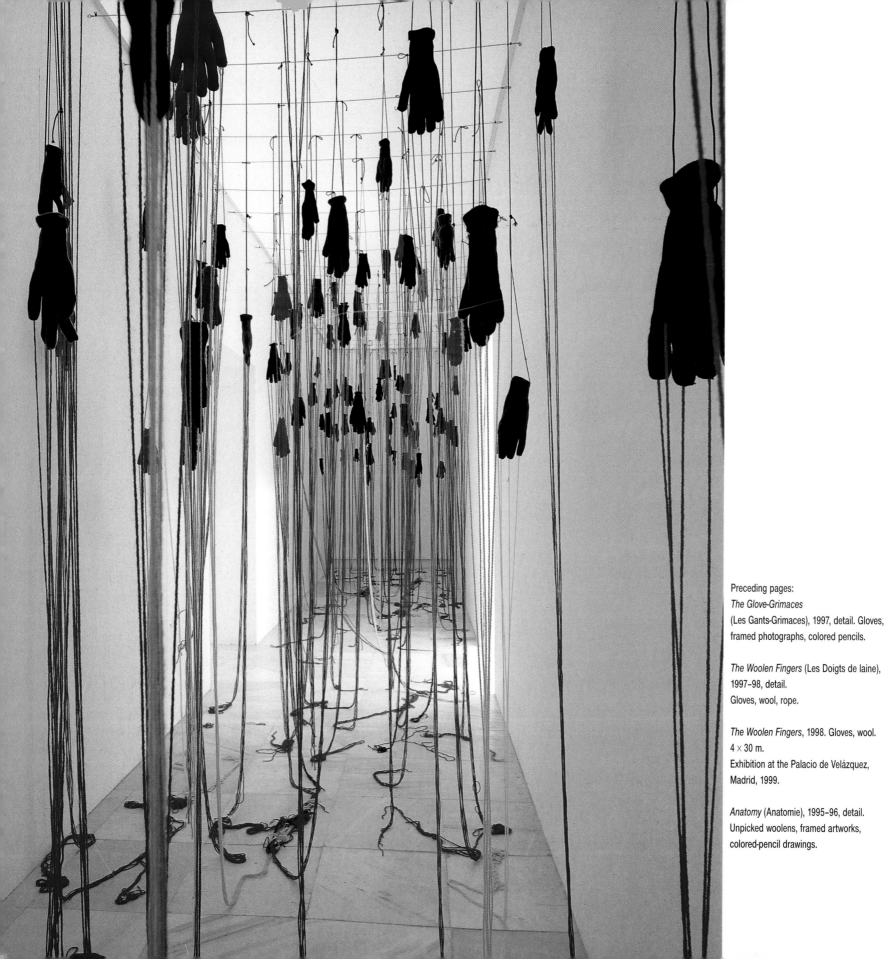

Preceding pages:
The Glove-Grimaces
(Les Gants-Grimaces), 1997, detail. Gloves,
framed photographs, colored pencils.

The Woolen Fingers (Les Doigts de laine),
1997–98, detail.
Gloves, wool, rope.

The Woolen Fingers, 1998. Gloves, wool.
4 × 30 m.
Exhibition at the Palacio de Velázquez,
Madrid, 1999.

Anatomy (Anatomie), 1995–96, detail.
Unpicked woolens, framed artworks,
colored-pencil drawings.

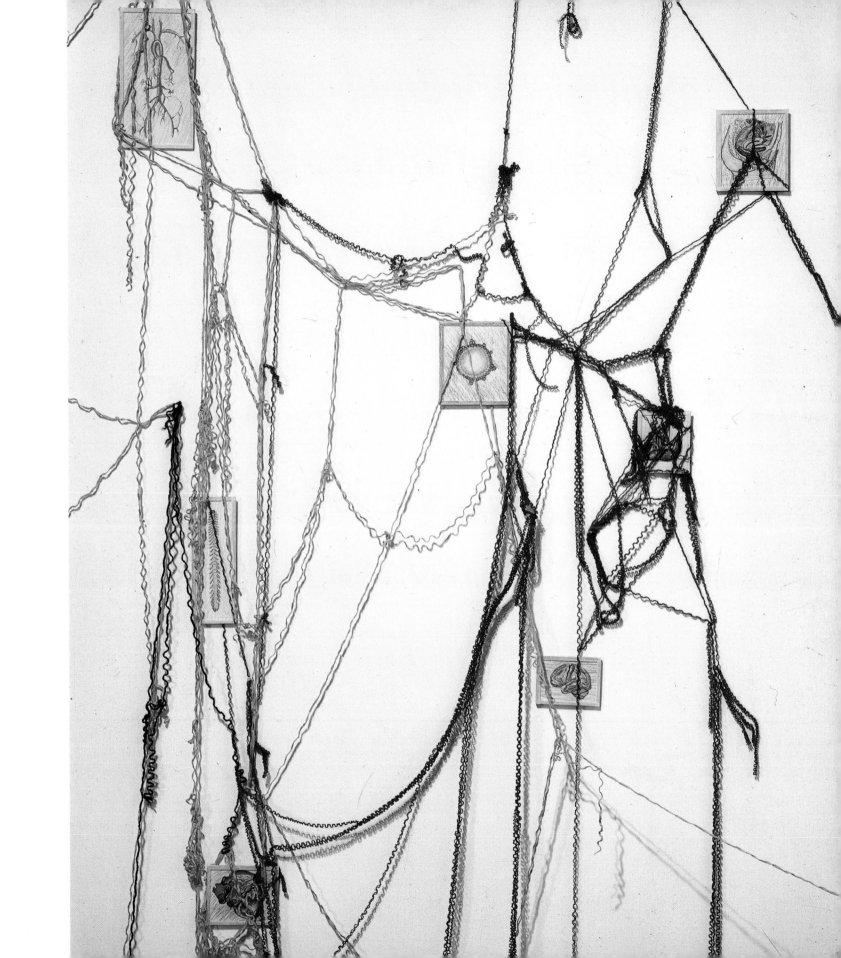

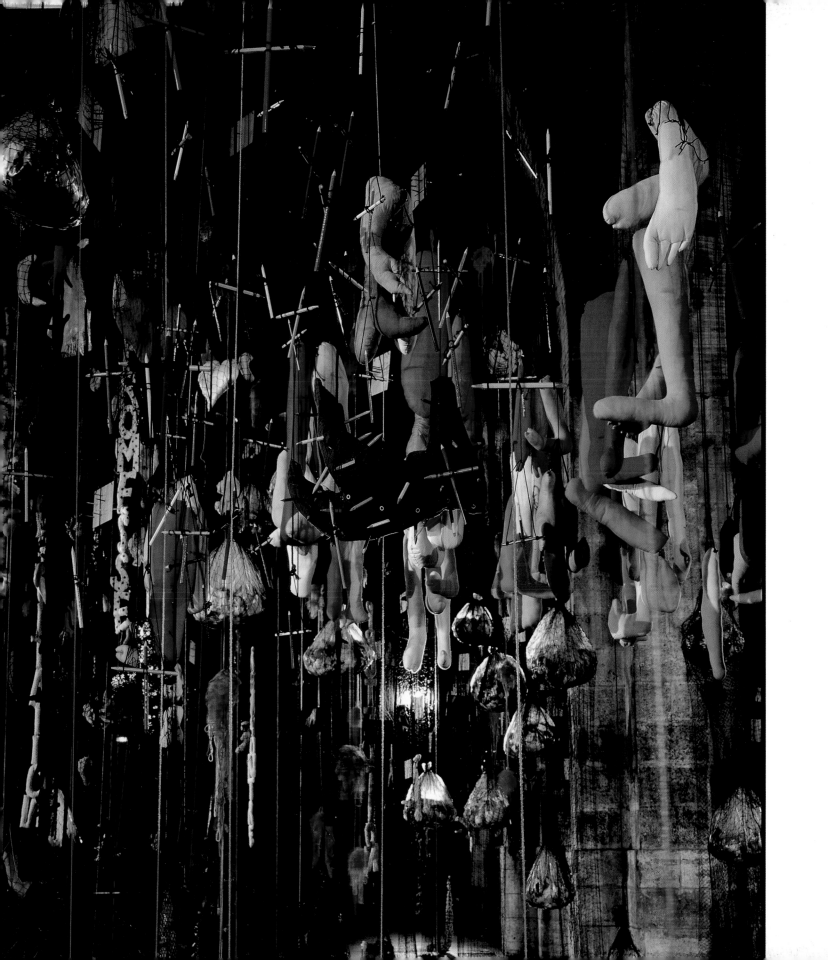

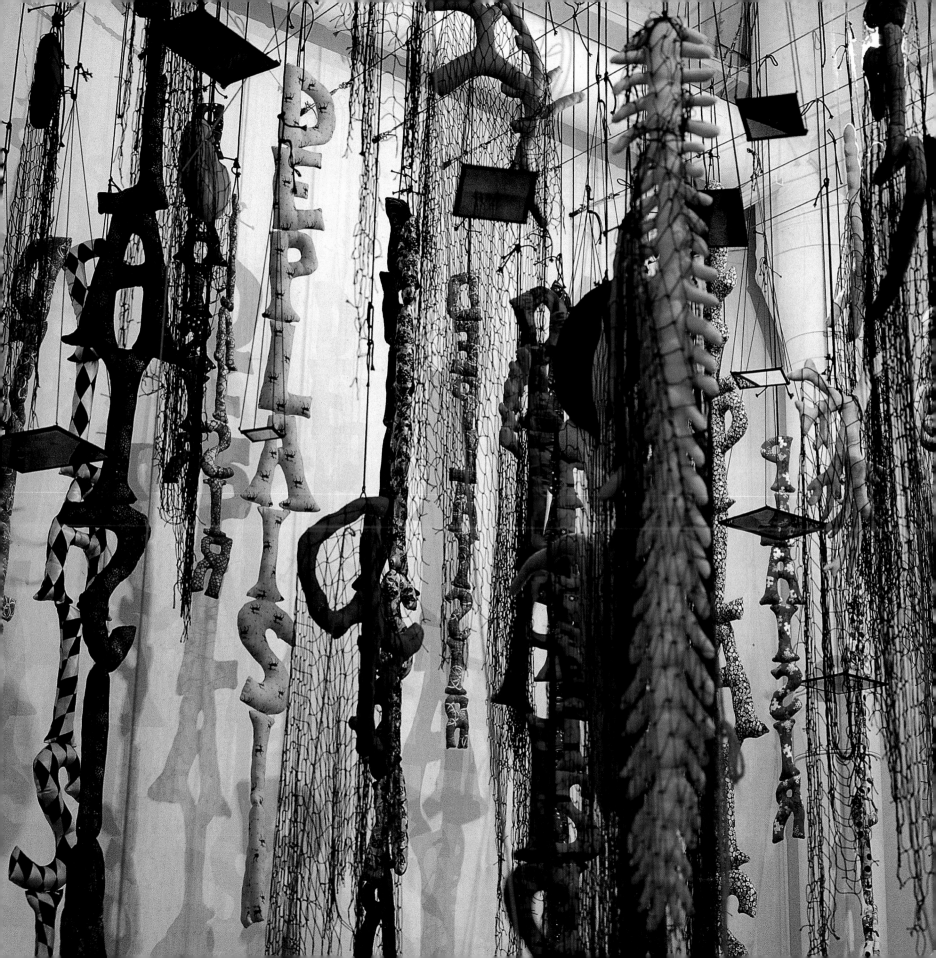

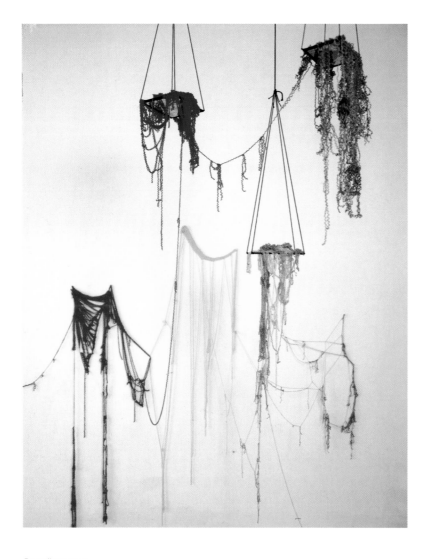

Preceding pages:
Dependence Independence (Dépendance Indépendance), 1995–96, detail.
Rope, wool, netting, plastic, stuffed animals, fabric, cardboard.
Bordeaux, Capc-Musée d'Art Contemporain Collection, 1996.

Pleasure Displeasure (Plaisir déplaisir), 1997.
Bordeaux, Capc-Musée d'Art Contemporain Collection, 1996.

In Balance (En balance), 1998, detail.
Unpicked woolens, photographs, rope.

Little Parade (Petite parade), 1997.
Stuffed animals, wool, net, fabric.
Exhibition at the Venice Biennale, 1997.

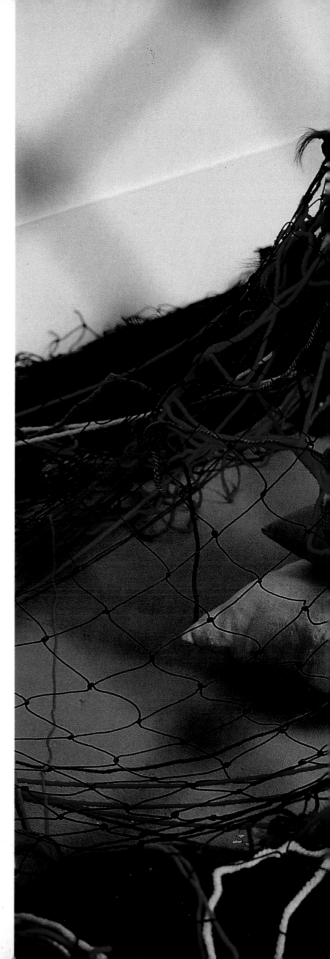

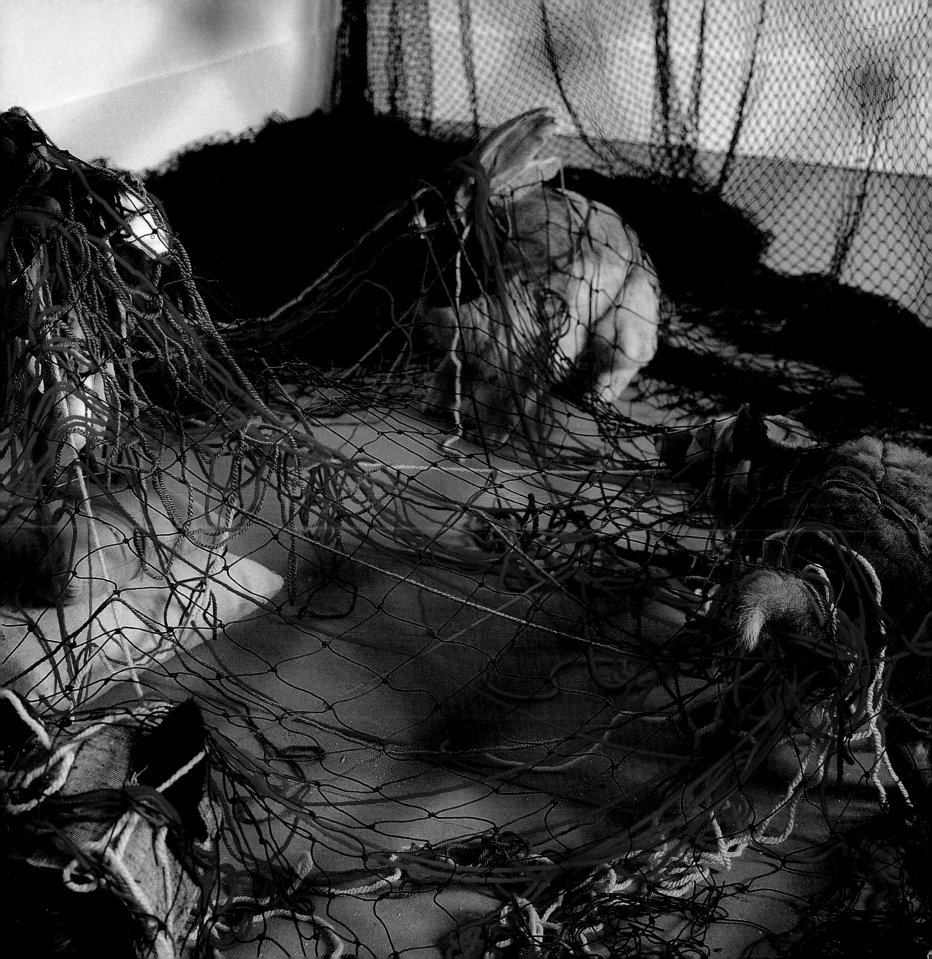

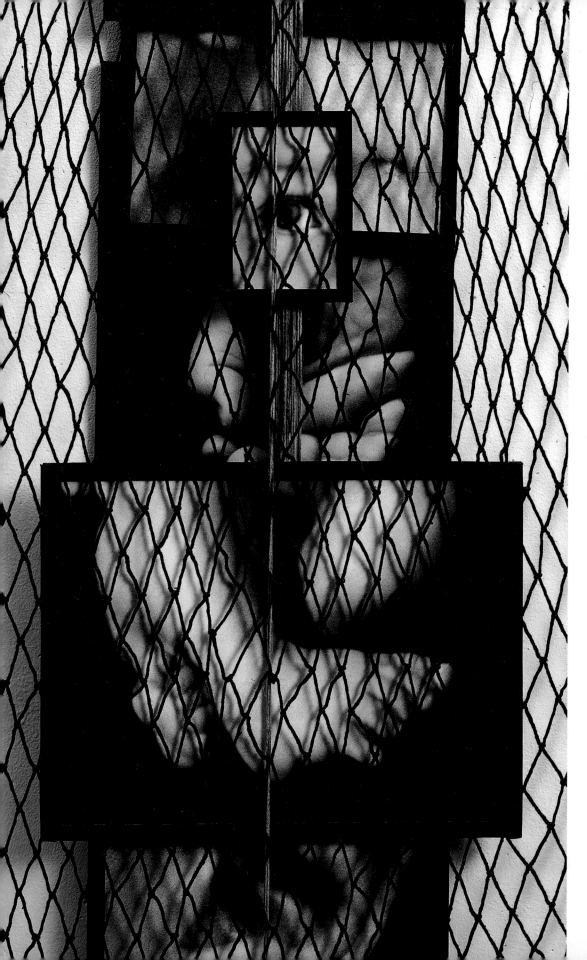

Game of Mourning (Jeu de deuil), 1994, detail.
Nets, black-and-white photographs.

My Vows under Netting (Mes vœux sous filet), 1997, detail.
Nets, black-and-white photographs, and writing.

Following pages:
In Balance, 1998.
Bolsters, net, hanging photographs, unpicked woolens.
"Premises" exhibition, Guggenheim Museum Soho, New York, 1998.

2 Clans 2 Families (2 clans 2 familles), 1997–98, detail.
Soft toys, plastic bags, photographs, wood, mounds of earth.

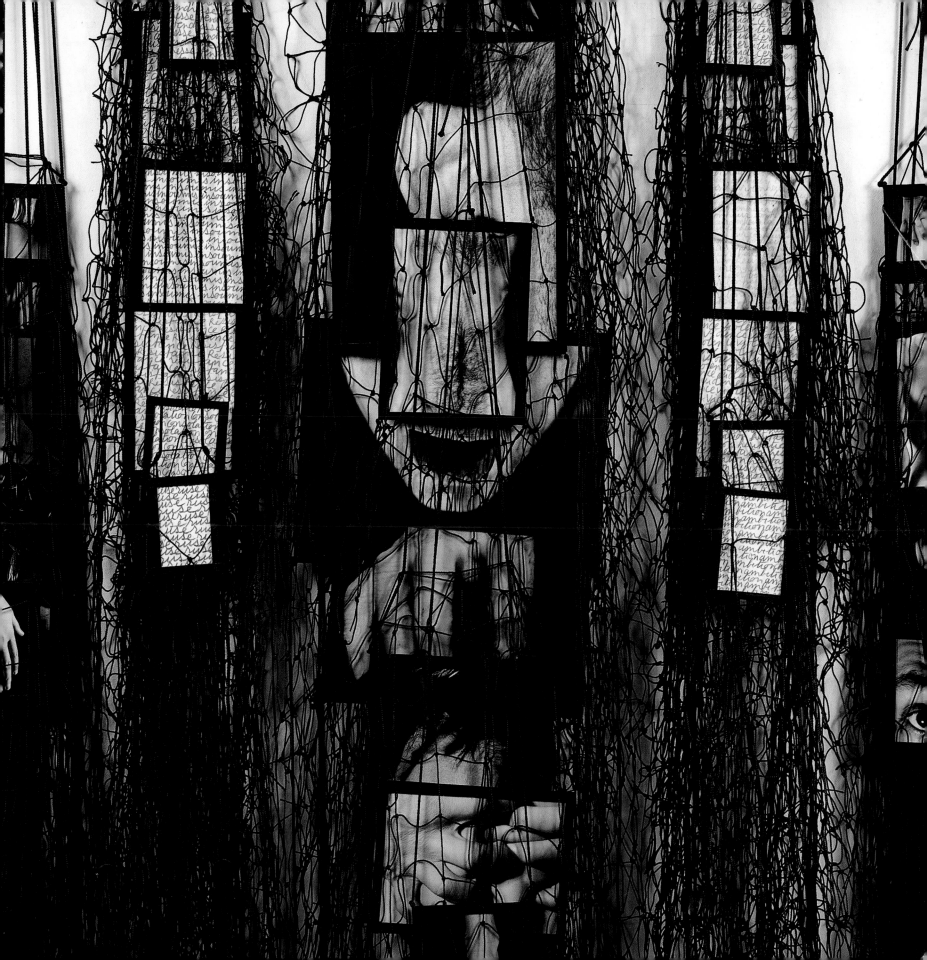

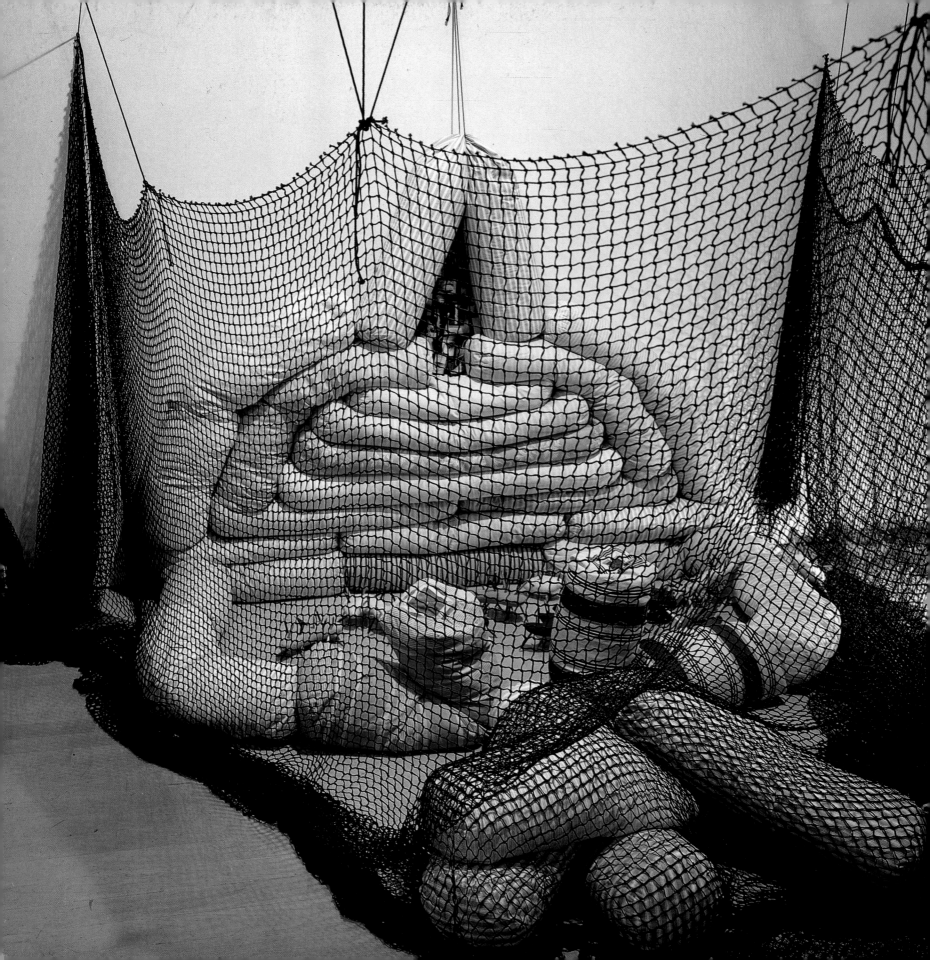

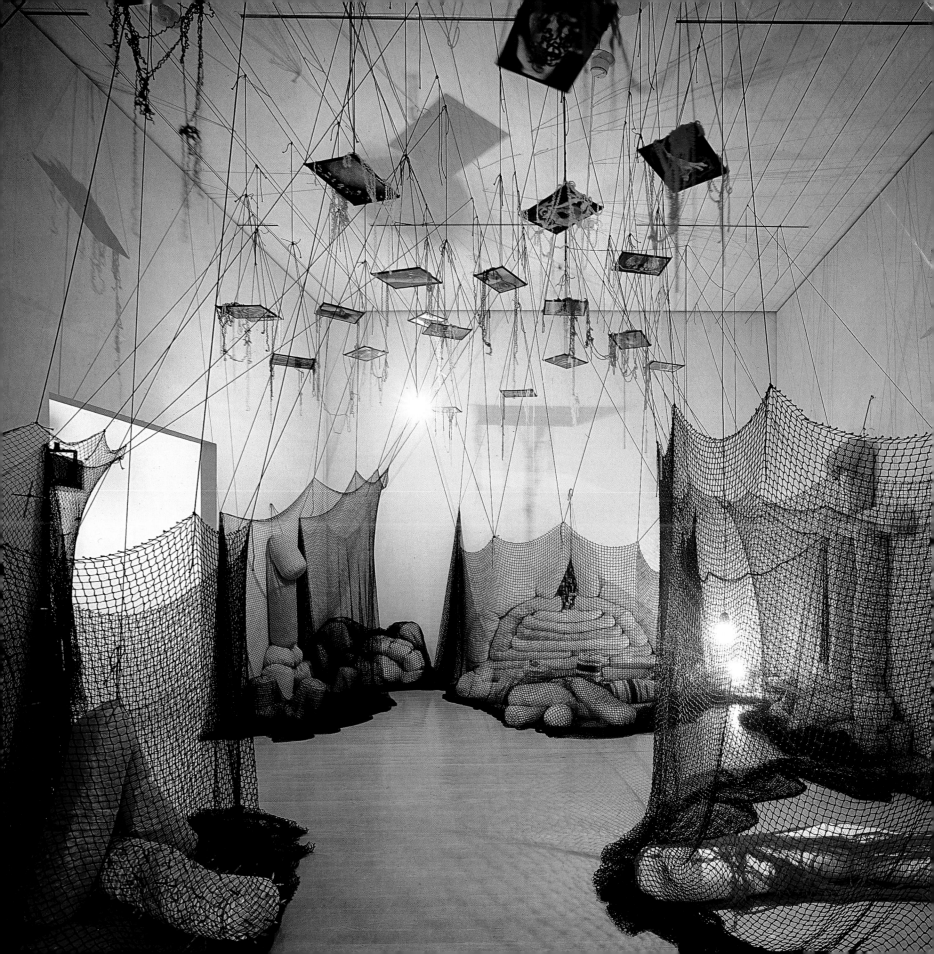

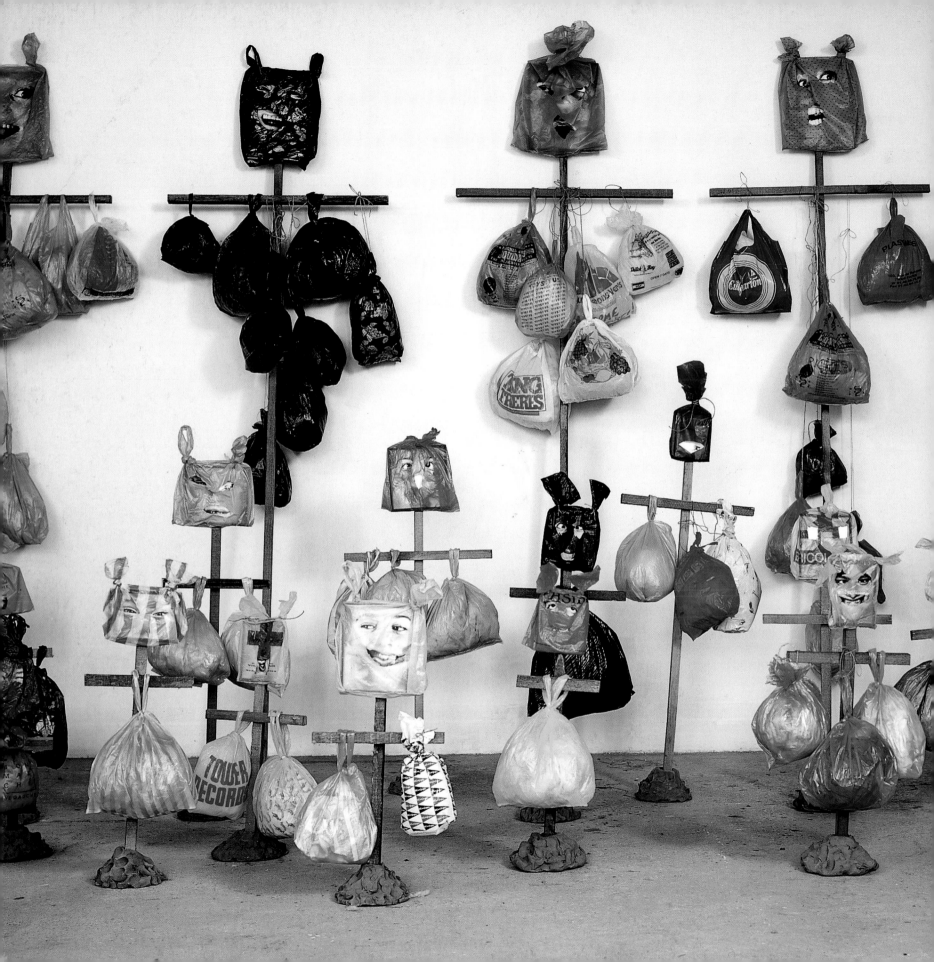

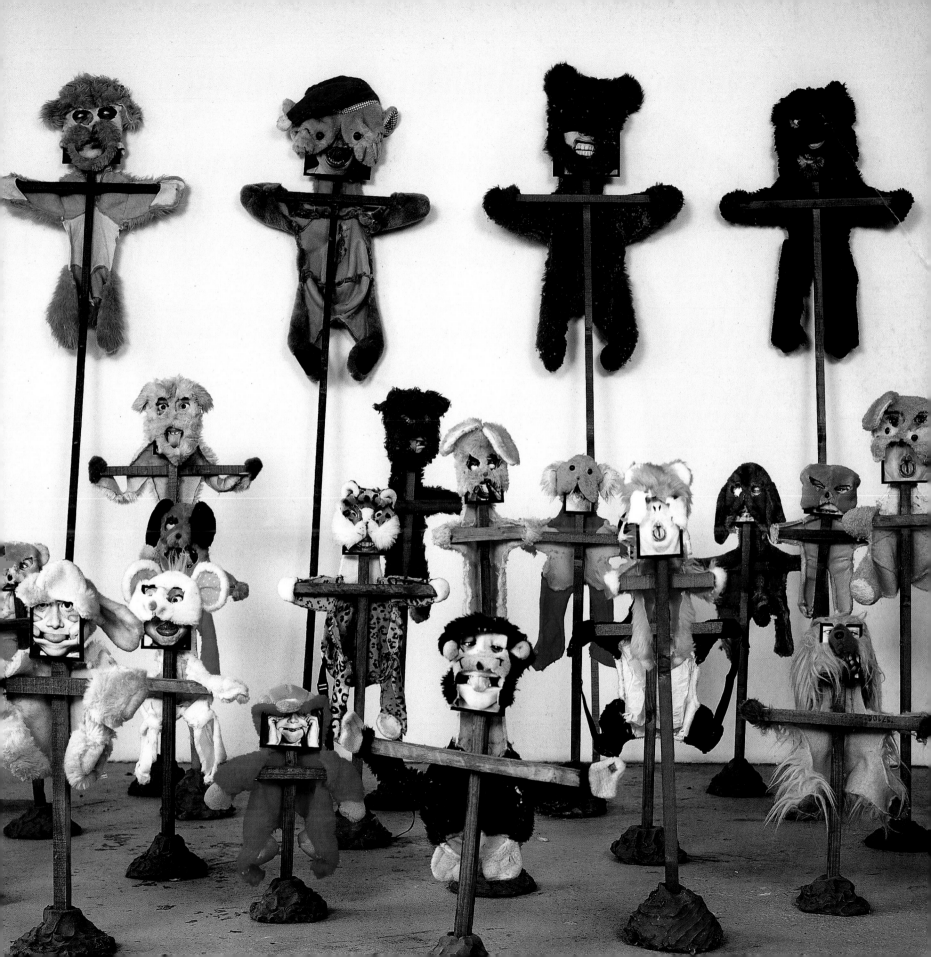

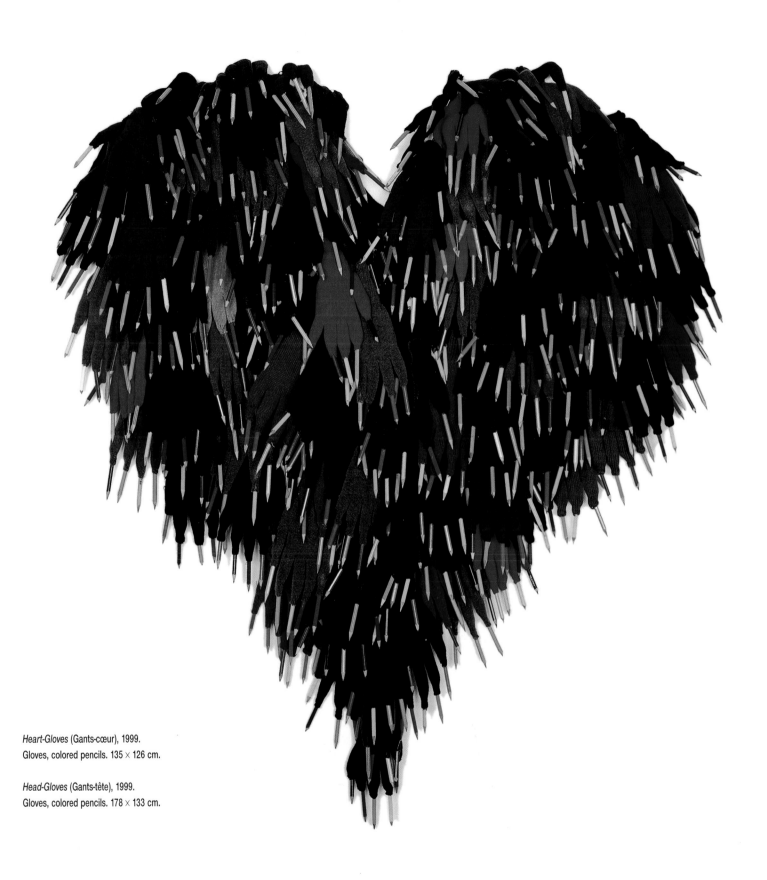

Heart-Gloves (Gants-cœur), 1999.
Gloves, colored pencils. 135 × 126 cm.

Head-Gloves (Gants-tête), 1999.
Gloves, colored pencils. 178 × 133 cm.

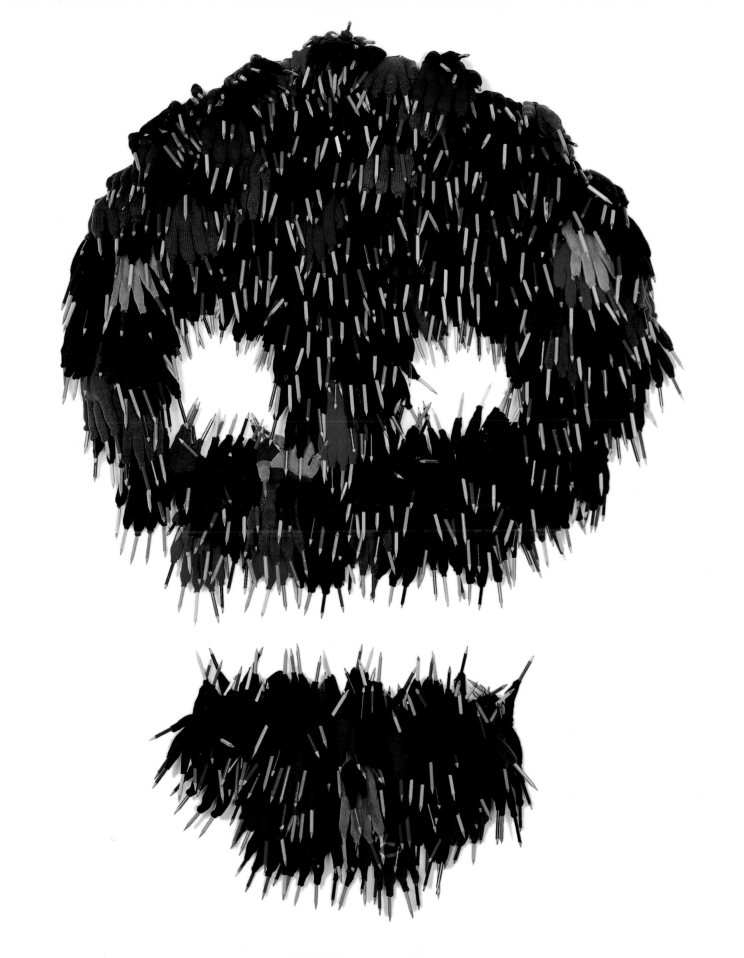

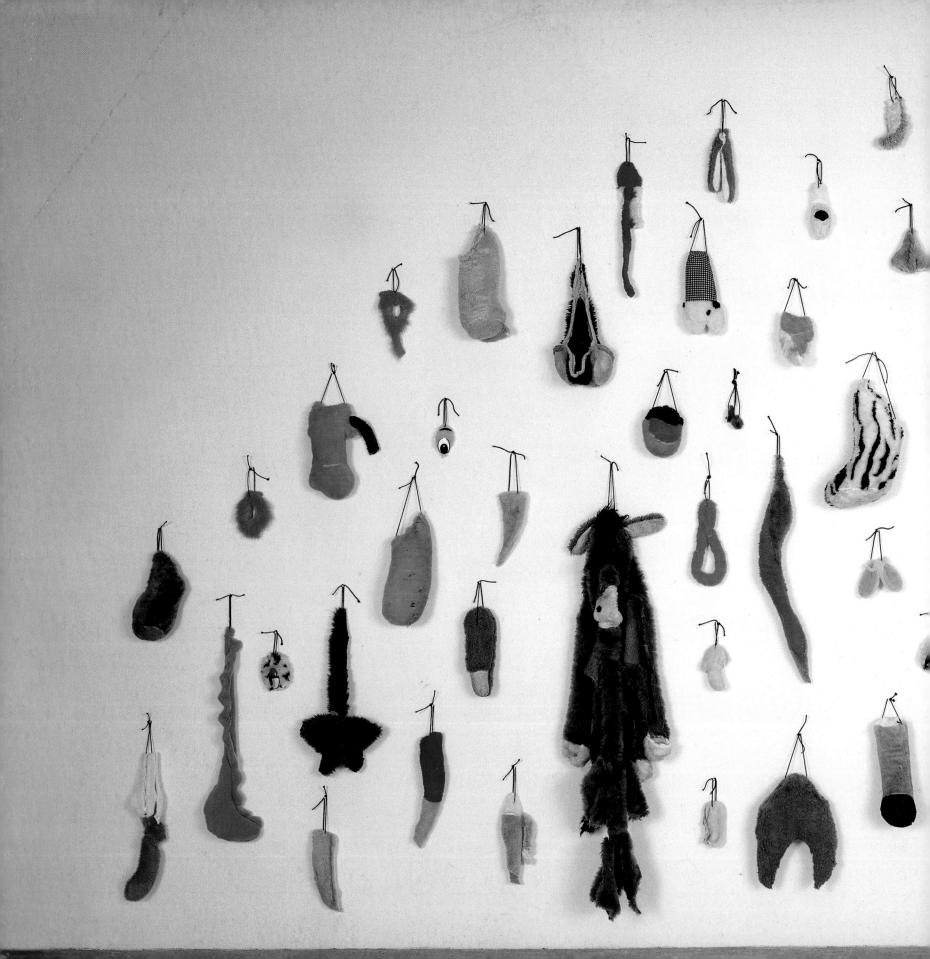

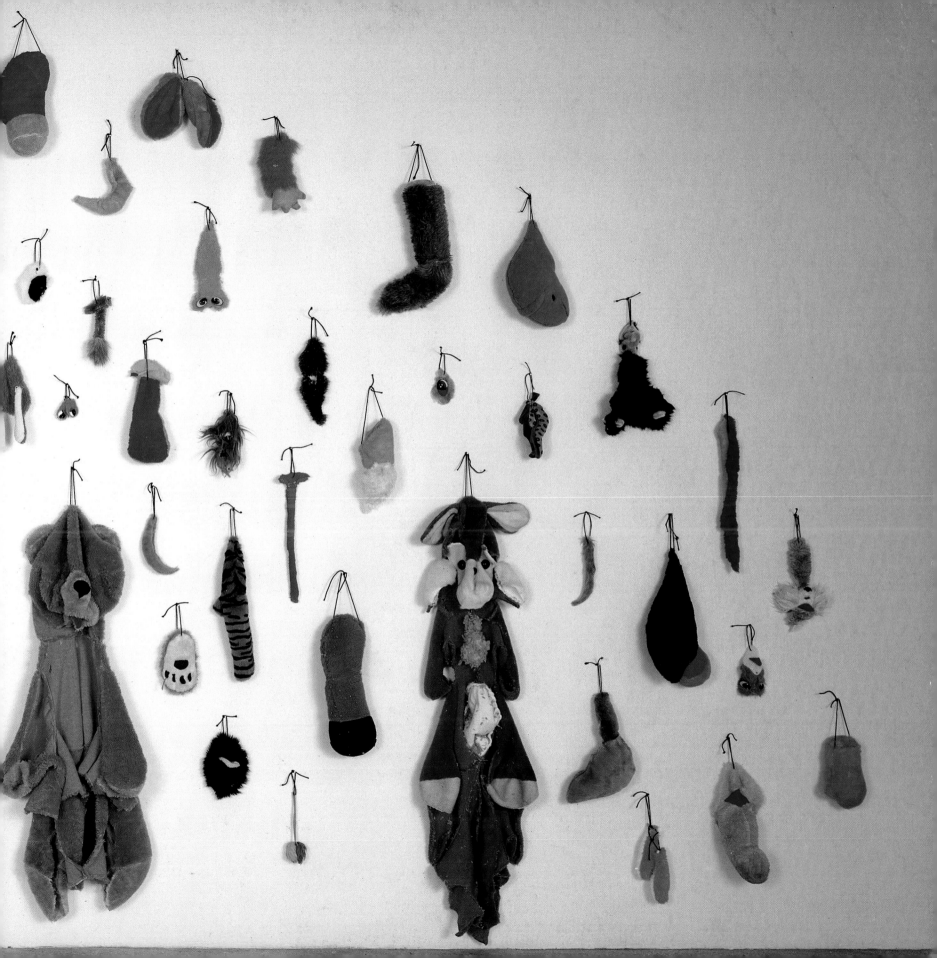

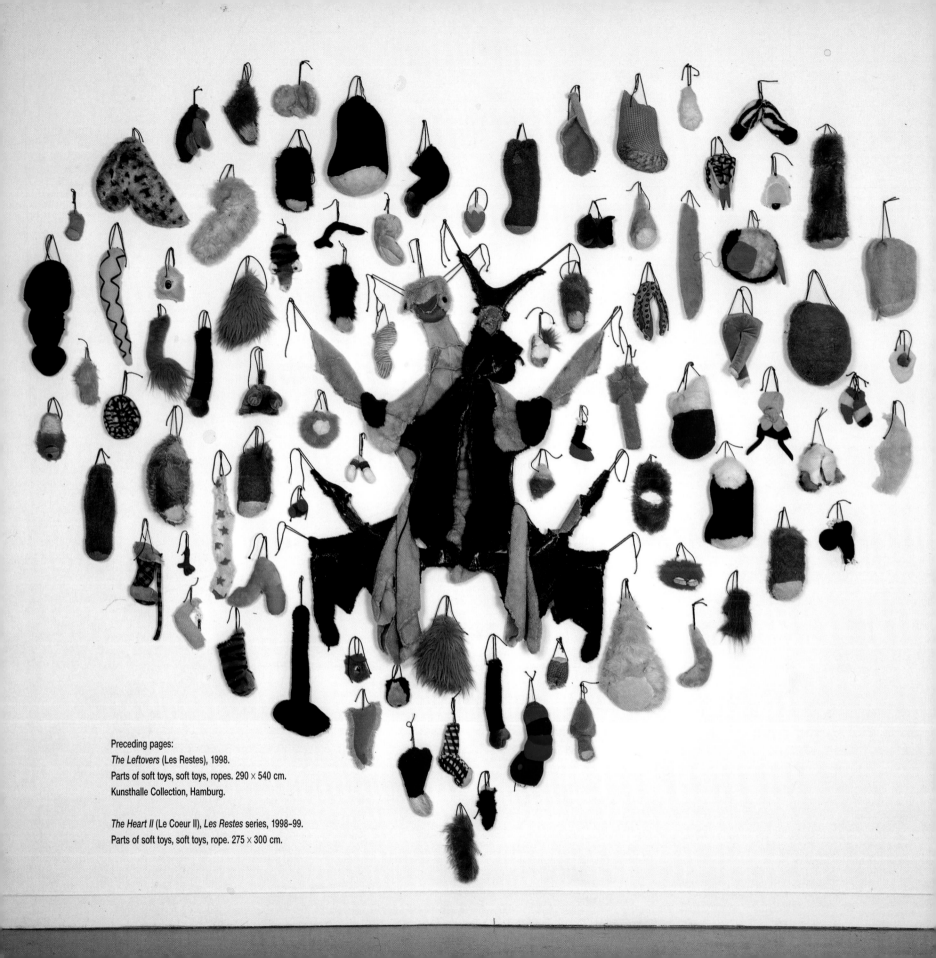

Preceding pages:
The Leftovers (Les Restes), 1998.
Parts of soft toys, soft toys, ropes. 290 × 540 cm.
Kunsthalle Collection, Hamburg.

The Heart II (Le Coeur II), *Les Restes* series, 1998–99.
Parts of soft toys, soft toys, rope. 275 × 300 cm.

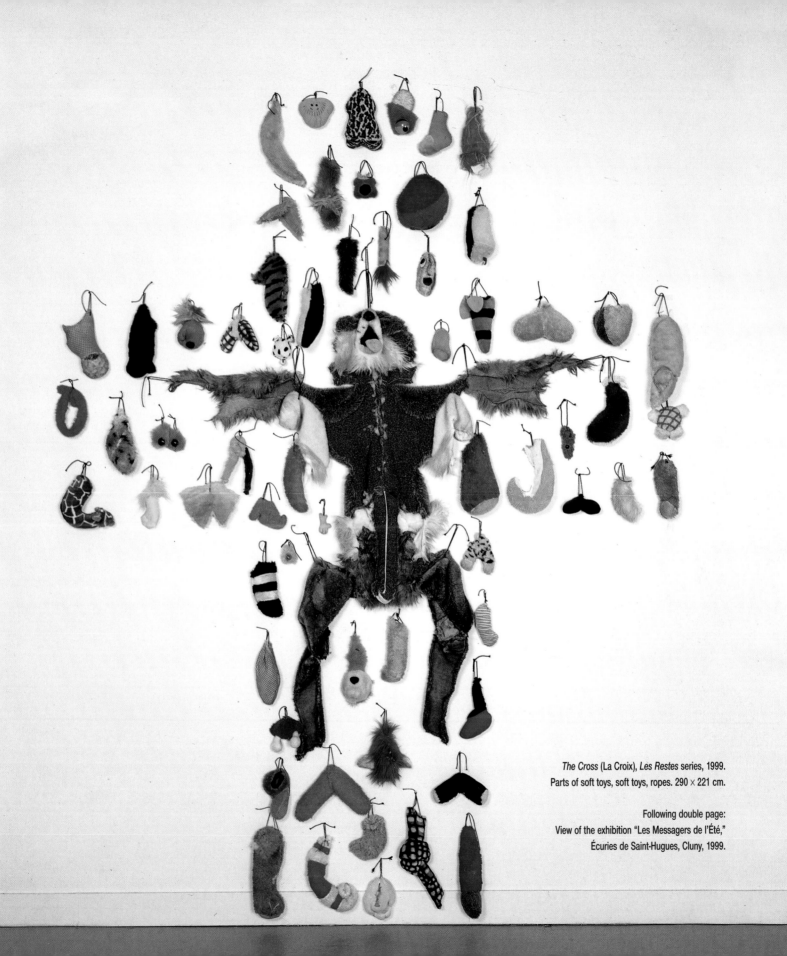

The Cross (La Croix), *Les Restes* series, 1999.
Parts of soft toys, soft toys, ropes. 290 × 221 cm.

Following double page:
View of the exhibition "Les Messagers de l'Été,"
Écuries de Saint-Hugues, Cluny, 1999.

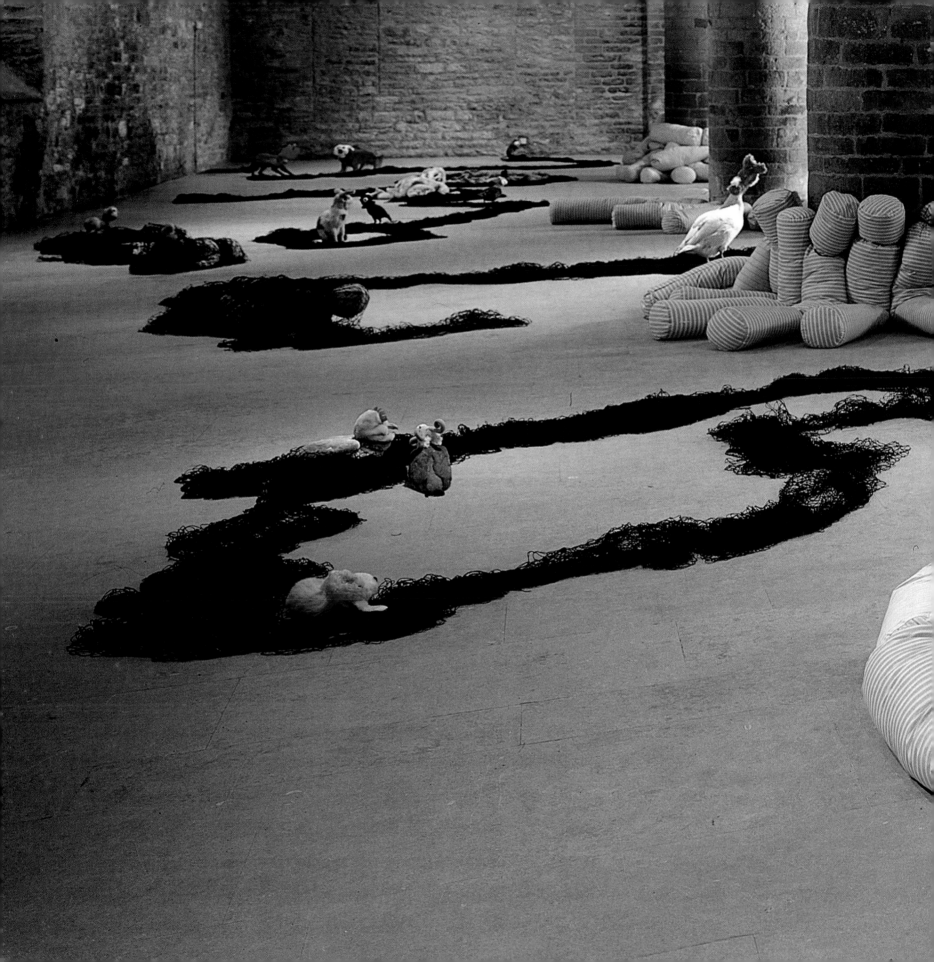

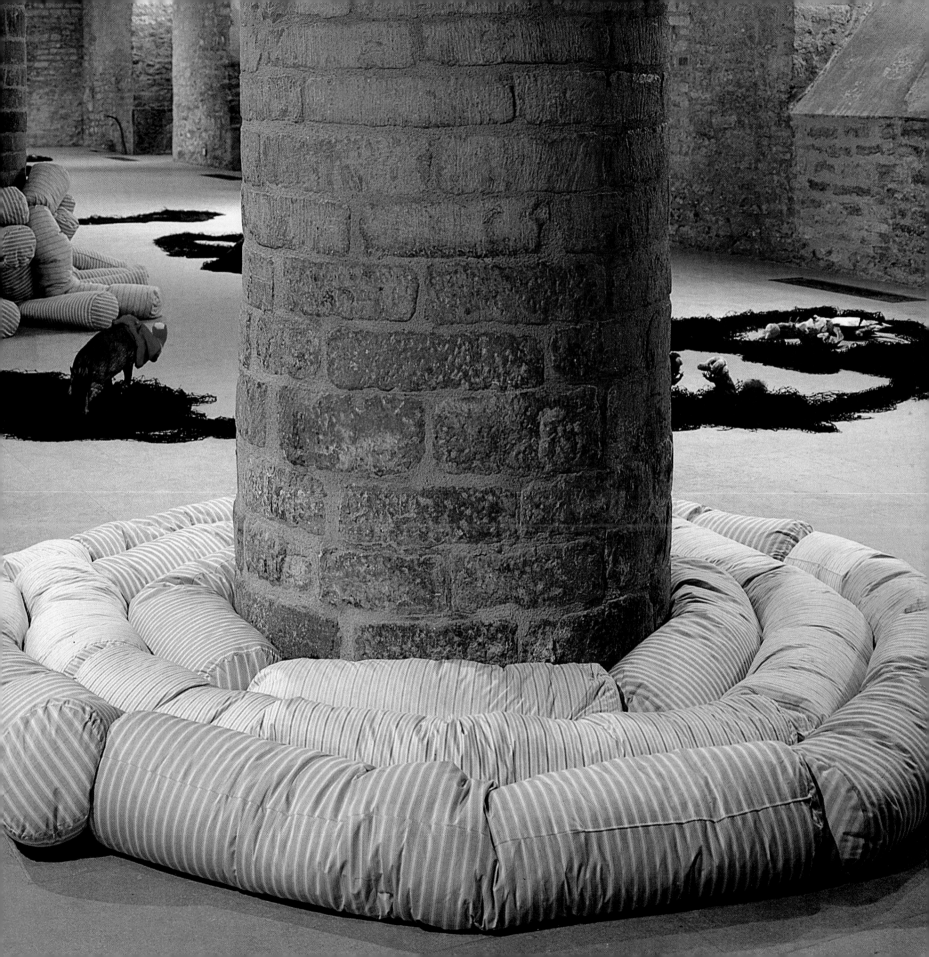

Although, in a search for its origins, modern art has regularly given its bourgeois credentials fresh gloss with a quick lick of so-called "popular culture," it has not succeeded in becoming a true "art of the people." From the "primitivism" of the early twentieth century to the kitsch which pervades contemporary art, "downgraded" populist forms have provided a fund of material for modernist adventures, though without genuinely lasting effects on the process of sublimation that underpins the Western conception of art. Although "popular" culture is familiar to all, it can easily elude both those who think of it as alien or "other," and those who can only take it periodically, in homeopathic doses. It is the result of a pointless exercise performed on something useful—or on something verging on the useful (a spoon, a piece of painted furniture, a metal object turned into an ashtray decorated with a story)—a process that implies it possesses primarily a use value. Its basic form is preordained—the search is not for originality, for novelty, but for specificity. Like the art of the insane, of children, or of "primitive" societies, it is anachronistic and meaningless, and hence picturesque. It is thus surprising that any artist would be brave enough to try their hand at it.

Annette Messager presents herself as a "downgraded" artist. "Downgraded" of course like every woman—especially if that woman has pretences to art. Why, it might be asked, should a woman want to become an artist at all? In reply, Annette Messager quotes Robert Filliou: "To make life more interesting than art." This is an apostolic rather than strictly artistic ambition, rejecting as it does art's supremacy by putting "life" above "history," and "truth" above "beauty." One becomes an artist in order to derail art, to shake it up, to return it to the personal. As opposed to some abstract notion of an entity called "life," life for this artist is her own life, though by the same token it is the viewer's too, as is shown by the incessant shifts in her titles from the possessive to the indefinite article and back again—*Mes clichés* (My Clichés); *Les indices* (The Clues); *Mes vœux* (My Vows). Subordinating art to life necessarily entails the devaluation of models and of structures: Annette Messager co-opts artistic forms and so complies with the pre-eminent demands

Annette Messager.

of art. Journal and photo-novel, the Minimalist idiom of the 1970s, paintings and baroque compositions during the 1980s—flicking through the prevalent forms of the last few years, we encounter all the "clichés" around which her oeuvre has deliberately been organized.

Obedience and violence are two sides of a single attitude that rejects art lacking in heroism or bitterness, the attitude of an artist who has no hesitation in reconfiguring a "popular" art such as the cinema (an art of which she is especially fond, an "art of love," as she calls it), one which sets up no overriding ironic stance, but which nonetheless cultivates its own unspoken agenda.[1] Popular art, like amateur art—another devalued and everyday form in which practice (a notion crucial to Annette Messager) carries more weight than the project—was essential to the artist's discovery of the world as a child. Born and raised in northern France at Berck, a town with a sizable population of sick and convalescent living in the shadow of the local sanatorium, Annette would have encountered at a young age votive offerings and other objects of popular devotion, as well as all the crafts and skills that boredom and isolation render endemic in such communities. Against the backdrop of a town torn apart by the war, churches—which served for the youthful Annette both as a personal refuge and as a place in and from which she could rebel against her atheist parents—were havens of hope and succor, as well as places of fear and death, spaces where, gazing at the forms, colors, and objects that filled them, she might have sensed a supernatural presence. The dual nature of religious artefacts, that both focused the solace of faith and bore witness to heartfelt suffering, marked Annette deeply, and resurfaces in many of her artistic ventures.

"EVERYBODY MADE ART"

In Berck, she tells us, everybody made art. Many of its inhabitants, for whom—given the situation of the town—the sea and the world of the imagination alone offered hope of escape, frequently engaged in the pastimes of writing, photography, and painting (primarily seascapes). An architect, her father was also a painter and photographer; receptive to the visual arts, he initiated his daughter not only into old master painting (that they would go to see in museums and churches) but also into Art Brut, especially into the work of Jean Dubuffet, with whose writings he was well acquainted. Making art with whatever comes to hand is not only a practice common among amateur artists but was also a principle forcefully advocated by Dubuffet himself, and one which Annette, following in the footsteps of her father, was to make her own. Her father was a textbook example of the cathartic function of painting: it was, she informs us, the only activity during which he seemed calm and serene to her young eyes. This childhood experience of an art fuelled by suffering, but resulting in peacefulness, that protects and develops a power to cure, became essential to her own creative enterprise.

The church of Notre-Dame-des-Sables, Berck-Plage, France. Interior view.

In the art of ritual offering, the ex-voto, and the religious painting, in the seething seascape and in image-making more generally, the subject depicted is always of the highest importance, more important than formal considerations, materials, or means—although they remain significant, particularly when they are original or demand ingenuity. The subject represented does not always have to form a picture *strictu sensu*: symbol, metonymy, and literary means are often pressed into service to palliate difficulties or shortfalls in depiction. Decorative elements too play a major role, sometimes even overrunning the subject of the image itself. Finally, such works are characterized by multiplication, by proliferation even: clusters of objects such as one might stumble upon in a church standing next to the altar or to a statue of healing saints, patchworks of ex-votos, or the amateur artist's tireless accumulation of well-nigh identical works. In the realm of popular art, repetition does nothing to dampen the effectiveness of the image; on the contrary, as in the case of a litany or incantation, iteration simply reinforces its power. These qualities resurface in Annette Messager's work, rendering it all the more immediate: readily understandable, familiar yet precious and underpinned by a timeless tradition, her pieces have the universally acknowledged attractions of openness and disinterestedness.

PHOTOGRAPHY AND DISAPPEARANCE

Over the last one hundred years, creating pictures has, thanks to photography, become one of the most widespread individual and family pastimes. Photography gives form to memories which, with the passing years, it can help to fix; in this sense photography is a project that extends in time, making pictures that are deferred the second they are taken. A photograph is snapped "for later on." In everyday usage, a picture once taken is valued above all as a "souvenir," serving, for instance, to reawaken memories or resurrect a period from long-lost youth. [The photographer will tend to take more and more shots, while the sitter will try to arrange them into a narrative system or make them into mosaic-like compositions] so as to recapitulate pieces from a body fragmented by the transformations time has wrought. Behind the photograph one can glimpse the disappearance, the namelessness of the figures, of the sitters, of the landscapes, and the destruction of identity that the image is intended to forestall, temporarily at least. Beneath this almost instantaneous act (as sudden, Annette Messager reminds us, as the hunter's death-dealing blow), there lies a responsibility which only comes to the fore much later, when the pages of a photo album are joyously turned or sadly mislaid. When all possibility of identifying what is depicted has long since vanished, the image loses all existence—unless some lover of the unknown or of the past identifies with it anew in a wholly different way. To truly exist,

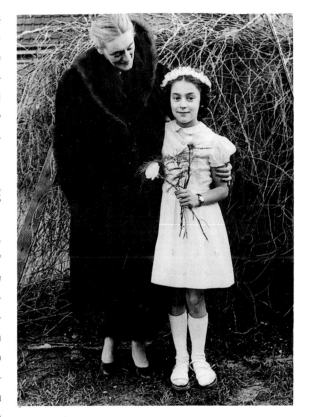

Annette Messager with her mother on the day of her first Communion.

a photograph has to *belong* to someone. It is an image which can never be assigned to another; it can only be handed down conditionally, as an heirloom.

To take photographs is to show, since photography is a process which allows vision to extend in space as well as back in time. The practice of art, be it amateur or professional, has centered on this capacity for exposure, for revealing all to the best possible effect, that is, by way of respecting both the creator's own truth and her artistic intentions. The point of balance between the documentary role and the mark of intentionality separates the "amateur" from the "artist." Like family snapshots that jog the memory, photographic exposure is inextricably linked to a canon of truth inherent in its techniques. With Annette Messager, these processes underpin a body of work which, far from dispensing with truth, is founded upon it.

Annette Messager began taking photos as a child. So, she recalls, did her father, whom photography put into a particular state of excitement, quite different from his mood when holding a paintbrush. It is as well to remember that in France, following the end of World War II, photography acquired a peculiar status. Offering a safe haven to the memory of the dead whose effigies lay all around—in the family home, in church, on monuments—it also played a significant role in the reconstruction of society through its appearance in the pages of illustrated magazines that disseminated the heartening images of a country soon to regain all her former opulence. For her often sickly father, photography became symptomatic of a new-found lust for life.

Coincidentally, photography was to provide Annette Messager with her first real opportunity to discover the world. Unbeknown to Annette, her mother entered a snapshot (a landscape) that her daughter had taken as an adolescent in a national competition. The photograph won (simply "because they wanted my region of the north to win"), and she started out on her first true adventure, a round-the-world trip.

Even before that chance event, photography, with its mixture of smiles and tears—combining with popular art, the Church, and the sanatorium with its lost and saved, and its often good-humored and care-free inmates—had already taken young Annette on a voyage around the world of emotion and feeling. Her whole oeuvre would later introduce us to that: the living, or rather reliving, of life's joyful and unhappy moments, "at every instant healing and, at the same time, reopening old wounds."[2] Exposed to the experience of death in her earliest years, to the idea of love as a redeeming virtue (not only in the religion which she followed, but also through the shining example of her own mother giving a new lease of life to her father), to sin (once again through her father), to madness, to art and its corollary in the Art Brut of which she became so fond, she committed herself to action, to engagement with the real world. Religion, love, and art are above all ideal forms of practice, of action, that is, they are types of unmediated concentration on living. Often dubbed "the sixth sense," "practicality" has roots deep

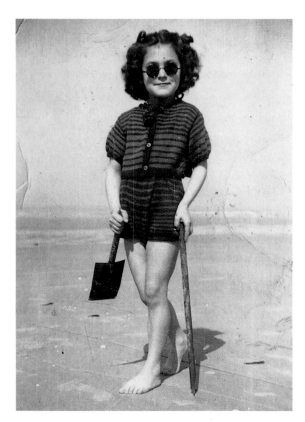

Annette on the beach, Easter 1949.

within humanity. It was to become the plinth on which Annette Messager was to place her whole work: indeed, one of the earliest names she was to adopt on entering the art world was "Annette femme pratique" (Annette, a practical woman).

FIRST PARIS, THEN THE WORLD

The young child who dreamed of becoming a nun or a ballerina became a teenager who knew she was to be an artist. She left Berck in the early 1960s and went to study in Paris. She chose the École des Arts Décoratifs, which was reputed to be more dynamic and less academic than the École des Beaux-Arts. Her own convictions quickly strengthened and she avoided student circles, where "everybody was either painting or making plaster casts," her marginal position becoming even clearer in her first independent works. "I wasn't sure what I wanted to do exactly, but I knew what I didn't want to do. At exhibitions I saw strong, powerful paintings, overblown images, and I said to myself that there must be something else to do."

Inner impulses drove her to turn elsewhere. In the northern French museums she had visited with her father, she remembered mostly paintings by outsiders such as Goya, Ensor, Soutine, and Bacon—artists who did not idealize painting, but who made it serve suffering, serve the lowest of the low, humanity at its most aimless. These artists wended a humorous, even caustic, path, presenting art as a principle of redemption, the flash of life that lifts the subject up out of the gutter. Dubuffet, who remained a fundamental reference point, was an artist of just this type; not only his own work, but also his efforts on behalf of Art Brut were to have a considerable effect on Annette Messager's chosen trajectory. In 1967, a large-scale show of Dubuffet's Art Brut collection fired her imagination: Adolf Wölfli's fantastic drawings and Jeanne Tripier's extraordinary embroidery provided striking examples of an art that, as she was often to remark later, required no more than the most familiar means—a pencil, a needle, some glue—quite devoid of all the pomp and circumstance of the paraphernalia of so-called "great art."

AN ART FOR THE INDIVIDUAL

In Paris, her reading, the places she visited, and finally her initial forays into art confirmed an interest in those twentieth-century figures who had been fascinated by an idiosyncratic approach to art in whatever age or corner of the globe, those who had listened most closely to irrational phenomena: the Surrealists. She felt particularly indebted to André Breton: "My interest in the little things of life probably comes from him." The photographs in his novel *Nadja* captivated her. At the time the Surrealist spirit was underestimated, at a low ebb compared to Dada that was highly fashionable

Annette Messager, around 1958.

among the upcoming iconoclastic avant-garde. Seen as an academic practice, Surrealism was reproached both for its literary bent—something which made it all the more alluring for Annette Messager—and for its enduring attachment to the image.

It was through the intermediary of another female figure, Louise Nevelson, that Annette Messager drew close to Surrealist works, taking much inspiration in her early efforts from the American artist's object boxes.

At once artistic model and model woman artist, Louise Nevelson's example led Messager to exploit her taste for, and knowledge of, popular culture without inhibitions. As a student, she had steered clear of any dominant grouping and had instead concentrated her efforts on personal experimentation of a private nature, constructing house-like boxes divided into compartments and drawers packed with tiny objects. None of these early boxes, exhibited sporadically in the window of Lucien Durand's gallery, survives. Today she accords them scant importance, except in so far as they constituted a deliberately marginal exercise, a secret and solitary activity that had no truck with prevailing artistic ideas and which fell outside the constraints of the teaching arena. In fact, these early years were spent walking around Paris ("I spent my days going to the cinema and seeing exhibitions"), meeting people, and above all making journeys, of which there were many throughout the period.

DISCOVERING THE WORLD

The photography competition that Annette Messager won entitled her to take a round-the-world trip in the company of one other person. She left in 1964 with her godmother on a two-and-a-half-month journey that took her to southern Europe, and thence to Hong Kong, Japan, the Philippines, Cambodia, India, and then Israel. Unable to visit them on this first trip, the following year they traveled to Nepal and Ceylon. A trip to the United States, undertaken as a student of the École des Arts Décoratifs, was to follow later.

These various tourist trips were to provide a treasure trove of information, images, and sensations that she has regularly drawn on throughout her career. Later too, she would jump at any opportunity to travel to new places that might enrich her artistic vocabulary. In southern Europe, she was to discover churches decked out with ex-votos, votive figurines, and all the other manifestations of popular piety. Asia, and India in particular, introduced her to new types of imagery, examples of which she was to squirrel away, as well as to new forms of suffering and poverty and to visions of humanity racked by pain. She had bought her first top-quality camera in Hong Kong, and the discoveries she made were henceforth illustrated with photographs. Though one can well imagine that these experiences and images influenced the future course of her artistic research—and she has said as much herself—it is an intriguing fact that the

With Nikita, in 1960.

work she was to create once back in France is totally untainted by exoticism.

This highly characteristic trait of Messager's also transpires in her strongly individual attitude to the world: the more significant the images referred to, the more thoroughly they are assimilated, until they are entirely transformed and thus divorced from any perceivable relationship to their origin. This process of letting the image steep until its substratum distills into the creative process is an essential task that fuels the work of an artist who otherwise derives singular enjoyment from simply copying items of a nondescript kind.

OFF THE BEATEN TRACK

Once back in Paris, her interest in study waned noticeably, to the point that her presence in the school was no longer desirable. She then gathered together a group of young artist friends from Paris and met up with a fellow student from the École des Arts Décoratifs, Anne Poirier (who was not known by this surname at the time), as well as with Antonio Miralda and Joan Rabascal. At this time, the social environment was explosive and feminism was beginning to become organized. Annette Messager, however, did not share the ambition of many in May 1968 to bring great art into the street, instead taking solace from the realization that the path of artistic creation lies off the beaten track.

At this time, she earned her living by making the most of her artistic talents: constructing mirrors in elaborate shapes and subjecting the silvering to acid treatment ("they sold really well"), she continued her personal research based on unpretentious and purposeless experiments, such as making life-size reproductions of women's accessories out of household materials ("sunglasses in cardboard and wire, paper shoes, aluminum-foil rings and watches"). She has confessed to coming at this time under the influence of Claes Oldenburg, a figure well known to French artists. Oldenburg had underlined the closeness of his art to that of Dubuffet and it was abundantly clear that he reveled in the everyday environment and popular culture. With his "stores" filled with papier-mâché replicas of domestic objects, his plaster-coated canvas or fabric works, and his improvisations, Oldenburg had embarked on an unfettered, joyous, and inventive relationship between life and art. His works—kneaded, sewn, stuffed, and colored—have their roots in a "homemade" tradition of production, the magnification of his chosen subjects evoking the child's world of toys or a film set. His desire to make an art that "embroils itself with everyday crap and still comes out on top,"[3] his attraction to the detritus of civilization and its more vulgar manifestations, his "soft," derisory pieces seemed designed to bewitch Annette Messager, since they corresponded so closely to her own plan to create an anti-heroic and wholly non-conformist art.

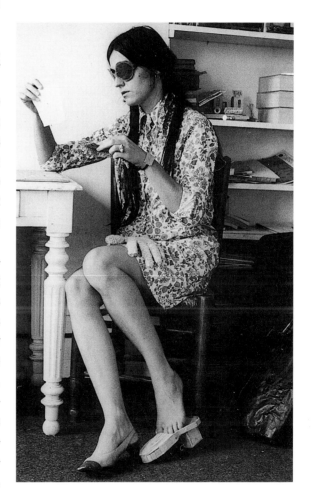

Annette Messager with a pair of glasses made out of cardboard, paper shoes, wire ring, fabric comb, and cardboard handbag, reading a fake envelope. Late 1960s.

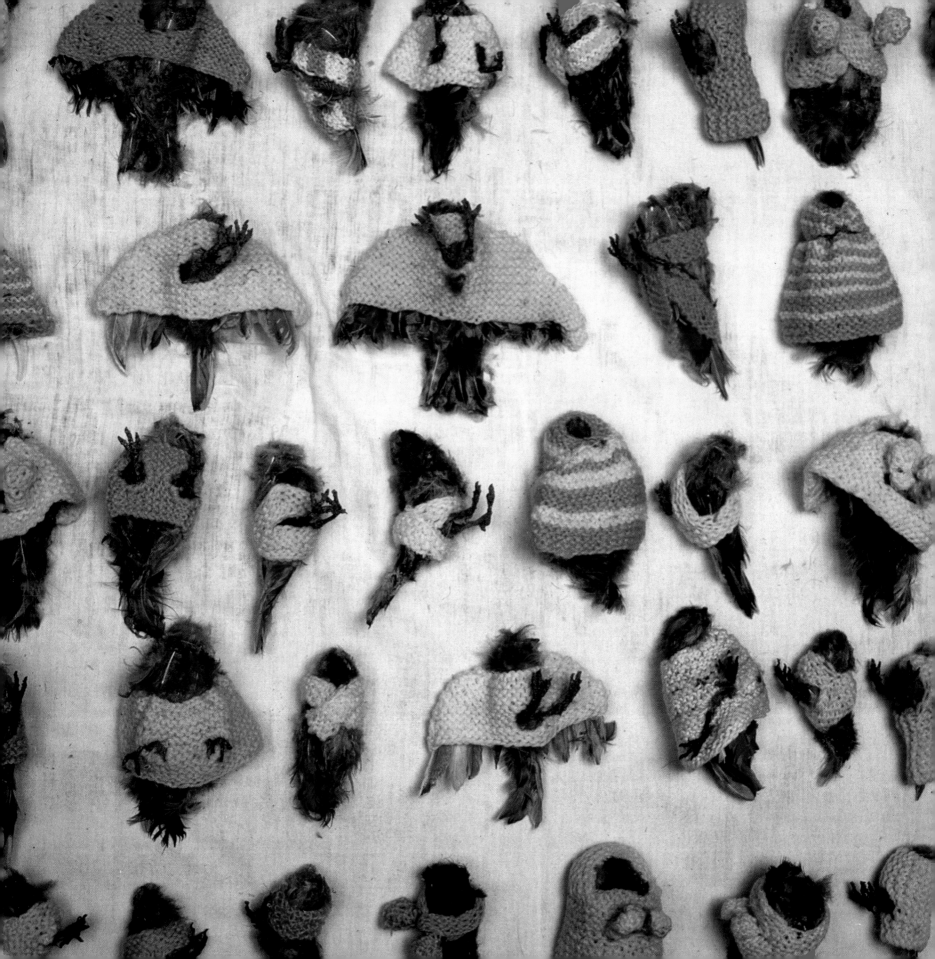

the dolls

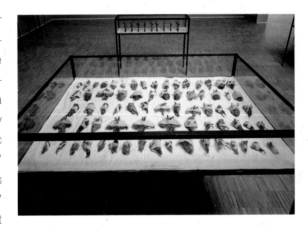

Annette Messager's working procedure was already clearly established in her earliest ventures: appropriating things and activities that have been devalued, and investing them with supreme value; inventorying the most anodyne private practices and catapulting them into the public sphere; and translating childhood games into the adult world. Feminism she treated less as a cause than as a framework that allowed her to progress onto new things, investigating its territory like, as she has said, "some ethnologist or art historian specializing in the ethnic arts." Since many of the practices in which she is engaged are typically "feminine," the implication might be that her work is primarily autobiographical, though this is a conclusion that she has been careful to neither confirm nor deny. Such "false" introspection does not prevent her from distilling "truth," however, and in sufficient quantities to keep her work balanced on a knife-edge between truth and falsehood, steering a middle course best characterized as "playacting." There is a histrionic side to her work, but unlike Performance artists (many of whom have been women), Annette Messager's theatrical attitude is but a personal precept, conceived of as a working method, not as a creation in itself.

ANNETTE MESSAGER, ARTIST

In *Les Pensionnaires* (The Boarders, 1971–72), the piece that broke with the early sequences of handmade objects and which saw the beginning of her oeuvre proper, Annette Messager was to seize on a new possibility, which she developed from within a private narrative, whose closest equivalent is a game. Following a request

The Boarders at Rest (Le Repos des pensionnaires), 1971–72, detail.
Feathers and wool, vitrine. 154 × 94 cm.
Musée National d'Art Moderne-CCI Collection,
Centre Georges Pompidou, Paris.

The Boarders at Rest, 1971–72.
Detail of the installation at the Musée National d'Art Moderne-CCI,
Centre Georges Pompidou, Paris, 2000.

from the Galerie Germain to produce a work using wool (in the context of a show sponsored by Woolmark), one day she came across a sparrow lying dead on the sidewalk. Once back in the studio, she made a mock-up of the bird out of feathers that she then swaddled in wool.

This first sparrow was soon joined by other "boarders," some stuffed, others simply built up out of feathers, all sporting little colored cardigans she had knitted for them. They were then christened like human infants. Initially derived from maternal care, the game then developed further: childhood accessories were made—a feather alphabet, a cage, exercise bars, remote-controlled vehicles, toys—which she arranged in various scenarios that were written down in a notebook and recorded in a series of drawings, paintings, and photographs. The crucial moments of childhood (the daily walk, various punishments, the afternoon nap) are all there ("mimed," as the artist put it) in a touching yet grotesque manner (Annette Messager has even used the term "fake" in this connection). This capacity of conjuring up childhood without sentimentality and of speaking of woman without concession—in spite of the battery of clichés surrounding them—in both this work and in the subsequent *Albums*, arose from the ambiguous position adopted by the artist, as at once actor in and maker of the game. The game, with its cruel as well as its innocent overtones, brings to mind the worlds of childhood and of madness.

The birds are presented in a vitrine and accompanied by handwritten, disingenuous texts divided into chapters and inscribed in school notebooks. These describe in minute detail everyday situations related in the first person, illustrated with captioned black-and-white photos and even a few color plates, as well as with little drawings evocative of either the vignettes that appear in picture books or of technical drawings in specialized journals. There are also small-scale painted portraits of each bird. The material is documentary in the sense that materials for a performance are documentary: a few relics to which a growing mass of commentaries are attached: images, and images of images, observations on actions, and commentaries on images. The central question revolves around how to record what are after all insignificant activities, and transform them into something legendary, something like the story of a saint's life or an explorer's tale. However absurd and derisory, morbid and irrational it may be, the action thought of as a whole remains more significant than its representations. Indeed the artist's entire oeuvre is based on the fact that representation is in the end unable to speak of the real, incapable even of pretending to speak of it, and that representation has to be helped along, shored up, made good. In the end it is the vitrine, the wall, and the whole museum apparatus that is called upon to impart dignity to the scattered elements, whose models are the intimate diary and the child's doll with her accessories.

It was in this piece that Annette Messager first made use of the image of the doll. The doll is the female archetype par excellence, the one with which women are most often identified: little girls play with dolls, but grown women *turn into* dolls, or at least play at being dolls. The doll is commonly used to refer to the artificiality, the lack of maturity, and even, on a somewhat different level, the malevolence supposedly inherent in the female personality. Some maintain that the predominant trait of females is to be always "playing at life"—the tendency may be cleverly concealed, but sooner or later, privately, secretly, it will emerge. It is on precisely this feature that Annette Messager's work relies; by deliberately "playing at life," she turns it into a means of exploring the world through works that stage various "games of life." Following on from the Surrealists, as well as of other visionary artists like Goya and Ensor who made such an impression on her as a child, the universe she portrays is populated by dolls, but it is invested with all the powerful experiences of mature womanhood that give all their lost humanity and vulnerability back to the childhood toys.

Thanks to the innocent confidences of their fictional "mother," and through the *Boarders'* tiny bodies fallen into the grip of death, we can experience for ourselves all the growing pains of an ordinary childhood. Simultaneously pampered and tortured, the birds record our pulsions and act as the oscilloscope of our conscience. Annette Messager's toys offer an instrument for measuring life and the body, difference and indifference, for measuring art itself. The action of measuring and of measuring up to art, envisaged as a domestic activity involving recording and weighing, constituted a particular section in Annette Messager's agenda that would be continued over the succeeding months in *The Boarders* project, for which she adopted the ironic sobriquet "Annette Messager, artist."

THE COLLECTIONS

At the same time as *The Boarders*, she was elaborating what she calls "Collections," games that she devised and organized herself. In albums reminiscent of the private diary, the photo album, and the recipe book, she executed or inserted her own drawings as well as gathering, annotating, and transforming pictures and sayings found in magazines and newspapers. The fifty-six *Albums* provide an image of a particular type of woman—"the collector"—while at the same time portraying femininity more broadly: its preoccupations and traits, its trials and tribulations.

For the first album, *Le Mariage de Mlle Annette Messager* (The Wedding of Mlle. Annette Messager), she cut out wedding announcements and photos from newspapers, substituting her own name for that of the bride. As the collector thrusts herself into the arms of dozens of husbands-to-be in countless photos stuck into the

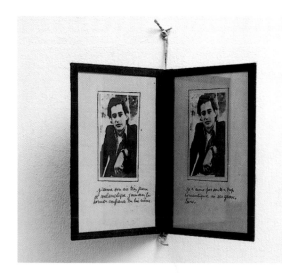

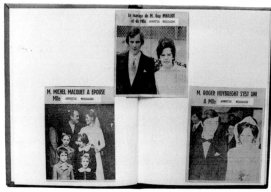

"Annette Messager, Collector," album-collection nos. 2 and 10, *Men that I Like, Men that I Don't Like (Les hommes que j'aime, les hommes que j'aime pas)*, 1971, detail.

"Annette Messager, Collector," album-collection no. 1, *The Wedding of Mlle. Annette Messager (Le Mariage de Mlle Annette Messager)*, 1971.

"Annette Messager, Collector," album-collection no. 3, *Children with Their Eyes Scratched Out (Les Enfants aux yeux rayés)*, 1971–72, overall view and details. Musée d'Art Moderne de la Ville de Paris Collection.

notebooks, she becomes an immediately recognizable figure: a young girl who has always tried hard to please and to conform, and who confides her—scarcely ambitious—daydreams to a scrapbook, whose making, one can imagine, occupies every second of a "secret life." This figure is the very epitome of the doll fabricated by convention, who escapes into a dream world that is tailor-made for her—a child who, by playing at wedding games, plays at being a woman.

Through the ideas the girl presents in dozens of her notebooks, the (real) artist can deploy her ironic stance, framing a critique that confronts us with a time-worn, stereotyped image of woman. At the same time, however, Annette Messager herself harks back to her past, to her childhood, memories of which provide source materials for the majority of the *Albums*. The scrapbooks offer a chance to let childhood speak for itself, to regain its intuitiveness, its exaggeration, its love of mockery, and its sense of wonder, to relive the way it feeds directly into reality. In the second album, *Les Hommes que j'aime, les Hommes que j'aime pas* (Men That I Like, Men That I Don't Like), she noted down her own critical, "out of the mouths of babes" remarks on pictures of various men, either simply cut out from magazines, or else photos of friends ("I like his chubby cheeks," "I don't like his phony peasant air"). By making a shortcoming seem positive, or a quality appear dubious, Annette Messager, through these exercises in out-and-out subjectivity, offers a readjusted version of the supposed objectivity such judgements purport to display, and makes us readdress our own criteria: Do I think the same thing as she does? The "reader" is trapped, just as he or she is within the games of interpretation presented in the family photo album ("my grandmother looked kind"). Subsequent albums confirm the potential equivalence between the reader and the albums of our starry-eyed collector (Messager uses the term *midinette*, meaning "a soppy, empty-headed girl"): they open one by one the compartments of the unspoken, of unspeakable futility, of small-minded transgressions, of simple-minded pride, or of misplaced curiosity. At the same time, a closer reading shows up the artificial nature of the journals that Messager peppers with little clues, like the countless incorrect addition sums in the album called *Mes dépenses pendant un mois* (My Expenses for a Month).

The most frequently reproduced collections are *Les Enfants aux yeux rayés* (Children with Their Eyes Scratched Out) and *Les Tortures voluntaires* (The Voluntary Tortures), probably because they are immediately disturbing and thus intriguing. Collecting photographs of children and scribbling out their eyes is a bizarre thing for a *midinette* to do, since it is an act inhabited by a quite foreign symbolic order, and constitutes a transgression much more powerful than the minor ones committed up to that point. This time, the game she stages is one that concerns death, although with the same traits of obviousness and innocuousness as the more

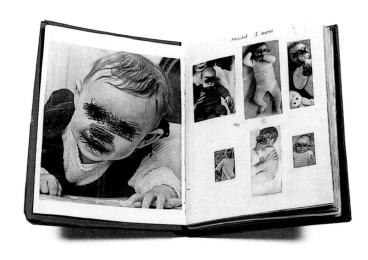

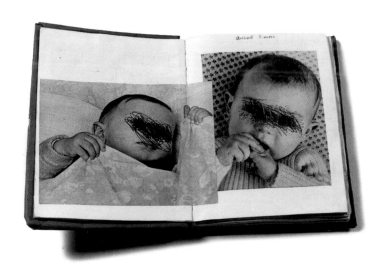

frivolous acts described elsewhere: "He'd be four and a half," "He'd be five," the captions intone. Be they real dead children or children killed symbolically, they have been wiped out by the destruction of their gaze. The gesture cannot be explained away as mere provocation: the intention is to expose what is a private act, and thereby show us a hidden zone within even the most unsophisticated and unexceptional creatures, a zone on the borders of madness. The young woman's secret revolt against what

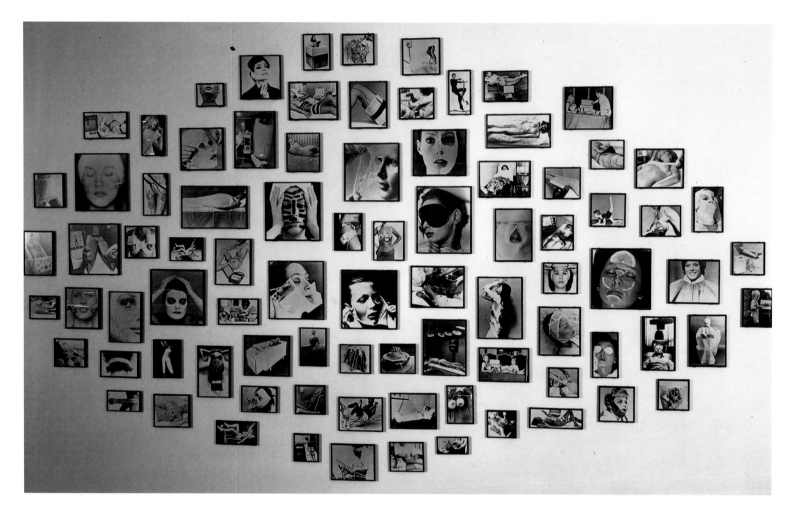

"Annette Messager, Collector," album-collection no. 18,
The Voluntary Tortures (Les Tortures volontaires), 1972.
Black-and-white photographs. Overall dimensions 200 × 400 cm.
Fonds Régional d'Art Contemporain Rhône-Alpes Collection.

should be the most sacred thing in her universe is the monstrous mirror image of the understated violence inherent in the daily conditioning that keeps her confined in childhood. Baldly put, the refusal to be a mother is translated into a refusal to be looked at by a child—an atrocity that is then thrown in the face of the viewer. The profanation is all the more violent since it is meted out on a photograph found by chance—that is, onto the image of a real child that the girl has co-opted for her own ends. These pictures,

which are after all relatively unsensational, especially when compared to those showing the punishments meted out on women in *The Voluntary Tortures*, confront us with an act of transgression perpetrated against fundamental values and beliefs that we are rarely prepared to call into question today.

The personal album and the use of photography place us squarely in the zone of the real, made all the more unambiguous and incontrovertible by its very ordinariness. Outside a purely imaginative context, interfering with a picture of another person is a more treacherous aggression than physical assault, one which, since it cannot be remedied, may have profound repercussions. To evoke the death of a real person by vandalizing its image—especially when the image concerned is that of a vulnerable being, a young life over whom the threat of sudden death is still thought to hang—is an act of negation that maligns humanity. A photo, when it has not been created explicitly with an "artistic" goal in mind, is not the same type of image as a painted portrait; it remains attached to its subject, and liberties taken with it are viewed by the subject as malicious in intent. Quite apart from any latent superstitions, in the case of the morbid scrawl that covers the *Children...* photographs, the strong resistance encountered in trying to dissociate the image from reality, combined with the sense of profanation that any modification or destruction of a representation of a human being entails, results in a feeling of singular haplessness. Cornered in our interpretations, we reject the image for what it is, and perceive only a young woman's cruelty, just as we can only consider the wrinkles drawn over the faces of the pretty women in *Mes jalousies* (My Jealousies) as unmasking the envy of the artist herself.

MODEL IMAGES

In collating the thousand and one ordeals women are prepared to go through for the sake of beauty, *The Voluntary Tortures* provide a devastating image of humanity (and it is clearly understood that condemnation should extend beyond the female sex). As in *Children with Their Eyes Scratched Out*, our interest is less centered on the subject (the women) than on their motives for denying the inevitable reality of their bodies. Using the various examples as so many pieces of evidence, this collection takes us beyond the absurdity and grotesqueness inherent in the comic attachments and prostheses portrayed, and as we contemplate these signs of rampant dehumanization in the name of human perfectibility, we are dragged into a zone of tangible fear and shame. The question once more revolves around the stigmata applied to the body when an image is made of it. Composed originally for the purposes of advertising and staged like a fashion shoot, the pictures do not reveal private experiences caught by the camera, but the collective desire of thousands of women, that is in turn only

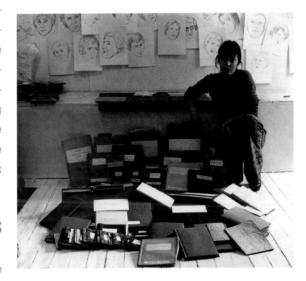

Annette Messager with her album-collections, 1972.

a mimetic response to male desire. It is therefore a chimaera—embodied, however, in the shape of a woman in all her finery, a mechanized Future Eve in strict accordance with the modernist dream. For it is indeed the modern world which appears here: a world prepared to liberate women but only through a combination of the machine and sexuality, ironically yoked together in this work. The *Albums* collection disposes of both past and present "model images" with which female identity is interwoven. Whatever the point of view adopted, the truth of woman as it transpires through the various *Collections* proves fragmentary and contradictory. In the context of the girl collector's project, *The Voluntary Tortures* represents the obverse of other *Collections* that show her intimate obsession with beauty and seduction, just as *Children with Their Eyes Scratched Out* provides a counter to her fantasies of blooming motherhood. In both albums, as in all the *Collections*, whether "negative" (*Voluntary Tortures, My Jealousies,* and *Qualificatifs donnés aux femmes* [Names Applied to Women]) or "positive," the subject disturbs because it lacks a moral basis: the collection was compiled neither to denounce nor to educate, but rather to let a woman jeer at other women, to scorn the attributes of femininity that remain nonetheless a locus of desire. Woman as presented in Annette Messager's collections addresses a contradictory confession to herself. Where one might have expected a unified being, one finds, once inhibitions and guilt have been jettisoned, a complicated, paradoxical figure.

A PRE-POSTHUMOUS ART

Through the albums, the artist gradually focused on the personality of the figure behind them, at the same time consciously multiplying the signs that allow the identification of the figure with the artist herself. It is her own photograph that serves as the portrait of the young woman, who even has the same name as the artist. The subject is manifestly in a phase of building herself an identity: she is looking for a suitable signature (*Ma meilleure signature* [My Best Signature]); she collects every scrap concerning her life (*Mes travaux d'aiguille* [My Needlework]; *My Expenses for a Month*; *Ma collection de champignons* [My Mushroom Collection]) and her creations (*Mes dessins d'enfant* [My Drawings When I Was a Child]; *Mes croquis d'oiseaux* [My Sketches of Birds]; *J'apprends le dessin* [I Learn to Draw]); she explores her feelings (*Men That I Like; Men That I Don't Like*); she tries to discover what the future holds (*Mon avenir par le horoscope* [My Future by the Horoscope]); she imagines the picture others have of her (*Comment mes amis feraient mon portrait* [How My Friends Would Do My Portrait]); she identifies with a famous person who has a name that sounds like hers (*Tout sur Messagier* [Everything About Messagier]); and rewrites herself as the heroine of a crime novel (*Ma vie illustrée* [My Life, Illustrated]). Her identity is made up

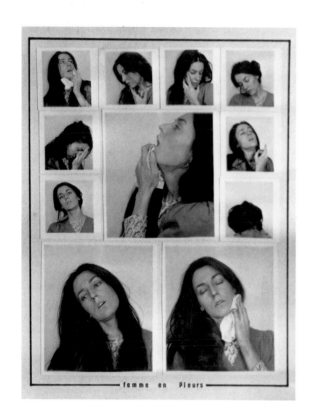

"Annette Messager, Collector," *Woman Crying* (Femme en pleurs), 1973. Black-and-white photographs, 24 × 18 cm.

"Annette Messager, Collector," album-collection no. 25, *My Jealousies* (Mes jalousies), 1972, details. Black-and-white photographs. Fonds Régional d'Art Contemporain Aquitaine Collection.

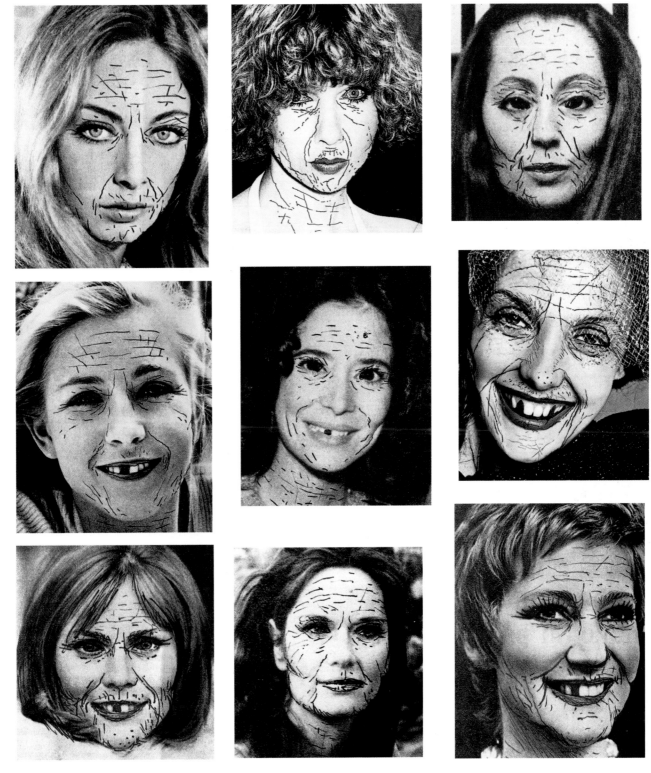

of tiny pieces, for the most part fashioned in the same way as we mold our bodies. A whole area of the work of Annette Messager—who is herself trying to forge her own identity as an artist through her work—is devoted to weaving and unpicking identity, to tracking, not exceptional qualities of one kind or another, but the underlying common traits, to a process of addition that continues up to saturation point.

The viewer, drawn into a maze to which he or she should never have been allowed access, is assaulted by a mass of disordered, undifferentiated data ranging from the anodyne to the confessional. Like an archeologist sorting through the fruits of her excavations, everything has to be taken into account, as everything comprises part of a whole that can be localized but not totally encompassed, that does not need to be recomposed but through which a path has to be carved. The journey within the young woman, undertaken under her own instructions—since it is she that has arranged its successive stages—but which is open to interpretations of which she remains unaware, can be compared to the unearthing of a tomb. Importance is normally granted to the futile gestures of daily life only when they provide signs of the life of a person long since dead. One only has contact with private notebooks—especially intimate documents such as the erotic output in *Mes dessins secrets* (My Secret Drawings), for example—when, cleaning out the attic, one stumbles across the personal possessions of a dead person. The viewer is pushed into the position of a voyeur, but even more is asked to recall a loss, to be party to a form of resurrection. That is why these notebooks, inscribed in a copybook hand and laying bare the workings of a scarcely fertile imagination, attract us as do relics. A term that might be applied is "pre-posthumous," since each *Collection* forms part of an artificial form of remembrance. In the way of a film script (in the sort of film that kills off its heroine before the story gets underway), Annette Messager here rehearses a truly autobiographical style.

If the collector and the artist are two separate entities—and this distinction is one on which Annette Messager places great emphasis—the pre-posthumous experience she goes through is the same she lived as a child; the example of her father is there (who, with death hanging over him, had not been able to live life to the full during his youth, and so returned to it later on, to the detriment of his family), as is the example of her young friends riddled with tuberculosis, who would play at imitating their own ailments.

Traversing death in an effort to regain childhood is the founding experience inaugurated with *The Boarders* and the *Collections*, one that prepared the ground for all the subsequent pieces. From it flows lightness, astringency, universality: Annette Messager exploited to the full the potential for cross-fertilization, contradiction, and duplication inherent in this phenomenon of two lives, to the point that it became the very fount of creativity, splitting herself in two and then into multiple personalities, configured in new sources of inspiration.

"Annette Messager, Collector," album-collection no. 23, *How My Friends Would Do My Portrait* (Comment mes amis feraient mon portrait), 1972. 55 photographs, 62 drawings, and notebook. Overall dimensions 220 x 280 cm.

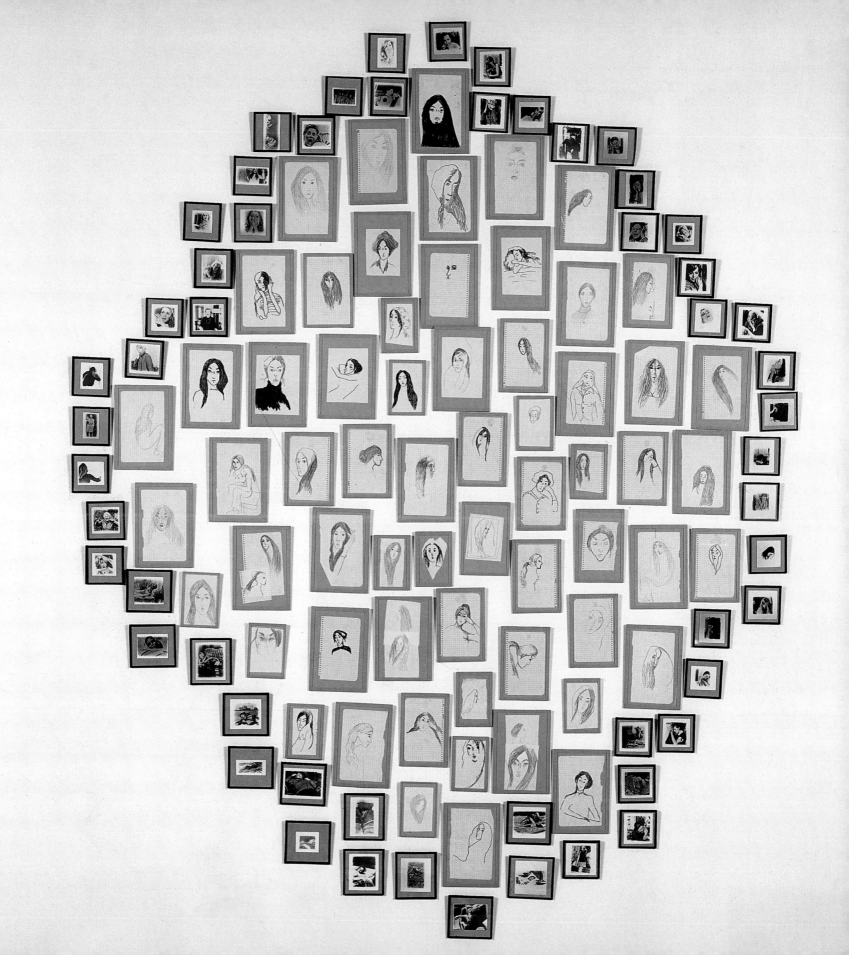

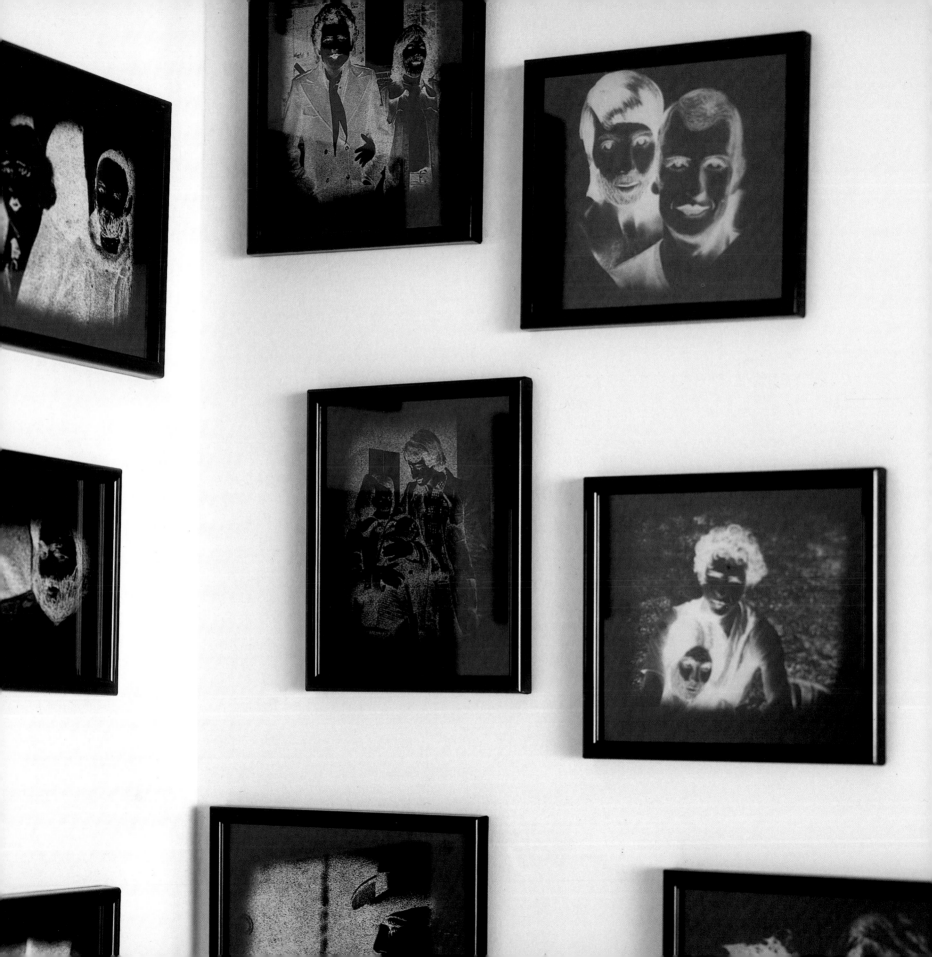

a model artist

Though highly individual, particularly in the way its feminine side is deliberately exaggerated, Annette Messager's preoccupation with the ordinary, with everyday life, with private issues, was not an isolated phenomenon. It belonged to a current that affected many young artists in the early 1970s, a trend which Harald Szeemann, at the time director of the Bern Kunsthalle, attempted to encapsulate in the catchall notion of "individual mythologies." Following on from the ebullient iconoclasm of the 1960s, and the subsequent relaunch of figuration in the wake of Pop art, the new tendency marked the reawakening of a more personal approach, in which autobiography fulfilled the crucial structuring role, and which was characterized by narrative voices that borrowed many of their formal features from the human sciences. Defended in France by the review *L'Art vivant*, and especially by Gilbert Lascaut, the trend found its home in a new experimental space at the Musée d'Art Moderne de la Ville de Paris known as ARC, initially under the direction of Pierre Gaudibert and then, from 1974, of Suzanne Pagé.

APPROPRIATIONS

Annette Messager formed part of a group of young artists who represented a new current in France. Leading figures included Jean Le Gac and Cadere. These artists—and others such as Christian Boltanski, Paul-Armand Gette, and Bernard Borgeaud—had been alerted to the crucial importance of the work of Fluxus and Beuys by Ben, who already enjoyed a busy international career, and by Sarkis, who did much to promote the work of Beuys. Even if these artists consciously strove not

"Annette Messager, Collector," album-collection no. 11,
The Men-Women and the Women-Men
(Les Hommes-femmes et les Femmes-hommes), 1972, detail.

to be too concerned with events on the other side of the Atlantic, it is obvious that they also felt the influence of Andy Warhol, the American's films having an especially significant impact.

Finding herself somewhat marginalized in what was an exclusively male preserve, Annette Messager drew strength from the encouragement of Christian Boltanski, who was to start working with her and became a close companion. Due to her receptivity to new forms of objective narrative revolving around photography, she remained—in a way that Boltanski was to share—much closer than many to

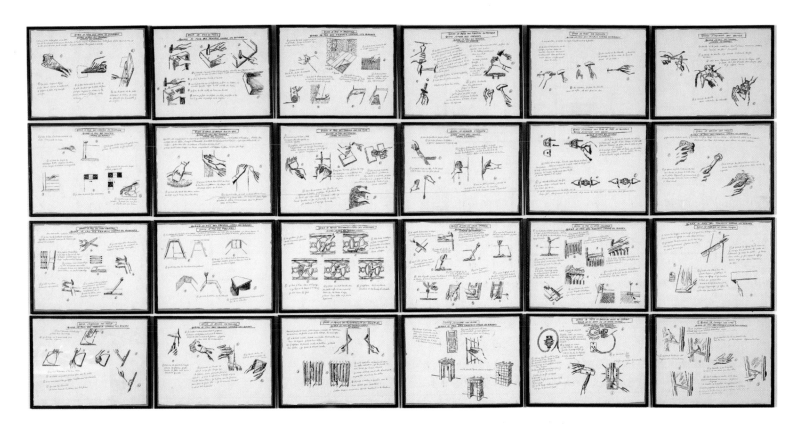

popular culture and to non-Western art forms. At the same time, she did not neglect contemporary art from other countries: in addition to the work of artists she was to unearth in the pages of art journals or during her travels, aspects of her work now drew on figures such as Ed Ruscha, whose books of photographs, without commentary, captured humdrum scenes from the everyday environment (*Every Building on the Sunset Strip*, 1966), Bernd and Hilla Becher and their photographs devoted to the repetitive forms of industrial architecture, and Gerhard Richter and his paintings produced directly from photographs ("I saw his paintings of the sky,

"Annette Messager, a Practical Woman," *When I Do Some Building Work Like Men* (Quand je fais des travaux comme les hommes), 1974. Ink on paper, 24 drawings. Each 33.5 × 45 cm.

the sea, and the landscapes as collections, and the process interested me hugely, just like the work of Hans Peter Feldmann and his collections of images of the banal").

Co-opting images from the most diverse sources became typical of Annette Messager's artistic practice. The process relates to the fundamental operation of appropriation, upon which all stages of her creative process have been based. As such, it is inextricably bound up with a form of extreme close-up in which she can pinpoint a form, an approach or an idea within a given image, extract it, and exploit it directly, once it has been rendered wholly or partially unrecognizable. Over time, this approach has allowed Annette Messager to adapt herself to successive art movements and to enrich her work through such contacts without ever having to sacrifice her originality or losing her commitment to a form of creativity which finds everything it needs for its sustenance within the space of "the home."

DOUBLE LIFE

The home is the seminal model, the keystone of her entire oeuvre. As in Art Brut—as she has said herself—she finds all her materials close at hand. Moreover, the various parts of the house give rise to different art forms. She immediately divided up the little apartment she had taken on arriving in Paris and shared out various activities among the different rooms, keeping the living room for performances with the *Boarders*, setting aside the bedroom for writing and for pasting the *Collections*. Although the motivation for these arrangements was initially practical and followed a remark by a friend that stressed the paradoxical nature of the two activities, the artist was very soon driven to consciously divide her oeuvre into two, as reflected by the layout of the apartment itself. This "double life" comprised, on the one side, the domestic theater played out around the dead birds—designated as an activity of the "artist"—and, on the other, the collation, selection, and manufacture of elements that went to make up the *Albums,* as compiled by the "collector." Her tiny dining room was christened with the ironically grandiose title of "The Studio," thereby investing the space with an artistic aura that the works themselves were not able to confer.

This domestic geography, which was soon to extend beyond its circumscribed architectural limits, was to continue developing over the next few years, and mark the onset of other cycles that came under the remit of, for example, the *femme pratique* (practical woman), the *truqueuse* (trickster), and the *colporteuse* (peddler). The thespian overtones of these characterizations evoke the kinds of private theatrical performances so much in vogue at the turn of the twentieth century (with the French stage in mind, one might think of the names of dramatis personae found in the acerbic comedies of Alfred Jarry or Alphonse Allais that the Surrealists also took up in their sketches)

and whose spirit endures, if slightly altered, in the cinema. It surfaces, for example, in Jean Renoir's *La Règle du jeu*—one of her favorite films—in which a slice of life unfolds in a country house where the characters' own little histories meet History with a capital "H" through the intermediary of a theatrical fantasy that reveals much about both. As the early *Albums* show, Annette Messager's works operate in similar fashion, hidden away inside a house for which performances in various styles are organized.

GAMES OF CONGRUENCE

Everything that lies outside the house is an object of seduction and envy. Travel, the unknown, the other, have to be ensnared and then sucked into the domestic space. Hence three of the *Albums* were devoted to travel, one gathering together a group of women's drawings she had found, the other two making use of pictures of famous women. Domestication of the image passes through a number of phases of appropriation: collection, commentary (by drawing or writing on the image), and copying. The most suitable material for this opening out onto the outside world is a photograph from a magazine, first cut out then hijacked for new purposes: divorced from its context, it is appropriated, reinterpreted, modified, and transferred, without losing anything of its intimate relationship with an object that has been torn from its origin in life. By taming the image, the artist is able to familiarize the viewer with whatever it represents. The unknown person, the stranger, the film star now seem very close to us: indeed they become so accessible that they are deprived of all originality. One feels totally at home with Annette Messager's travel pictures, never in awe of the celebrities she chooses, never surprised by the unknown. Unlike academic painters who treated similar subjects in former times, she does not glorify the exotic landscape, nor does she flatter her models, or exalt the starlet. It is not the subject that is recast, but the image, transforming its nature and altering the way it is to be decoded. Obliterating artifice, eliminating rather than exacerbating the distance—no matter how small it may be—inherent in representation, the artist undermines the value of her own efforts. Her work thus poses the question of the very value of art.

Where, for the viewer, does the artist's creativity lie? Is it to be found in this process that reminds us of the wheel of fortune, that puts what are ordinarily the most vaunted images at the bottom and the most nondescript at the top? Is it in the compilation of the sometimes botched, sometimes painstaking albums that remain, in spite of their overstated modesty, handmade? Or is it in the spectacle to which we have been invited, and in which each component—the artist, the images, and the albums—are actors playing at art?

Annette Messager at once cultivates and revels in this uneasiness. At the very

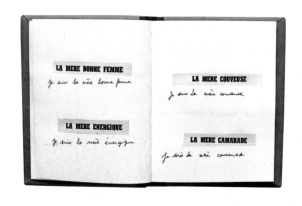

"Annette Messager, Collector," album-collection no. 6,
Everything About My Child (Tout sur mon enfant), 1971–72, detail.

outset, by presenting herself as a devalued artist and taking as her subjects practices that have inspired countless talents in the past but which do not conform to the received idea of an artist, by accentuating the specifically feminine nature of her work to the point of calling it "women's work" and of dubbing a dining room full of birds wearing fancy dress a "studio," she questions the nature of art. It is as if art—and we are no longer quite sure what it is or should be—can only be identified in its extremes, indicated by such controversial examples as these. All activities deemed "art," but which are not, interest her: Art Brut, popular art, but also the "art" of living, the "art" of giving pleasure, etc. In the same way, all types of picture—since art is primarily the empire of

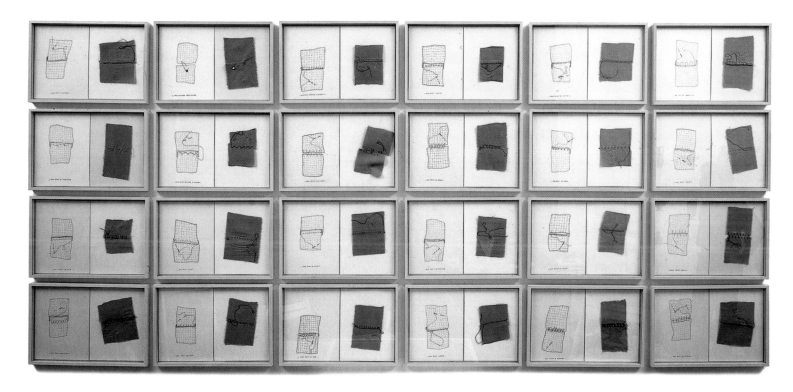

the image—attract her attention. As in the album of *Approches* (Approaches), in which the eye is drawn in step by step to the most indecent zone of the image, increasingly obvious but also increasingly blurred as enlargement progresses, the artist also twists and turns around art, approaching it closer and closer until the inevitable disappointment. Like Sardanapalas dancing for a tyrant known as art, her work is always on the move, motivated by a desire for art, and yet kept at a distance by the fear of being absorbed by it. Annette Messager's identity relies on the fact that she is never clearly identified with "the artist," a title that she never employs without first making it abundantly clear that she has no real right to it.

"Annette Messager, a Practical Woman," album-collection no. 7,
My Needlework (Mes travaux d'aiguille), 1972.
Drawings and stitched fabric. Each panel 30.5 × 45.5 cm.
Musée de Peinture et de Sculpture Collection, Grenoble.

A group of album-collections with mail items.

This peculiar trait means that she now occupies a unique place on the international art scene. Unlike women artists in America, who have explicitly claimed the right to be artists and who have been hard at work forging a new identity for the female artist to parallel that of their male counterparts, Annette Messager has attained her freedom through a multifaceted, shifting, fragile identity, whose keynote is indeterminacy. Compared to those male artists perturbed by the failure of utopian ideals and who have felt forced to reclaim or reinvent their status, her activity operates in an unbounded space that stretches its tentacles around art before zeroing in on territories that in the past were left uncharted or disdained. At the antipodes of an art that imposes its views, she has invented one that insinuates, that entreats, that might be looked down upon, but which never gives up. Very quickly, she even took the risk of making popular art, that gives pleasure and that, having thrown off the yoke of theory and radicalism, can address the public in a familiar tone. Although the distribution networks open to modern art, along with the general public's distrust of much contemporary work, have not made it possible for her to gain wide acceptance, Annette Messager is still undoubtedly one of the very few artists today to have acquired a large following without having to alter her chosen course or shy away from change.

In France especially, her retiring nature and her indifference to the exalted status of the artist are far removed from the universally accepted conception of the dignity of art. Though iconoclastic on occasion, France is not a country that rejects the figure of the artist out of hand. On the contrary, an entire mythology has grown up of the individual striving to be an artist in the face of overwhelming odds, a myth that remains entrenched even after the artworks themselves have long since disappeared, or even if they never existed per se. The figure of the creator considered independently of the work of art, and whose existence is attested instead by biography and legend, is a postulate of art. People can identify with such a figure, whose model extends beyond the strict confines of the professional sphere. Deliberate anonymity, as well as being extremely rare and primarily provocative in nature, only covers acts perpetrated by identifiable groups that stand in for the individual artist, and the flimsy disguise is in any case lifted as quickly as possible. Even in the few cases in which interest in works by unidentified authors has been vocal, as in Art Brut, the first thing people attempt to do is to authenticate the artists, give them a name, and discover exactly who they are.

Annette Messager did not choose to remain nameless herself, however; more subversively still, she has imitated the archetype of the "artist" to the point of throwing her/its identity into doubt. By telling us *too much* about herself, by amassing every scrap of information, finally by assimilating her identity to that of a girl who is interested in everything

(save, precisely, in art, which occupies no place whatsoever, even in her private diaries), the artist proper, reduced to little more than a fantasy, vanishes. Though some sort of identity can be assembled piecemeal, Messager the artist slips through our fingers, without, however, ever degenerating into pure fiction. Much of the data given is, we know, true enough, though sometimes even the author seems to have been unaware of the fact. But the process as a whole is one of make-believe in which an "artist's life" is dreamed up, much in the same way as, in the Renaissance, the *Vite* were concocted by Vasari, the creator of a history of art based on an edifying, but for the most part

... ma Julie... mon canard... ma louloutte... ma rose... ma nana... ma beauté... ma bergère... mon trou... mon lapin... mon cœur... ma petasse... ma princesse... mon rat... ma bourgeoise... mon chouchou... ma liorne... ma poupée... ma bêle... ma gonzesse... ma titine, ma toutoune... ma femme... mon boudin... ma conquête... ma donzelle... mon cœur... mon poussin... ma cocotte... ma mie... ma jouvencelle... mon echalas... ma poulette... ma deesse... ma morue... mon adorée... ma reine... ma joie de vivre... mon cageot... mon petit diable... ma ronflasse... mon soleil... mon chaton... mon bijoux... ma trainée... mon oiseau des îles... ma mecanique... mon roudoudou... ma mijorée... ma lumière... ma putain... mon morceau...

legendary, biography of the artist. With biography becoming the principal tool in the analysis of artworks, many writers have taken to delving into the psychology of the artist so as to see how it relates to the works. Annette Messager takes this type of psychological study as a template in order to compose an autobiography that she extrapolates to risible limits, exploring the most banal regions of "her" private world. After dissecting what is a very ordinary persona, the image of the artist finds itself less pristine but somehow more human for all that, and closer to the rest of us. Each of us could, if we

"Annette Messager, Collector," album-collection no. 35, *Names Applied to Women* (Qualificatifs donnés aux femmes), 1972. Ink on paper. (Names given include: "... my duck ... my shepherdess ... my princess ... my rat ... my lioness ... my black pudding ... my chick ... my maiden ... my little devil ... my machinery ... my whore ... my bit ...")

wanted, add a personal chapter or two to an ongoing self-analysis, which is not proffered as a model but held up as a mirror. Unlike all the other autobiographical dispensations in contemporary art, the fictional nature of this identity has enabled Annette Messager to address collective truths. Following a clearly signposted path of introspection, she adapts to it a model that her contemporaries have disowned, that of the "novelized autobiography."

"MAKE LIFE MORE INTERESTING THAN ART"

Another paradox arises from Annette Messager's work. By creating a commonplace figure propelled on to the public stage like a real artist, and for whom elements of biography have been invented, Annette Messager has become involved in much the same processes as a film director who has to give substance to a literary character. Although she deliberately skims the surface of reality and relies solely on constituents taken directly from life, she is still devising what is a literary enterprise in which the establishment of a persona and her introspection by means of an intimate diary are both quintessentially verbal acts. In the *Albums*, language holds the work together like a cement, from which various elements can be built up into a single story, thereby imparting meaning to the mass of details accumulated. Language organizes the images, underpins them, gives them a raison d'être, and above all allows them to enter the domain of time. The restitution of time—one of the advantages of literature that, prior to the advent of film, made it so spectacularly good at adhering to life—is a crucial feature of Annette Messager's work. At each stage of her career, art is vehicled by words in a different way, diary, narrative, play, litany, and layout being only a few examples.

Although Filliou's self-proclaimed edict "to make life more interesting than art" lies at the farthest remove from the actual practice of the visual arts, it is somewhat more familiar to the writer who has to immerse himself in the shared material of the language in order to create. The basis of language and of words, and above all of common parlance, offers access to life and, hence, to the public. In the *Albums*, as in *The Boarders,* it is writing—the manuscript annotations composed in a simple if colorful style—that put us immediately on an equal footing with the artwork. The highly individual and painstaking handwriting, with its hesitations and crossings out, infuses the mass of documents with life, clarifying the image. This handwritten character gives the *Albums* the stamp of authenticity, demonstrating their private nature in a way that is impossible with an isolated element. Speech, writing, and narrative are thus used or hinted at in a great many works, providing a framework. The instruction manual, the confidential diary, the tale, the prayer—all linguistic forms that can be intimately assimilated, yet remain deeply anchored in life—will be marshaled, and reproduced or illustrated. They form the core of

an oeuvre that has proceeded rather in the way of a *Bildungsroman*. Laid out like an obstacle course, with carefully labeled chapters, each with its own stories and lessons, digressions and deviations, they always revert to a linear narrative structure that follows the ups and downs of human experience. It is a destiny that unfolds in the hermetically sealed environment of the "house," which, by moving from room to room, discovers the

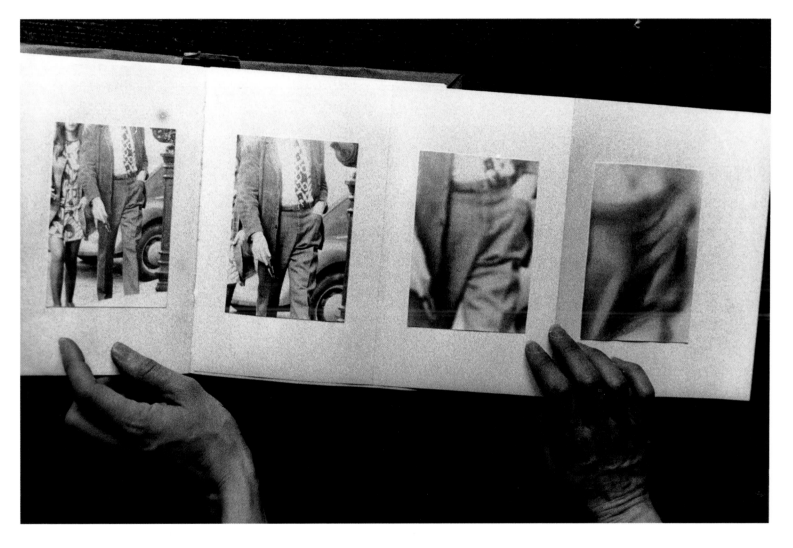

world. This amounts to a kind of wandering "around her room," in which (in the same way as Xavier de Maistre's late-eighteenth-century extrapolation of the self rode on the back of the burgeoning success of travel writing) Annette Messager's updated version counters in equal measure both normalization in the name of "international art" and the quaint allurements of "World Art."

"Annette Messager, Collector," album-collection no. 24, *To Find My Best Signature* (Pour trouver ma meilleure signature), 1972, detail.

"Annette Messager, Collector," album-collection no. 8, *The Approaches* (Les approches), 1971–72, detail.

IL FAUT CRAINDRE
LA FEMME ET LE TONNERRE

CHEZ LA FEMME
LES DENTS DE SAGESSE NE POUSSENT
QU'APRÈS LA MORT

SI LA FEMME ÉTAIT BONNE,
DIEU AUSSI EN AURAIT EU UNE

LA FEMME EST UN ÊTRE
QUI S'HABILLE
BABILLE
ET SE DESHABILLE

QUAND LA FILLE NAÎT,
MÊME LES MURS PLEURENT

LES FEMMES SONT PLEINES
DE SAGESSE,
ET FOLLES QUAND ELLES RÉFLÉCHISSENT

LA FEMME
EST UN MAL NECESSAIRE

AIME TA FEMME COMME TON ÂME
ET BATS-LA COMME TA PELISSE

C'EST LA FEMME
QUI A FAIT POUSSER LES CHEVEUX BLANCS
DU DIABLE

the world pinned

The first group of *Collections* was compiled in 1971–72. It contains numerous elements that Annette Messager would return to in future *Collections* (*Annette, A Practical Woman*, comprising a series of plates) and in other self-contained works (*Qualificatifs* extends *The Proverbs*; *Le Bonheur illustré* [Happiness Illustrated] continues *Mes propositions de bonheur* [My Propositions Concerning Happiness], etc.). She added other anthologies to the albums, with these new works taking the form of a sequence of illustrated plates or composite units made up of an accumulation of images. These demonstrate a preoccupation with picture-making that explicitly responds to the challenge of "historical painting": narrative, didactic, monumental. At a number of shows to which she was invited (the Musée de Rude in Dijon, with Boltanski and Le Gac, in 1973, at the Munich Lenbachhaus Städtische Galerie, followed by the ARC, in 1974), she devised a way of presenting the exhibits that combined all the various display alternatives. The *Collections* were presented in the kind of long, horizontal showcases with legs used in ethnographical or archeological museums, or set up as installations along the walls, the whole presentation being halfway between historical museum and fine arts gallery. As imposing in terms of scale as any academic composition, these wall pieces stretched practically from floor to ceiling in a dense network of little pictures comprised of squares of fabric, illustrations, and drawings pinned to the picture-rail.

These elements depicted a series of "histories," of stories composed by ordinary women, or about ordinary women, that had broken free from the privacy of the albums and left the book to become "pictures" in their own right. First, there was *The Voluntary Tortures*, reconfigured into a pattern of black and white photographs that

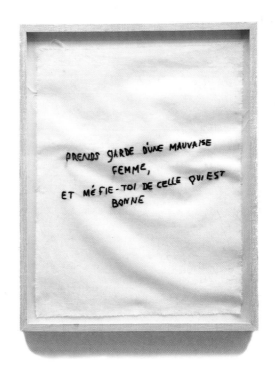

"Annette Messager, Collector," *My Collection of Proverbs*, 1974, details. Embroidery on fabric. Each 35 × 28 cm. (see p. 185*)

seemed meager, but whose content was telling. The large-scale, slightly off-square, notched arrangement used for these particular photographs was typical of her early installations. Then there was the *Proverbs* collection—an anthology of sayings critical of womankind—which were embroidered onto little squares of white cloth. Finally, there was *Happiness Illustrated*, made up of a lengthy sequence of color pencil drawings copied from illustrations in tourist brochures. The modular arrangement, consciously unpremeditated and imperfect, was an ironic pastiche of the prevailing geometric Minimalism. It set the stage for a "pinned world," complete with aberrations, mishaps, and undercurrents. In this world, the most harmless-looking articles are displayed as carrying an erotic charge: from do-it-yourself diagrams to lists of proverbs, from beauty products to the dream industry, for which the artist acts as both voyeur, and—for our benefit—procuress.

REPEAT AND MULTIPLY

To this end, images had to be repeated and multiplied to saturation point. Not content with merely collecting diverse elements, the artist allowed them to go forth and multiply, copying them painstakingly in various techniques. As Daniel Semin has emphasized, such a maniacal enterprise is reminiscent of the techniques of repetition found in the novels of the Marquis de Sade. Semin, who reminds us that at the time Annette Messager was reading that author, traces parallels between the "enumeration of everyday rules of domestic economy" to which the artist's work is devoted, and the presentation of "turpitude, torture, flagellation, hanging, and buggery" omnipresent in de Sade's writings, showing how both are motivated by a sexual curiosity that leads to a desperate quest for knowledge.[4]

The viewer is caught up in the hysterical activation of images that pervade the museum space, becoming bound up in a process of repetition, refusing to collapse or to retreat into any single form. Only the narrative—developed by way of pictorial alphabets—remains. This story of stereotypes, initially concerned with collating those generated by women, extends more generally to stereotypes linked to desire (*Happiness Illustrated*), and more specifically those concocted by the female collector (*Les Effroyables aventures d'Annette Messager, truqueuse* [The Horrifying Adventures of Annette Messager, Trickster]; *Petite pratique magique quotidienne* [Little Handbook of Everyday Magic], etc.). These catalogs correspond to a fragmented picture that adopts the basic rules of collage on a magnified scale. Composed of disjointed elements, the latter is organized in accordance with two potential readings. Whereas the majority of the plates extracted from the albums are presented in an orderly arrangement suggestive of a book's double-page spread, others—notably *The Voluntary*

Happiness Illustrated (Le Bonheur illustré), 1975–76, detail. Colored pencils.
Each drawing 38 × 46 cm.
Exhibition at the Musée de Peinture et de Sculpture, Grenoble, 1989–90.

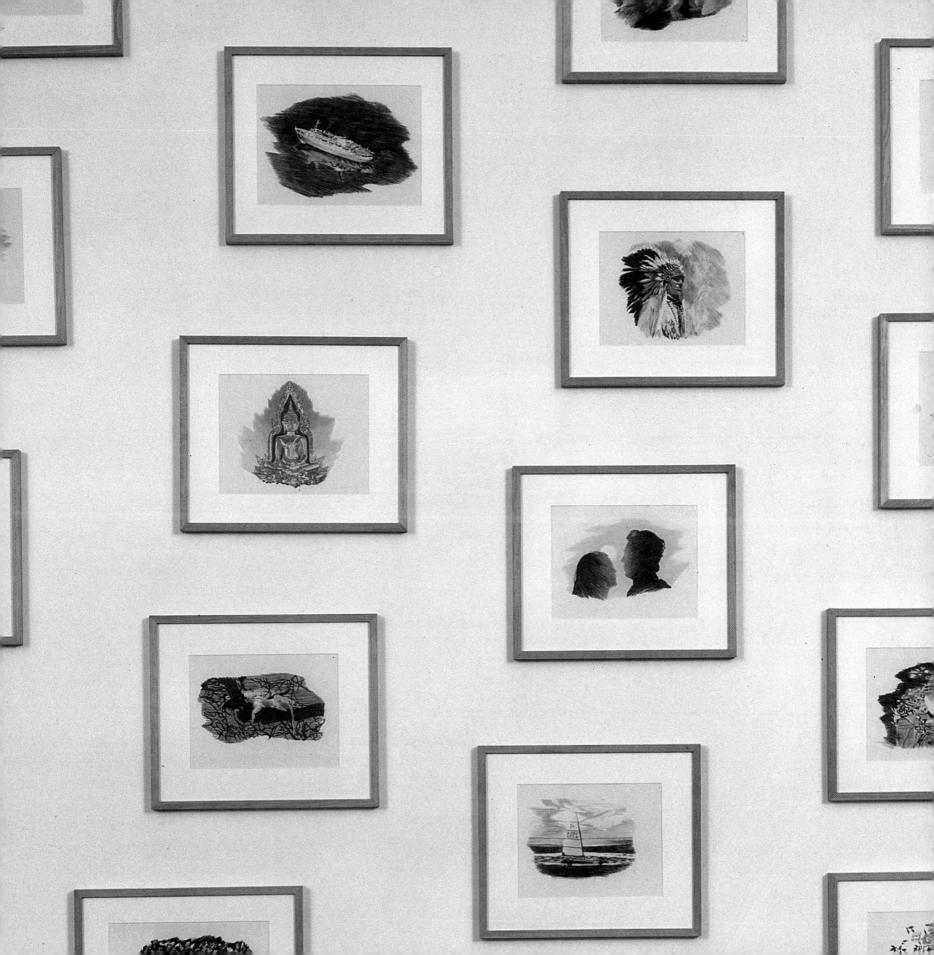

Tortures reconceived of as a wall piece and *The Horrifying Adventures of Annette Messager, Trickster*—seem to have been arranged haphazardly. These works bring to mind those pictures composed of multiple portraits grouped in a single frame which are increasingly replacing the traditional family album, and over which the eye skims uncertainly in an erratic zigzag from picture to picture, and through space and time. The way the same objects reappear again and again in new guises, the way chronology jars and images clash invites a synthetic, kaleidoscopic reading that readily seizes the overall movement, but can take in only a handful of details. This method of viewing a piece is unusual in the modern museum context, and endows the image with a wholly original status. The individual images are not meant to be seen; their function is to be there, to be part of the whole. The image is presence, not of a decorative order (in later installations some of the images may be hidden), but of a physical one. Each fragment possesses sufficient reason unto itself, whether it is perceived or not, its role being to contribute to the overall form and meaning.

The idea of an overall meaning only fully comprehensible through individual elements, of a form that results from the accretion of smaller forms, is one of the original features of Annette Messager's work, which displays, by today's standards, exceptional coherence. The individual components are all interrelated, even though they are produced in the studio and only later installed at the venue. She has also been drawn to create and to rethink many types of presentation, since her works cannot meaningfully exist as a whole outside the display environment. Like ex-votos, which only acquire full significance when they are presented in a church, her works are "artistic" not in nature but in function, their meaning being released only once they come into contact with the world. Wholly pragmatic, her oeuvre has no place for abstraction or for theoretical speculation, being instead an impressively inventive approach to the simple fact of showing, of offering up the entirety of whatever is to be disclosed. By ringing the changes among the visual means deployed, Annette Messager ensures they lose nothing of their vigor or novelty, while every new series imparts fresh impetus.

FROM EFFECT TO EXAGGERATION

The Proverbs, The Voluntary Tortures, The Horrifying Adventures of Annette Messager, Trickster, and *Happiness Illustrated* are all works which contain violence, or which, in one way or another, act violently upon the viewer. Displaying some of the derogatory proverbs which have long been applied to womankind, and, for the sake of parody, writing them in the typically feminine craft of embroidery—the very epitome of submission to a now disparaged condition—is simultaneously an act of revenge and of masochism. Selecting magazine clippings that betray the inane yet

"Annette Messager, Collector," album-collection no. 47, *Little Manual of Everyday Magic* (Petite pratique magique quotidienne), 1973, detail and overall view.

voluntary conditioning of women is to present the viewer with an experience both indecent and ghoulish. Showing oneself in a succession of little drawings depicting horrifying scenes of torture and sexual assault constitutes a sadomasochistic attack on the dignity of two conditions that Annette Messager herself is supposed to embody—that of artist and that of woman. Finally, the gaudy, syrupy pseudo-idyllic images that rub our noses in the vulgarity of pleasures in which we all indulge at one time or another constitute an act of aggression perpetrated on our self-image, a slap in the face for our aesthetic sensibilities. At the same time, such atrocities hark back to the world of childhood, to the common experience at that age of reveling in make-believe violence, of manipulating and imitating it, to the pleasures of writing swear words in embroidery, of drawing obscene sketches, of peeping at pictures of naked women, or of frightening oneself to death by imagining the most ghastly predicaments. They take one back to a stage of innocence as regards taste, to a time when we could all rejoice in the blandishments of the image, in little more than its color and charm. Beneath their unsavory veneer, such pictures recapture something of the child's mind and reawaken long dormant instincts. Very soon, we catch ourselves reading with a smile proverbs that should disgust us, and delighting in scrutinizing the ridiculous poses and exposed body parts of young women beautifying themselves, or else commenting on the adventures of a forlorn Mills & Boon heroine lost in one of the Marquis de Sade's chateaux and savoring the cheap pleasures afforded by pictures of sun-kissed tropical atolls.

Annette Messager's work conveys a sense of humor run riot, of grotesque exaggeration. Her whole oeuvre is an exaggeration rather than a fiction: it overplays the "her indoors" side, yet at the same time overstates its perversity. Similarly, the exhibitionism on which her work depends serves less to expose personality traits—which in fact remain concealed—than to perform a process of enlargement, of aggrandizement. The *cahiers* also include collections of ecstatic-looking expressions taken from film magazines, studies of exaggerated emotional states (fear, astonishment, surprise, etc.) posed for the camera. She also collects advertisements based on the "before and after" concept that show their effectiveness through an exploitation of the irrational. Her fondness for Goya and for the art of the mentally ill has roots in a view of art that can transfigure the most commonplace reality through a process of observation transcending the faculty of reason. Through such exaggeration, effected in the main by mere changes in scale, the most innocent-looking object can appear fantastic, grotesque or prophetic. Fairy tales, to which the artist often refers, make much of such metamorphoses. As she has said, she loves the way in which "life is enlarged, in which a serene and friendly world can suddenly appear unstable, violently threatening or dangerous" in tales where everything is "blown up, amplified, theatrical."[5] By deforming reality in this way,

by presenting it as a spectacle, she interprets, comments on and judges it in an understated manner, while acting on the perceptions of the viewer, whose position becomes theatrical and whose gaze is rendered fetishistic.

THE BODY BOOBY-TRAPPED

The 1970s was the decade of Body art and of a type of Conceptual art that favored both compulsive actions and maniacal normalization. Annette Messager was simultaneously close to and at some remove from these two tendencies. She shared with artists such as On Kawara, Stanley Brouwn, and Hanne Darboven a new-found commitment to the ordinary body and to acts of anti-heroism, but she left off introspection and experiment, employing their models but eschewing their ambitions. Various cycles of illustrations, such as *Annette, femme pratique* (Annette, a Practical Woman, 1974)—*Ma vie pratique* (My Practical Life) and *Quand je fais des travaux comme des hommes* (When I Do Building Work Like Men)—as well as the notebooks from *Annette Messager, Trickster* (1975) that are related to these practices, are in fact couched in a humorous tone marked by a taste for fun. Taking her inspiration from the technical flash cards that come with do-it-yourself manuals, she rewrites their advice in the first person singular—"When I fight damp," "When I install a light socket"—painstakingly redrawing the instructive technical diagrams in colored pencil. Such recasting is less a straightforward image of obsessive repetition than a sort of absurd parody of the encyclopedic impulse thought typical of male erudition, and which she relegates to the level of a recipe card. The old-fashioned style of both cards and drawings makes them seem from another era, while similarity to forged documents *trouvés* further underlines their essential fictional character. Moreover, in notebooks from *Annette Messager, Trickster* she uses her own body almost as if it belonged to no one in particular. She derives amusement from redesigning it, just as she had done in a more obviously humorous manner with the photographs she took from magazines in the *Albums*. She treats it as an object on which to perform comic fantasies and diverse forms of hybridization or inversion. Here, as in the later series *Les Hommes-femmes et les Femmes-hommes* (The Men-Women and the Women-Men), in which she inverted the gender of couples appearing on photographic negatives by adding a beard here or a pair of long eyelashes there, she exploits the conspicuous nature of surplus secondary sexual characteristics and their commutation (the phenomenon of the "bearded lady" is a further example). A cycle of drawings in another notebook simulates the transparency of a body through which internal elements (digestive tract, skeleton, fetus, etc.) are clearly visible. In a third, huge spiders are seen besieging naked human bodies, spinning their webs over them. The body is nothing more than an excuse for amusing little sketches which

"Annette Messager, Trickster," *The Horrifying Adventures of Annette Messager* (Les effroyables aventures d'Annette Messager), 1974–75, details.

"Annette Messager, Trickster," *The Horrifying Adventures of Annette Messager* (Les effroyables aventures d'Annette Messager), 1974–75. Photographs and drawings. Overall dimensions 200 × 338 cm.

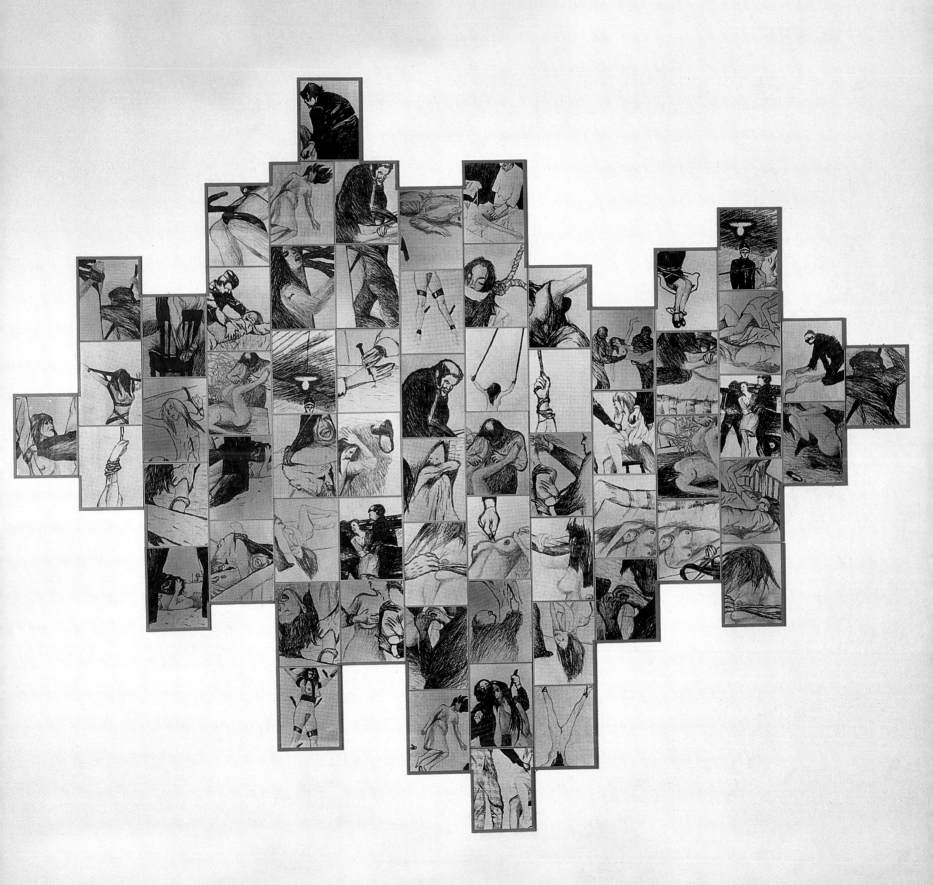

beg the question as to whether the "trick" is performed by drawing directly onto the body or by retouching the photograph.

If her poetical use of the body might be compared to works of the same period by Gina Pane or Carolee Schneeman, artists whose performances also included self-inflicted mutilation and degradation, Annette Messager's joyful outpourings are of a radically different ilk. In her work, the female body is neither a field of (re)conquest nor an instrument of transgression: it is just another cliché among others, in fact the most "clichéd" of all clichés, the point where all desires, all phantasms, all received ideas converge. It is for this reason that the body—mistreated every which way, and with a disdain for the forms of symbolic over-investment by which its originality is constructed—becomes Annette Messager's preferred realm. "Rectified" or "assisted" (in accordance with ideas introduced by Marcel Duchamp), it is reduced to the status of an *objet trouvé*, a "prefabricated object" as it were.

CODES AND CLICHÉS

The cliché, treated as a subject in itself, is another fundamental building block in Annette Messager's work. A generic image whose meaning has been worn smooth by massive overuse, with no past and no future, the cliché is a collective creation, born of the projection of desires. The cliché's consensual nature restricts it to the realm of the banal where all originality is banished, all distinctions are spurious, and all beauty and expression are purely conventional. It is the formalization of a "ready-made idea," a synthetic image which has little more than a nodding acquaintance with reality, yet which constitutes a universally recognized form. To pinpoint or fabricate a cliché is to refer back to a pre-established image that must virtually condition its later forms. Pre-establishing an image—whose palpable form is only a temporary vehicle—is one of the necessary conditions for the role play on which Annette Messager's whole oeuvre relies and which thus places art on an equal footing with a much discredited form deliberately shunned by artists. Since the first *Albums,* Annette Messager has hunted for and collected clichés, or else she has slipped into the form herself so as to create new variants. As with a cliché, her works contain images of everybody, of everybody's memories; as with the cliché, they serve to actuate stereotypes. Annette Messager's oeuvre proceeds by accretion, by repetition, by the interpretation of hackneyed expressions whose primary function is simply to ensure their circulation.

Her interest naturally extends to all forms of codification and of visual language. This was evident in the early "feather alphabet" designed for the *Boarder* birds, a series of letters based on the Roman alphabet made of plaited feathers and reminiscent

"Annette Messager, Trickster," *The Woman and...* (La femme et...), 1975. Drawings and photographs in a notebook.

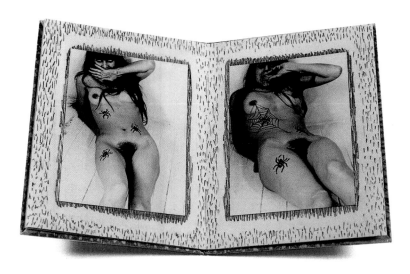

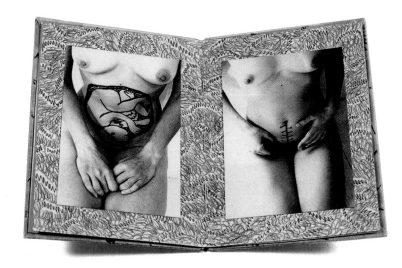

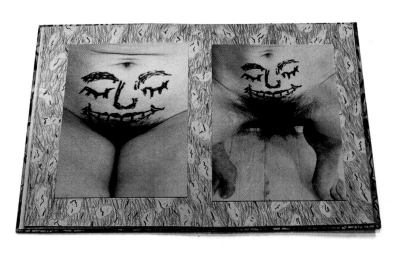

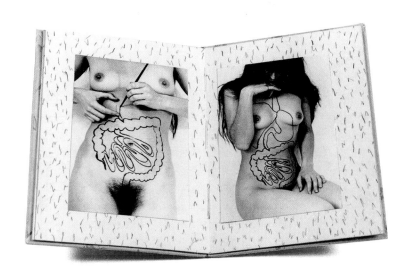

of scout orienteering markers. The *Albums* also contain a number of collections dedicated to the encoding of the language of love and feelings, made up of film stills or pictures from photo-novels portraying attitudes symptomatic of a wide gamut of emotions, from normal to feverish (*Attitudes et expressions diverses* [Various Attitudes and Expressions], *Mes clichés-témoins* [My Photographic Records]). Another sequence reproduces judo attack and defense positions (*Les Attaques, les Défenses* [Attacks, Defenses]), while another comprises a sequence of the most important movements in gymnastics (*Ma gymnastique* [My Gymnastics]). These series of regimented body shapes, readily identifiable and easily reproduced, lay the foundations for other categories of models that are organized into image systems, just as in those variants of stagecraft, such as pantomime, in which the body itself conveys an image. This body-image, which is subsequently conjugated in a limited number of key postures, is of the same type as that featured in the sex- or crime-orientated emblems reproduced in sophisticated or popular illustrations of various types which were to constitute a favorite source of material.

la rencontre *l'élan* *la révélation*

Annette Messager is concerned with tracing those everyday activities that have already been sorted into an image system and which can thus serve as an unmediated type of language with no need of an alphabet. One of the richest sources for illustrations has been instruction manuals. The sewing stitches reproduced in books from the "practical woman" cycle (*My Needlework*), the cooking methods, and the sexual positions all offer pictorial typologies in which images serve as a language. In one of her last books linked to the *Collections* series, *Mes Jeux de mains* (My Hand Signs, 1975), she invented a coded language of the countless suggestive positions that can be produced by gestures using both hands. Linking the signs to what she termed "strategies"—for instance, "My Giraffe Position" and "My Functionary Position" as incorporated into "My Strategy of Similarity"—she executed little drawings that look like diagrams from an instruction booklet designed for the deaf and dumb. The notion of artistic "vocabulary" as derived from the model of language is common enough: in Annette Messager's projects, the importance

of setting out substitutive linguistic elements (clichés, codes, basic forms, etc.) as fundamental constituents in her work is even clearer.

ROLE PLAY

In addition to using drawing to "fabricate" found objects, Annette Messager also resorted to photography: while she was still working out of her tiny apartment on rue Paul-Fort, photographic work was already an important component in her creations. Photographing objects and pictures, and indiscriminately mixing her own prints with pictures selected and cut out from magazines, she learned how to do her own developing, thus allowing her once again to exploit a new technique in a "homemade" context. Her predilection for working solely in black and white (though the prints were occasionally tinted) underscored the document's "second-hand" side and the possibility of its being produced at home. The small-scale black pencil drawings on squared-paper notebooks that portray the heroine's various misadventures are photographed and the prints rearranged into a kind of half-finished jigsaw puzzle. The technique lets the viewer witness the scenes as a third party: the drawings provide a concise if sketchy detailing of the events (the "evidence for the prosecution," as Annette Messager herself puts it), while the photographs serve to reproduce the "proof." The images carry with them a secondary narrative that plunges the

le secret *le piège* *le retour*

viewer into the world of a criminal investigation. The long list of ordeals the young woman undergoes during her scabrous adventures serves as a backdrop to the process of successively updating the "investigations." The picture does not describe a situation per se, but furnishes documents for it, the action being partially, rather than completely, represented through a jumbled series of fragments drawn into a composition, whose primary features derive from the discontinuity of its elements. Reality is not apprehended as a homogenous entity, but arises through a fortuitous addition of parts. Photography, whose role it is to provide the "proof," here simply authenticates the drawings, investing them with a degree of likelihood. The entire series of pieces following *The Horrifying Adventures...* derives from similar interconnections between drawings of photographs and photographs of drawings.

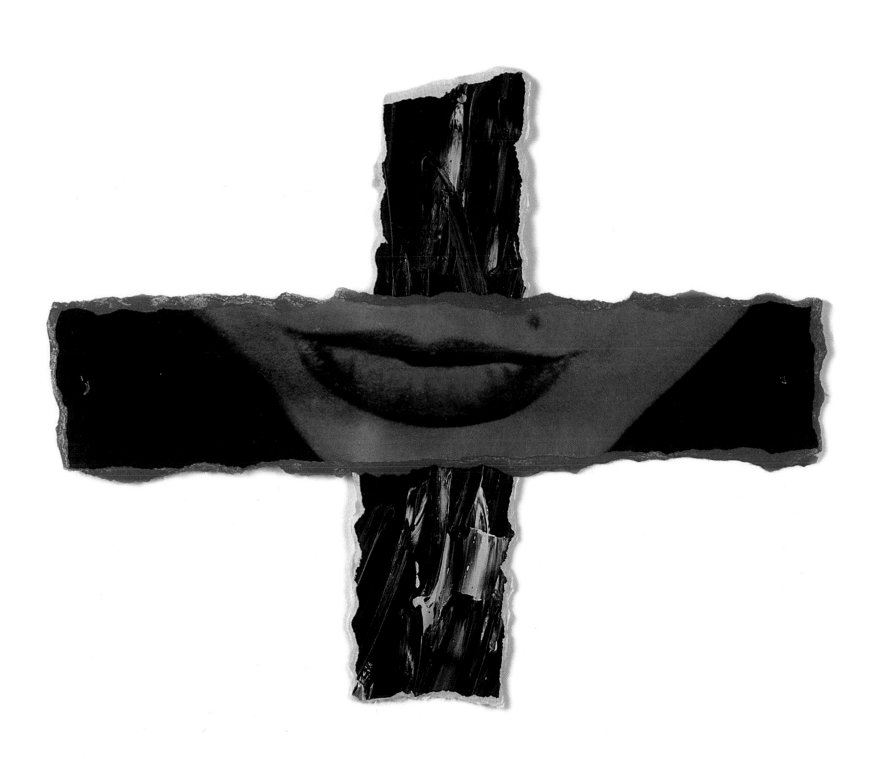

image manufacture

The series *Mes clichés* (My Clichés, 1976–77), *Portrait des amants* (Portrait of the Lovers, 1978), and *Le Feuilleton* (The Serial, 1978) followed *The Horrifying Adventures of Annette Messager, Trickster*, continuing and extending their basic idea. *My Prints* is a composition taken from a set of drawings from *The Horrifying Adventures...*, arranged around a large, centrally placed, brightly tinted, black-and-white photo. Reminiscent of the credits sequence in a film, it resulted from the overprinting of two photos: a woman on a beach taken directly from *Happiness Illustrated* is inscribed on the close-up face of the heroine, on which the title is printed in negative. The cinema was an explicit point of reference both in this work and in an extensive series of "tableaux" that the artist embarked on at this time. More specifically though, the reference is to films dating from Annette Messager's childhood, to the Hollywood of the 1950s and to a genre which she is especially fond of, film noir. She went on to flood entire areas of her existence—her everyday life, her friends, her earlier work—with the same cinematic lighting. *Portrait of the Lovers* is made up from an arrangement of photographic portraits of various female friends and of the artist herself. In the corner of each is a "faked" mug shot—in fact a charcoal drawing—of their lover, the whole framing a panoramic Technicolor landscape. The relationship set up between the two circles of black and white images and the photographs of scantily clad young women hints at a crime with undertones of the vice squad, whereas the picture in the middle evokes a dubious tropical atmosphere conducive to the seedier side of sex. As had often been the case with film posters of the period, Annette Messager's portraits were drawn from photographs and then rephotographed, the central image being a photomontage tinted in oil. Such complex techniques are echoed by complex references that combine to situate the real—the portrait of twelve identifiable couples—in a fictional realm.

The Clues (Les Indices), 1980–81, detail.
Glue-mounted photographs with paint. 22 × 22 cm.

The Serial, "The Accident" (Le Feuilleton, "L'Accident"), 1978.
Color photograph and charcoal drawings. 115 × 87 cm.

The various parts of *The Serial* appear in a large color poster made up of several disjointed fragments, one being invariably drawn and the other in black and white. Each of these two parts refers to an episode from a fragmentary narrative in a "mini-series" ("The Nightmare," "The Accident," etc.), whose main points are condensed into a single image. "The Nightmare," for example, shows a sleeping couple (a familiar image that includes the artist herself), a frightened-looking face, and a group of objects such as might have found their way on to a bedside table (bracelets, jewelry, etc.) drawn in charcoal, once again apparently laid out like "evidence for the prosecution." The three prints, then, borrow from three different idioms: the everyday, the drama, and the criminal investigation. The whole forms a complete image that seems to have been torn up and then stuck together again, like evidence in an imaginary police report. Whereas it is true that the image has been centered, and appears more unified than earlier pieces, the different technical means used emphasize the heterogeneity of the components and the hybrid character of the whole. The three original images were chosen from various collections of pictures in the possession of the artist—mug shots for the face, images of daily routines for the couple, and photo-novels for the objects—which are redrawn or rephotographed, then enlarged, mounted, painted, cut up, and glued. This do-it-yourself approach in the studio and laboratory soon became paramount. "It was colorful bits of painting and cut-out photographs—painting was photography and photography was painting; things might be unmixable but everything *was* mixed up. The photographs were taken from magazines; I took a car and in my lab superimposed the shot with a picture from a photo-novel, one of a surgeon, for example, then I had the mock-up photographed in turn by a photographer who printed it up large format." The work is clearly a montage, in the style of an advertising poster. Like a number of modern artists, from Seurat and Toulouse-Lautrec on, Annette Messager uses the principle of the poster both for its overtness and its synthetic power. Posters are essentially declarative, they are mere surface, pure image. They are in perfect accordance with a taste for reality, and counter any speculative effect on the part of the artist. This flattening out of the image's constituent parts reflects

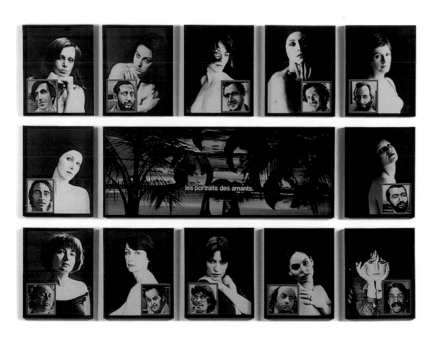

The Portrait of the Lovers (Le Portrait des amants), 1977.
Photographs and charcoal drawings. 204 × 282 cm.
Fonds Régional d'Art Contemporain Aquitaine Collection.

the Conceptual thinking that dominated the 1970s art scene and that Rauschenberg declared was the most important single factor in making art. In this way, anyone who tries to see more than is shown on the surface, who seeks to unearth the artist's intentions or find statements that validate the image presented in Annette Messager's work, is going to be sorely disappointed.

Unlike the theater playbill that had always conformed to traditional models, the painted cinema posters that emerged following the invention of color film became a wholly modern genre that relied on the power of images to incorporate the two most eye-catching elements of the film—the actors and the storyline—within a single dynamic sweep. Without neglecting the contribution of photography, from which the poster's techniques of montage and even its models derived, long the preferred option for posters was to reproduce drawings. As well as being lowbrow— for it was a type of reproduction traditionally associated with the advertising hoarding—the hand-drawn cinema poster was also suggestive, imparting added tension to the image and spelling out the fictional character of the film concerned. In the type of films that Annette Messager is most fond of, enjoyment stems from narrative qualities. All the elements of the film—the screenplay, the sets, the poses, and the facial expressions—are devised to be "more real than real." Voicing an admiration for Hitchcock, Annette Messager has on more than one occasion brought out the fascination that comes from seeing faces screwed up in terror, focused with surprise, or suspended in midair during some dramatic event. All these ingredients are to be found in *The Serial,* a work that consciously borrows from the codes of popular culture. Annette Messager is not interested in the cinema because it is concerned with images in motion (unlike many artists of her time, she is not herself a filmmaker), but in the way it can tell stories and create pictures on a culturally universal level. It is for this reason that her interest in the movies did not draw her to French New Wave cinema—with a few exceptions such as Agnès Varda's *Le Bonheur*, which might be compared to her own *Happiness Illustrated*, and above all Jean-Luc Godard's *Le Mépris*, a film that plays with the key moments of postwar cinema in ways similar to her own projects.

In addition to being rooted in familiar points of reference that have already been digested by the public, her work also grows out of the drive to make the real emerge from pretense, something that has kept it free of naturalistic methods and of over-literal connections to life. Among French directors, her counterpart might be a figure like Jacques Demy, whose bewitching films made in a delectably phony style present us with truths rarely communicated by the language of realism, conveying like few others the bizarre ups and downs of contemporary life. Like Demy, Annette Messager stages all her fairy tales in an everyday, ordinary world, filching

The Clues, 1981, details. Glue-mounted photographs with paint.
Various dimensions, each approx. 30 × 15 cm.

the backdrop against which her observations on the modern world are played out from the realm of popular culture. Both artists try to convey the bare essentials in an understated fashion. Whereas Demy forms part of an enduring if beleaguered tradition of filmmaking, Annette Messager has sounded a discordant note by letting her superficial images and her lightweight stories loose on an artistic scene still bowed down by its responsibilities to the fine arts proper. Neither the rebellious art of the 1960s, nor the art of the 1970s that was searching for an identity of its own, left much room for such a throwaway feel. The art milieu was developing in a more starkly intellectual direction in its existential self-questioning. If anything, Annette Messager's subsequent works have accentuated this marginal status, taking her work into an original and wholly new arena.

TRUTH AND MAKE-BELIEVE

A transitional series, *Les Indices* (Clues, 1980–81), orientated Annette Messager's oeuvre in a direction that would culminate in *Chimères* (Chimaeras, 1982). Returning to her idea of a visual alphabet whose every element would indicate a title or provide a clue, she now made more regular use of the potential of photography. Each sign is a fragment of a torn up picture which, like the components of *The Serial,* juxtaposes two orders of representation, the photograph and the photographed drawing. Body parts can be made out (a mouth, an eye), as well as objects such as a knife—objects which, thanks to hand-coloring and the tight cropping that makes them look still more like a series of crime exhibits, were presented in a highly dramatic way. Each piece derives from photographs taken by the artist, who went on to furnish raw material for many works to come with an increased number of shoots. Far from neutral in tone, the facial expressions in these tightly composed photographs are extreme, while the lighting is evocative, verging on the Expressionist. Wearing make-up, the models strike a pose before a black screen; the body is very cinematic, emerging from the shadowy depths into a pool of light. The "preparatory theater" that, in *The Boarders* and in the *Collections,* was confined to game-playing now fits comfortably in the photographic studio, between camera and darkroom. Having formerly played with little birds, Annette Messager was now manipulating human models, dressing them, putting their make-up on, lighting, directing, and arranging them like so many dolls, the photographs being ready for use only after a process of development, projection, distortion, enlargement, and cropping.

Tangentially alluding to these darkroom methods, her oeuvre now opened out into a secret realm, just as the earlier *Albums* had lifted the veil on a private world. The body parts are thus transformed into a chain of clues left after the fateful act—

in this case after the symbolic murder and dismembering of the model. Moving away from the order of reality so as to enter a symbolic order, the forms gradually shift from the schematic and cryptic abstracts of *The Clues* to the monstrous aberrations of *Chimaeras*.

The *Portraits cubistes* (Cubist Portraits, 1979–80) are, in their own way, also *Clues*, in that they too have their origin in a process of anatomizing the image, and function as pointers to a reality more complex than the image itself, one that the "portrait" will only partially and one-sidedly represent. The portrait as reinvented by the Cubists did not seek to convey a likeness, but rather the complex processes involved in making an image. Annette Messager's pseudo-Cubist pseudo-portraits amount to a sidelong glance thrown by an artist who remains wedded to the image in the direction of those who deconstruct it and try to bleach it of all psychological content. Annette Messager merely retains the Cubists' "cube," that is to say the manner in which forms are inscribed within an angular geometry. Cubism determines the irregular outline of the work as a whole, the fragmentation of the body treated as an object, and the general gray tonality of the empty zones. These elements are dissociated before being juxtaposed in the image in a heterodox fashion, as if to bring out the exemplary virtues of a Cubism that has been, as it were, stumbled upon by chance and used only because it coincided formally with the new direction her work was taking anyway, and into which she now injected palpable reality. From this "impossible portrait," all possible ones arise, parts of the same model's body being used repeatedly to give them form. Messager thus composes a gallery of portraits that are—in spite of the heavily flagged pastiche—more Expressionist than strictly Cubist, closer in fact to a kind of panorama of the emotions. Lying somewhere between the character heads of Franz Xavier Messerschmidt and out-and-out parody, these portraits show the human face as half dramatic, half comical. An amusing cycle of spoofs, the *Cubist Portraits* represent a stage in the investigation of the fragment which, from that moment on, was to become the crucial element in her work.

FILMMAKING FOR THE POOR

The relationship between photography and painting that started with *The Serial* and was then parodied in *Cubist Portraits*—a relationship paradoxically comprised of contradiction, interchange, and translation—was taken a step further in *Variétés*, a term that means "light music" in French. With outlines reminiscent of the ornamental curlicues that adorn picture frames or decorative friezes, these are paintings that belong to the margins of art. Spirals and wavelets, little hearts and triangles,

Cubist Portraits (Portraits cubistes), 1979–80, detail.
Photograph and paint, glue-mounted. Each approx. 40 × 25 cm.

plaits and moon shapes overlap and intertwine, gathering into large graphic arabesques that overrun the walls and spill over onto the ceiling, the whole image flowing and transforming itself like some bizarre creature.

An initial contradiction arises from the fact that these joyous cut-out garlands hardly suit the film noir character of the images within. A second incongruity stems from the juxtaposition of the supposedly realist cast of the photographs with the illusionist painting style, the two media being scrambled together so thoroughly that in the end both are shorn of their intrinsic qualities. Photography, for instance, is no longer able to vehicle the totality of the real since either the shot is deliberately out of focus or the facial expressions depicted are willfully theatrical. Painting, on the other hand, is relegated to serving as the helpmate or ersatz of photography, which it is used to "colorize" or to reproduce, several *Variétés* being based on pictures of dancers drawn in a mock-photographic style. Other works are suggestive of painterly effects in the way they have been cut out, as in *Nymphéas* (Waterlilies) in which indistinct, repainted faces appear from out of wavy lines evocative of the surface of water. The status of the image in these pieces is that of a reflection or an apparition, of a surface impression bereft of depth. If the subject around which the work revolves but never manages to penetrate is painting, the abiding reference remains the cinema. The shadowy image is composed like a film shot, and the models do their make-up and run through the script, their postures and expressions mimicking horror films or thrillers. The whole program is a variation based on Hitchcock models: "I like Hitchcock's images because, so as to get across a forced expression, he asks [the actors] to knit their brows or open their mouths . . . Hitchcock's expressions are really false, like close-ups from a photo-novel."[6] By the same token, the practice of tinting black-and-white images reminds one of the sudden bursts of color in *Vertigo* and the rather unreal look of early color films. Since it is the only space in which a symbolic and magical role for color persists, the world of the movies, the pre-eminent image-producing factory, is simultaneously the last preserve of painting. "Toward the end of the 1970s," the artist has commented, "I started calling myself 'a filmmaker for the poor,' using solely black and white paint, the pictures being unrolled along walls, the close-ups extreme."[7] Show business is hardly immune from showboating, from exaggerating and distorting reality to the point of no return. The snake-like non sequiturs of *Variétés* pursue the real world through every one of cinema's disguises and contortions, only to drown it in paint and retouch it in pencil, with no greater ambition than to bewitch, or simply to amuse. By highlighting this love of play and delight in the artificial, the territory of art is shifted into the popular arena and is invested with an oblique dynamic that fills it with renewed vigor.

Variétés, "The Heart" (Les Variétés, "Le cœur"), 1981.
Photograph and paint, glue-mounted. Approx. 40 × 55 cm.

Variétés, "The Three Totems" (Les Variétés, "Les trois totems"), 1981.
Photograph and paint, glue-mounted.
Overall dimensions approx. 270 × 160 cm.

fairyland and apocalypse

"I stick on eyes
I peel off ears
I cut off fingers
I rip off a breast
This is my law of exchange
I prune it
I quarter it
Into choice and cheaper cuts
I dismember it
I apportion it
I hate all things linear
I pin it
 I dry it
 I dampen it
 I dry it once more
 And it brings forth nothing but chimaeras."[8]

Chimaeras (Chimères), 1982–84, detail.
Acrylic and oil on photograph, glue-mounted. 300 × 250 cm.

Chimaeras, 1982–84, detail.
Acrylic and oil on photograph, glue-mounted. 245 × 280 cm.

The preceding text forms part of Annette Messager's introduction to *Chimaeras* (1982–84), a sizeable group of fantastic forms that were brought together in 1984 at the ARC in a large-scale installation christened *Chimaera Traps*. Employing her by now trademark dissections, the result was an extraordinary bestiary of giant bats, spiders, scissors, roots, keys, witches and other, less defined, forms of animal or humanoid appearance. This bestiary had origins in a hybrid cross between body parts. After plumbing the depths of everyday life and collecting the trivial images that go to make up the personality of ordinary young women today, the artist now entered a ghostly realm associated in the past with the instability and wickedness of the feminine. A close reader at the time of Michelet's semi-historical study *The Witch*, Annette Messager took to recycling the imaginary forms through which woman was thought to exert her demonic power. Displaying the same delight in contradiction that characterized her lists of insulting if amusing proverbs against women, or her painstakingly copy of a picture from a travel brochure, she selected parts of the body presented either in grotesque foreshortening or as terrifying snapshots—a pair of eyes rolling back into their sockets; a nose viewed from beneath; a detumescent penis— and reconfigured them as monstrous shapes trapped within an outlandish border. The paintwork harmonizes and enlivens the cut outs which, glued to a length of tulle, thus have the varnished sheen of a finished article, reminiscent of a shop sign or a board advertising a fairground attraction.

Chimaera Traps also reminds one just how close in spirit Annette Messager's work is to that of Oldenburg. The latter had earlier made brightly colored forms in plastered canvas, outsized replicas of garish everyday consumer articles such as Coca-Cola bottles, hamburgers, and cream cakes. For her part, Annette Messager transforms and extends this approach, shifting the idiom from that of the American dream to stereotyped images from the "female" dreamscape. Though monstrous, the visions she presents also echo the kind of trivial figures rehashed countless times in the popular imagination and which make up the well-worn vocabulary of supernatural iconography. More intriguing still than the images are the media used to convey them: abandoning all reference to "painting" proper, the twisted, fragile, and irregular shapes constitute a new type of object that, though still resolutely figurative, now stretches from floor to ceiling, storming the walls, and proliferating almost uncontrollably. Too light to be considered sculpture, these painting/photography crossbreeds constituted an event unique on the contemporary scene: their appearance was little short of an atrocity, a culpable compromise in which an artist abandoned ironic distance and embraced a secondary medium.

One of the most provocative things about this piece is the childlike pleasure given by these comical, disquieting articles, thrown together with little artistic pretension

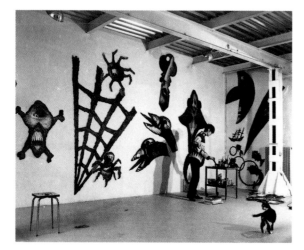

Annette Messager in her studio in front of *Chimaeras*, 1982.

and no conceptual framework. It marks the shift from work based on borrowings from popular culture to the invention of a genuinely new "popular language." In what is a return to a more primitive method of creating form, the shapes are not drawn, but cut out. With *Chimaeras*, Annette Messager attained the absolute limit of the devaluation of art to which her work had been tending, her oeuvre entering a phase of free and unbridled fantasy indicative of an artist who had escaped the norm.

METAMORPHOSES

On more than one occasion, commentators have cast a spotlight on the various antecedents that might have prompted Annette Messager's work on *Chimaeras*, from late-nineteenth-century Symbolist painters such as Gustave Moreau, from whom she borrowed the title, to the Surrealists, who provided something of a benchmark as regards the use of photography. Quite apart from Art Brut, which had long served as a liberating influence and a source of inspiration in respect of technique, another lineage can be drawn up, starting with Goya and leading through the greatest examples of those artists who strove to unite the common-place with the sublime.

For *Chimaeras* in particular, Annette Messager invokes both the great visionaries and the rural tradition of the *fabliau*, the medieval French fable. Like her Symbolist predecessors who exploited the rediscovery of the dreamlike world of fairy tales in the folklore studies of the time and who were to capitalize on the experiments in hermetic language undertaken by contemporary poets, and like the Surrealists, who were to delve deep into the sources not only of Freud's arcane new science but also into the worlds of the insane and the child, Annette Messager too sought to combine literature and vision, knowledge and intuition. She approached these time-honored storytelling tricks simultaneously with the eyes of an ethnologist and of a little girl who likes playing and making things up. Beyond its weirdness, sadistic compulsion, and playful provocations, the work also affectionately highlights those manifestations of a repressed, despised mentality that survive only in endemic forms in the dregs of a marginal culture, today the sole preserve of children and the uneducated. As in her *Albums*, Annette Messager tracked down the images she wanted to use in fairy-tale anthologies and then amassed her illustrations, choosing the most representative examples, the very archetypes of the dream. At the same time, she probed the bodies of her models, returning armed with the most horrifying grimaces and the most distorted poses. Systematically deforming the photographs by projecting them on to convex surfaces, she created new types of anamorphosis, unhinged views of the human body. From this rebirth

Chimaera Traps, 1986, detail.
Acrylic and oil on photograph, glue-mounted. Approx. 300 × 200 cm.

of an art of expression and of the grotesque emerged extremities of feeling, laughter, and tears, that were common currency in a society that did not yet entertain so many delusions as to the nature of death and deformity. Brought up amid so many sick people, inculcated in a religion in which the supernatural was never far away, and a frequent visitor to churches which have always offered shelter to the "dregs of humanity," she delved deep into her own childhood memories in a search for new source material for her comic fables.

Chimaeras also signals the advent of a kind of nostalgia, already latent in her earlier productions, for a more authentic, less inhibited time when humanity did not restrict reality to material substance alone, and could speak with a single, nameless voice. This lack of differentiation that allows an eye to be conjoined to another eye or else to a sexual organ, and a human being to be mixed with an animal or an object, runs counter to the cult of individuality engrained in our culture. The grimace, the hybrid, and the metamorphosis into an animal are all processes that cast aspersions on our belief in the sovereignty of the body. It is in this guise, however, that a living, feeling body is to be found, one with real flesh and a mind that lies at the antipodes of the frigid, constrained body of the pretty models featured in *Voluntary Tortures*.

Annette Messager also became increasingly interested in studies of the hysterical body, a theatrical entity which reveals inner states. The receptive bodies of the figures known as *femmes-clichés* (women-photographs/women-clichés), over the surface of which are laid drawings, bodies riddled with tension that topples over into drama, would become the blueprint body for the artist, one that presided over a "theater of the body" with which her new works would seek to dialogue.

ANNETTE, THE PEDDLER

For *Chimaeras*, as for three or four subsequent series, Annette Messager adopted a new identity—*La Colporteuse* (The Peddler). Gradually the portrait of the artist—who only saw herself to a limited extent as an artist proper—began to gain in density: she was first a Collector, then a Trickster, and now a Peddler. Each of these monikers refers to a facet of her activity as an artist that ranged from the most private to the overtly public. Her project had become a "voyage" around the identity of the artist that seeks to combine all her qualities. Collecting was supplemented by trickery (not replaced by it), then by hawking, which served as a recapitulation of all these earlier practices. From the initial *Collections* that had only been occasional products of a behind-the-scenes operation made almost for personal consumption, Annette Messager's work has progressively increased in complexity, and its public character has gradually become more evident. Each stage of this development has been

Chimaera Traps. Exhibition at the Vancouver Art Gallery, 1986.

accompanied by hybrid process in which a memory of the preceding phase persists, and a "biological" trace of all the others is, as it were, retained. Annette Messager's work unfolds in the way of a family tree, and interpretation has to take account of the original binomial—of *The Boarders* and the *Collections*.

The two early works, to which all her later pieces can clearly be seen to relate, did not furnish a system of principles or an artistic program, but rather the seeds of an inheritance. Unlike artists such as Marisa Merz, who reuses elements from earlier works directly in the creation of a new one in a ceaseless process of updating, with Annette Messager the question is one of *transmission*, facilitated from the outset by replication and reproduction. The collections initiate a chain of reminiscence, which becomes operational in the succeeding series and which affects the techniques, materials, and subjects to the same extent as it does the images. The artwork is a memory that speaks of memory without, however, speaking about itself. The richness of this approach resides precisely in the organic, non-tautological development that allows for considerable freedom in construction. Each "generation" of pieces—equivalent to one or several series—possesses its own personality and imaginative realm, and even allows for a measure of contradiction with respect to its predecessor. The need the pieces have to shake free is as strong as the bonds that remain intact: the artist is driven to reinvent herself endlessly, to break radically with what went before, to spring surprises, to indulge in digressions.

Tempting though it is to classify her work by genre according, for instance, to the movie categories to which she refers so readily, even these would soon be overwhelmed. Although she is one of the few contemporary artists still to make use, albeit discreetly, of the more restrictive genre of painting, an approach that derives comparisons from that field would fare no better, since the use and manipulation of the categories form a significant component of her work (a fact that had already emerged with *The Boarders*). In point of fact, her work delights in creating frameworks—which it then proceeds to dismantle. There is, however, a parallel between the way each series unfolds and the kind of genealogies that appear in works of logic. The first reference to come to mind is of course Lewis Carroll, with whose work Annette Messager's shares many features. Gilles Deleuze, in attempting to account for the popularity of Carroll today, gave an outline of the author that fits our artist's universe like a glove. Deleuze refers to "books for children, preferably little girls; astounding, unusual, and esoteric words; matrices, codes, and decoding; drawings and photos; a profound psychoanalytical content with exemplary logical and linguistic formalism."[9] The more extensive investigation of logical seriality Deleuze provided in the rest of *Logique du sens* (in which the Carroll study appears), where each point of a figure refers to other points of some other figure

Chimaeras, 1982–84, detail.
Overpainted photograph, glue-mounted. Approx. 100 × 100 cm.

belonging to another sequence, seems also to coincide with Annette Messager's methods perfectly and draws attention to links with topology that would become increasingly perceptible as her work developed.

OBVERSE/REVERSE

Following on from *Chimaeras*, *Effigies* (Effigies, 1984–85) returned to a more rigid formal frame that remained in place throughout each work. A series of neatly cut-out, geometrical yet vaguely anthropomorphic shapes, these large-scale two-dimensional, rigorously symmetrical black figures set the stage for a balletic group of mutating bodies that dance about against a starry sky. These eschatological visions of a maelstrom swirling around in zero gravity, alternately joyous-looking or frightening, usher us into a supernatural realm that has links to the world of religion. By borrowing elements from Christian iconography, arranged like a Last Judgement, for her depiction of Limbo, she recaptured the high-flown language of Dantesque demonology. The amalgam between photography and drawing introduces great diversity into this enumeration of various human types, that ranges from free-floating organs to headless bodies via all possible grotesque and hybrid variants. As is the case with certain popular beliefs, the pieces blend religious evocation with a traditional cosmogony evidenced by the frequent allusions to the signs of the zodiac and by the basic triangular shape of the effigies, seemingly derived from some esoteric vocabulary.

Following the mythical demons of earlier series, *Effigies* dealt with creatures spawned by superstitious beliefs. For the first time, Annette Messager bred and hybridized elements that, although they were rooted in a familiar world, had already been employed and thoroughly codified in the course of the history of painting. The strict mode of organization was in marked contrast to the fantasy of the *Chimaeras*. The overall topography of each work is governed by the dual ascending and descending movement of the Last Judgement, and the figure of the Judge standing at the summit of the composition (represented most often by an eye or a screaming mouth). These two features make the piece into a genuine "painting" at a time—the mid-1980s—when picture-making had regained the center ground on the international art scene. Unlike a number of French artists

Effigies (Effigies), 1985.
Exhibition, Musée d'Art Moderne de la Ville de Paris, 1995.

Effigies, 1985, detail.
Photographs and paint on canvas. Approx. 290 × 290 cm.

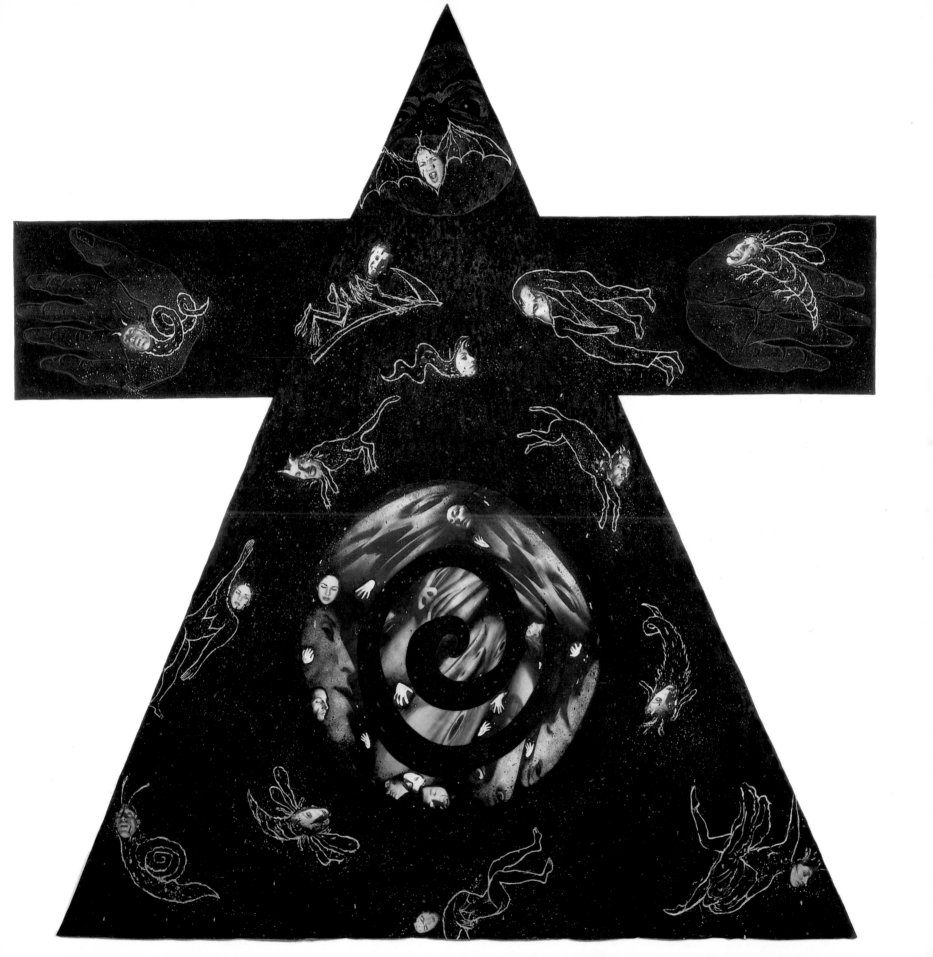

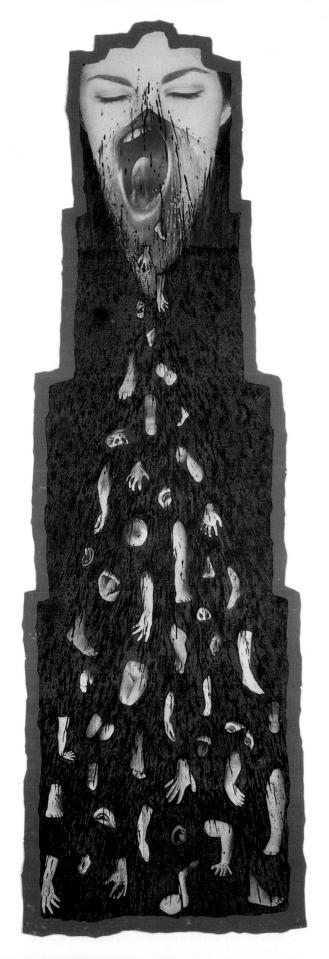

who backed away from what seemed a return to the past, Annette Messager saw in painting proper simply another area ripe for takeover, a new mode of reference to bring under control. In *Effigies*, as in succeeding series, scale, composition, drawing, painting, and the rigid, flat support all combined to establish relationships between the body parts that remained the source of her imagery.

Her works soon took on the appearance of full-sized religious paintings, both monumental and hieratic. *Effigies,* as with the later *Pièces Montées* and *Trophées* (Trophies), can be compared to altarpieces. The cut-outs of the former and the modular system of the horizontal or vertical formats of the *Trophies* are evocative of sections of altarpieces removed from their architectural setting. Moreover, the subjects borrow something of their vocabulary from religion too (lost souls, angels and demons, the apocalypse, the stigmata, etc.). The powerful and at the same time insidious presence of photography remained, however, binding symbol to reality and painting to life. Constituting a significant proportion of the imagery, the heads are always photographed and never drawn; they are the locus of humanity and life, being either extended by an imaginary line-drawn body (often gilded, a practice that accentuates the unreality of an already fantastical design), or treated as demonstrative images of decapitation.

The cut-out, planar, and geometric support, the frontality accentuated by the black background from which the photographs and drawings stand out, the paint that courses in droplets down the design, all combine, exacerbating the tendency to surface effect that could already be sensed in earlier works. This parti pris for the surface almost amounts to a systematic program, and, though patently belonging to the category of painting, works from these various series make no attempt at achieving depth. Even in its formal choices, Annette Messager's oeuvre remains wholeheartedly "superficial"—a paradoxical fact, since the history of painting has been one long quest to conquer three-dimensional space. The abandonment of illusion had already been evident in the literal and flat appearance of the early *Albums* and *Collections* and was soon to become a constant. There was a psychological motivation behind this: promoting the surface is the artist's way of paying lip-service to the superficiality commonly attributed to the female psyche, something she claims the right to as a positive quality. As against the quintessentially male conception of picture-making depending on words, she forges links with the natural and the supernatural that affirm the immediacy of perception, the all-importance of the tangible, and, in so doing, counters perspective with intuition, speculation with experience. The world she presents is thus not deep, but very broad, embracing everything from the infinite to the infinitesimal. The elements float free from the hierarchies perspective imposes, obverse and reverse openly cohabit.

Emotions ranging from delectable to violent emerge on the surface of the skin, "in a shudder," as Johanne Lamoureux has put it, going on to characterize Annette Messager's work as a "story about skin."[10] Indeed the work's "epidermic" nature is conveyed this time more literally by the actual representation of skin—more and more prevalent since the time of *Trophies*, which alluded directly to tattooing—and still more crucially in the importance given the frontiers at whose edge identity becomes determinate.

Annette Messager's work has been distinguished from the beginning by its commitment to tracing a borderline around art and woman, around the body and its organs and limbs. Since *The Horrifying Adventures...* frontiers have often been marked physically by a red line surrounding the image, very much like the border that, in the popular press, frames pictures of common criminals, victims or outlaws, or indeed all those who have dropped out of society or seem to have entered another world. For Annette Messager, cutting round an image is the best way of selecting and creating a form: such an abrupt demarcation line brings out the true nature of things by exemplifying their individuality. Inside a body, perceived through a nasal opening or a mouth, there lurks, not a concept of depth, but that of another, hidden surface, a frontier that has to be traced so as to provide the individual with its limits. The surfaces, as they abut, fold out the body, stretching it like a portrait made up of a sequence of charades, reminding us simultaneously of the inner linguistic structure of her work.

MOTIF AND WIT

Through the extrapolation of details taken from *Effigies,* the problematic of picture-making was developed further in *Les Voiles* (The Veils, 1985) and *Pièces Montées* (1985–86). In the former series, composite images made from photographs in conjunction with one or more levels of drawing or painting emerge from beneath layers of oblong veils. Centered around a single central motif, these unobtrusive notations and variants in a decidedly minor key on the theme of the portrait are reminiscent of the "Trickster's" notebooks, each little piece presenting a challenge to the material practice of making pictures. The lightweight veils and insubstantial motifs deprive such pieces of all consistency—yet the image still comes forth, imposing itself as a vibrant apparition. By dissociating the various stages involved in its production, Annette Messager endowed the image with fragility in preference to depth. This process of separation of which she is so fond confronts us with a form of painting that does not in fact result in pictures as such. The only tangible substances are associated

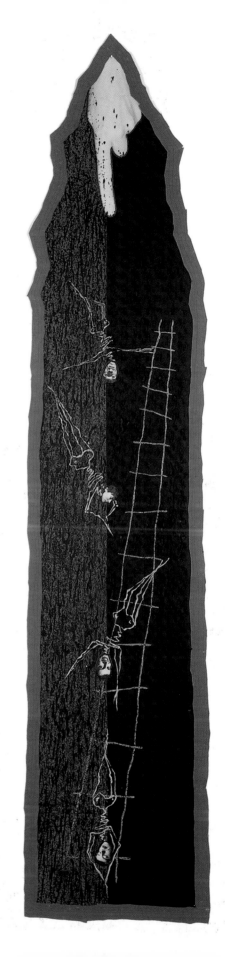

with the motif. As befits an idiom derived from the applied arts and interior decoration, the "motif" runs counter to the "subject." Illustration, decoration, repartee, it belongs to the collective domain rather than to individual creativity. Ransacking the stock of traditional images whose origins feel vaguely familiar, she adds a dose of the popular, a whiff of perfume from the East, a souvenir from the Middle Ages. Around each image, she embroiders a tale, rewrites a lost text which the image then serves to illustrate. The individual authority of the artist is submerged by a secret store of forms, by a memory of an origin that eludes us all, yet which belongs to everyone.

In the historical context of the "return to painting," a phenomenon that relied on the reconstitution of identities often linked to a sensation of national belonging, such understatement verged on the provocative, amounting to an act of resistance that was to adopt a still more caustic tone in the *Pièces Montées*.

As the title implies (the French refers both to pieces or spare parts being "mounted" and to multitiered cakes), *Pièces Montées* are fantastical lightweight constructions, absurdly etiolated picture parodies whose by now customary red framing has been baked into a sugar-coated pastry crust. In the majority of cases, the theme extends that of the *Effigies* and exploits the new-found collaboration between line drawing and photography. A ghoulish world is created, populated by figures consisting of a photographed head prolonged into a skeleton faintly drawn in gold. As with certain banners, the pieces are to be read vertically, the figures ascending or descending, some clambering up a kind of Jacob's ladder, others plummeting violently through space. As well as the Last Judgement, the underlying theme evoked is that of the Wheel of Fortune. The artist's pointing finger is a jocular stand-in for the Hand of God that casts men down to the bottom of the ladder (or could it be that this manifestly female digit that is occasionally replaced by a facial feature belongs instead to a simulacrum of the artist?). The *Pièces Montées* are light-hearted pieces that meld medieval iconography with Walt Disney cartoons. The reference to animation also evident in the simplistic and loose way the drawings are executed would be still more emphasized in *Trophies*. Cinematic imagery is still much in evidence, however, in the figures floating against a dark background, as if in some underwater cartoon. The spirit of Méliès, for whom Annette Messager has often voiced her admiration, haunts these works that convey by the simplest means imaginable all the charm of a dream.

Preceding pages:
Pièces Montées, 1986, details.
Oil and photographs, glue-mounted.
265 × 85 cm and 185 × 45 cm.

The Veils (Les Voiles), 1985, detail.
Veils, photographs, paintings.

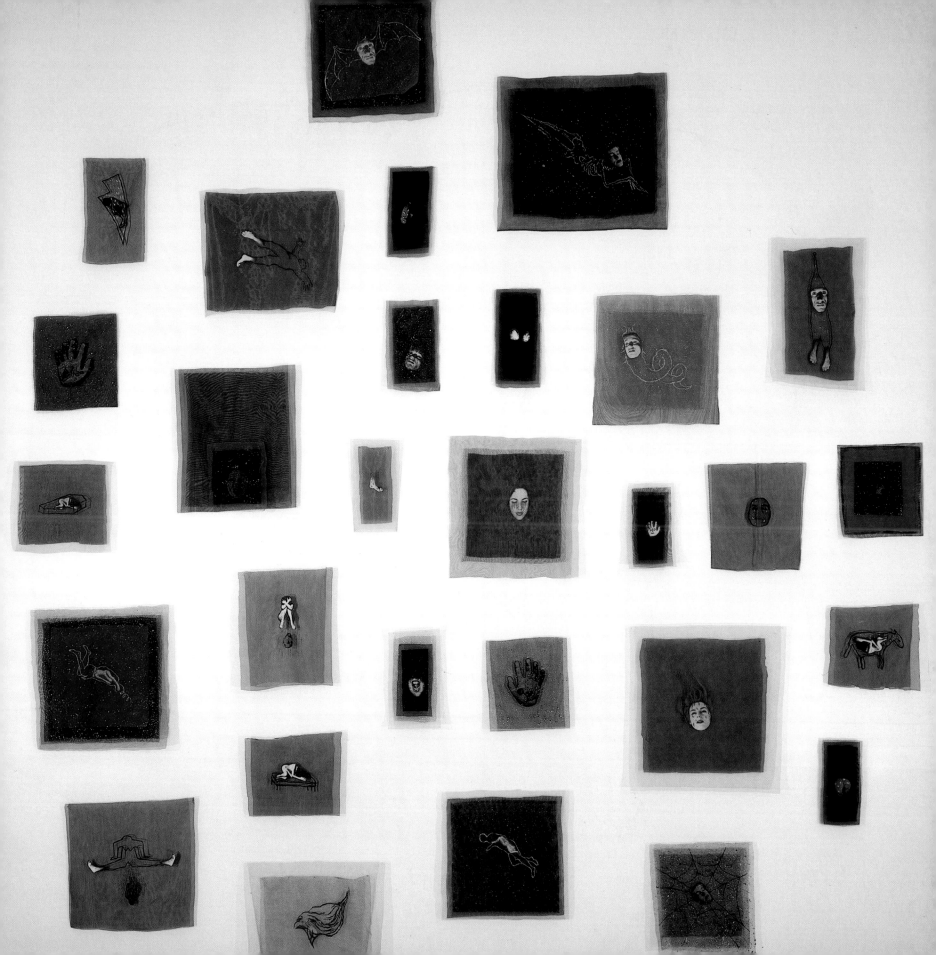

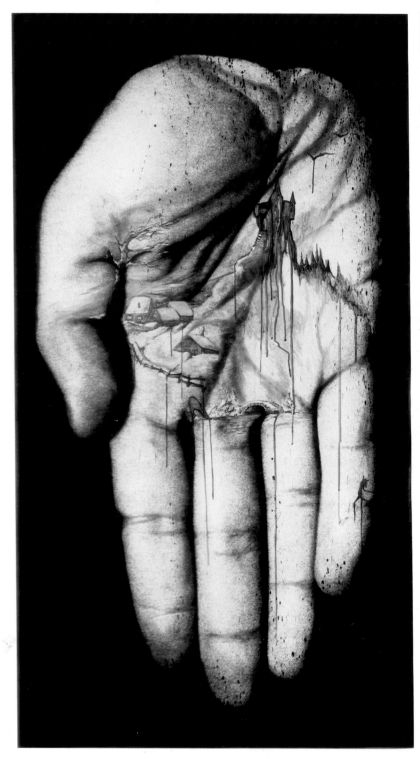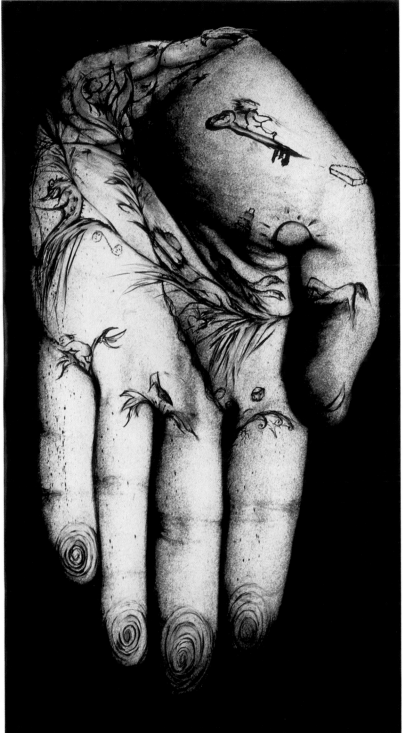

My Trophies (Mes trophées), 1986–88. Acrylic, charcoal, pastel on photographs. 206 × 170 cm. Fonds National d'Art Contemporain Collection.

topography of the body, topography of the soul

I n a short space of time, the three series *Mes Trophées* (My Trophies, 1986–88), *Mes Ouvrages* (My Works, 1987–88), and *Mes Vœux* (My Vows, 1988–89) were to reconfigure the vocabulary of Annette Messager's whole oeuvre. Though not severing every link with her earlier work, and taking a lead from the final series of the *Chimaeras*, *Effigies*, and *Pièces Montées* especially, these pieces amounted to a new beginning, something like a new dynasty. They involved taking components from earlier series, cutting them up, separating them, giving them their own identity, and reutilizing them. By focusing specifically on a number of features from earlier works—just as she had, albeit on a more modest scale, with the *Veils*, which she had invested with an individual autonomy and dimension—Annette Messager radically accelerated their creative potential by starting to produce various series in parallel. Hence, the small hand-drawn alterations to photographs, that she used in *Effigies* to introduce variety into the figures and in *Veils* to build up motifs, find in *Trophies* a vast arena in which to proliferate. In *Vows* and *Works,* fragmentary photographs of parts of the body first attain autonomy and then join forces in a constellation of small-scale compositions. The use of entire walls as the picture ground and of words inscribed directly on them—an approach first tried in *Chimaera Traps*—received more systematic treatment in *Works* and then in *The Little Effigies*. As these complex operations ramified further, they were accompanied by new formulations: the photographic emblems in *Trophies*, and the hand-written notes and little frames bound with a strip of black adhesive tape that occur in the *Works* series are employed as recurrent building blocks that appear constantly in subsequent works, to the point of becoming a personal "trademark."

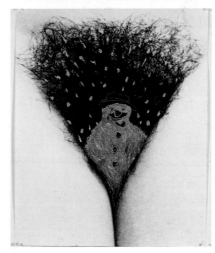

My Trophies, 1988. Photographs, overdrawn.
From top to bottom, 70 × 51 cm, 25 × 25 cm, 58 × 49 cm.

Problems concerning the status of picture-making, if not exactly avoided, lost something of their dominance; as becomes clear in her subsequent work, painting is affected by a kind of implosion that alters every one of its constituents. The work's primary referent is no longer the isolated image but the final composition.

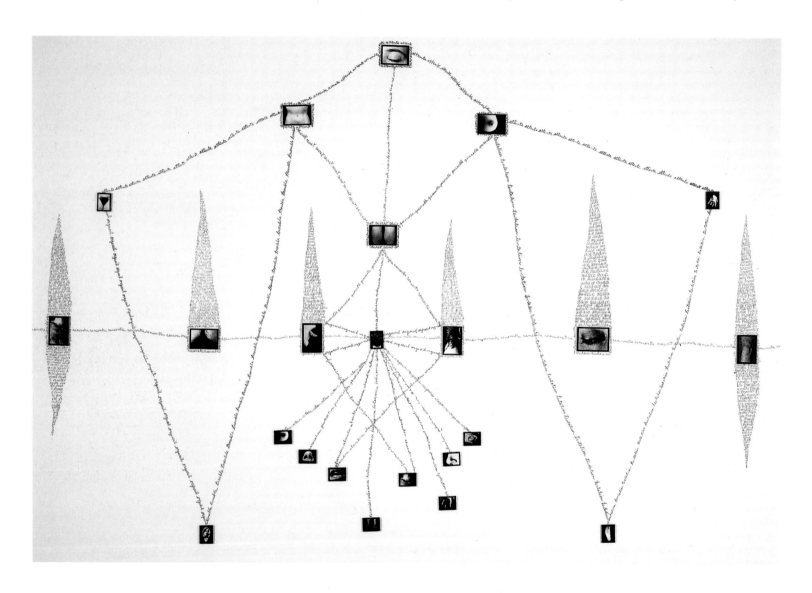

My Works (Mes ouvrages), 1988, detail.
Photographs and colored pencil on wall.
Installation at Cold City Gallery, Toronto, 1991.

The avowed source for these new creations is the mass of images that spontaneously arise during manifestations of popular culture: acts of devotion and superstition, street entertainment, demonstrations, magic spells, and graffiti, or—even more unstructured—stalls at the flea market.

As with Marcel Duchamp, the godfather of appropriation art who underlined the modest beginnings of many of his ready-mades ("In 1914, I made the *Bottle-Rack*. I had simply bought it at the BHV department store"),[11] the object—or installation as it had become—casts a backward glance to its lowly origins. Here, more than ever, Annette Messager makes clear her preference for everyday life, for the life of the underprivileged. Her work reverberates in unison with the nameless crowd, with anonymous places, with plebian pastimes. The ethnological distance that characterized her earlier works here recedes, to be replaced by a kind of osmosis with the very essence of the people. Jettisoning form, *Works* and *Vows* are systematized into an organic, gregarious arrangement of compact or fluid masses in which each element exists as an individual in the midst of the group, unique yet replaceable. The lowest common denominator is therefore not the fundamental element as such, nor the image, nor even form, but the operative mode of an anonymous, mass relationship. Unlike the artists of Nouveau Réalisme, who extracted their raw material directly from real life, and in contradistinction to Christian Boltanski, who uses everyday articles that remain recognizable as such, the ingredients of Annette Messager's work are images made by the artist, the feeling of reality they give emanating instead from the way they are used. Quite unlike the majority of modern artists, who submit what they take from reality to "artistic" transformation—an operation that can be reduced to simply removing items from one context to another—no transformation as such occurs in her work. Instead, the elements are placed in accordance with a pre-existing traditional practice: it is through such "positioning" that the piece is constituted, the system of reference bestowing meaning on the individual elements, as well as conferring an identity on the entire work. This new art of "placing" led her constantly to reformulate the ways the same store of images can be hung or arranged. The operations chosen to create what soon became an infinite variety of effects and forms (nailing, hanging, binding, layering, pinning, etc.) continued to expand in many subsequent series.

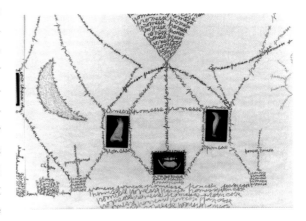

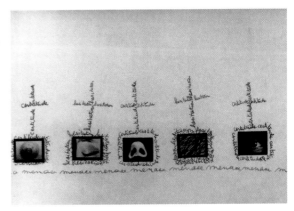

EXORCISMS

The traditional practices which still informed whole series from the late 1980s cannot be said to have been borrowed from life as it is generally lived today: the mass demonstration, the ex-voto, the relic, and the trousseau are models less evocative of everyday occurrences than extraordinary circumstances in themselves. Annette Messager's intention is neither to point up nor to elevate the commonplace, but to highlight the persistence, or at least the dormant memory, of the peculiar phenomena that lie at the very heart of our standardized existence.

My Works, 1988, details.
Photographs and colored pencil on wall.

Handwriting, embroidery, and manuscript illumination belong to the same family of minor practices with which individuals can intervene in the modern, rationalized world. Metaphorically speaking, Annette Messager's images hang from such "knots" that resist the deadweight of the everyday, attached to lengths of string and stretching a cat's cradle across life's painful and joyous moments alike—illness and death, marriage and struggle. These moments, during which memory gets the better of the unthinking reflexes of habit, when unusual behavior reconnects with models from long ago, are captured by the artist and invested with fresh drama. They all stimulate a zone in the viewer's mind where emotion and dream overlap, a place beyond the self as well as beyond time that converges on the domain of art. A readily perceptible resistance transpires in these works, which nothing connects to the context of their time—to their techniques or ways of life, or even to their history—and yet, each viewer is able to see something of themselves in the works.

Abandoning storytelling, even in the form of the meandering digressions so effectively orchestrated in her earlier works, Annette Messager kept faith with oral culture, with the "word of the thing." The words running across the wall in *Works*, words that serve at once to underpin and ensnare objects, are uttered interminably, until memory fails. None of these words—"promise," "protection," "temptation," "uncertainty"—is wholly anodyne. They are acts of exorcism that reinforce the "active" dimension of the piece: the shift from an art that speaks to an art that acts, from play to deeds, is not informed by any general claim on truth, but by the same reaffirmation of the human that has always been central to her work. In the universe of this artist, the word is real, just as the thing is real—and both are fragments of what it is to be human. Like the moment when one meets a person for the first time, the point at which one encounters art ought to be exceptional: rejecting the current overfamiliarity with the art experience, Annette Messager, by tracing history back to its source, confronts us once again with the "miraculous"—with the power of an utterance made flesh.

POEMS AND CALLIGRAMMES

Taking their cue from religious imagery and from pictures in palmistry manuals, the *Trophies* (1986–88) are made up of outsized enlargements of organic fragments, over which she embroidered grotesque and fabulous images in charcoal and watercolor, recalling the iconography of the *Chimaeras*. Elves, castles, witches, and animals slip through fingers, sweep down the curve of a foot, edge between a pair of buttocks. Although no longer physically present on the artwork, words often accompany the colored swirls, describing them in infinite screeds of what seem like visual poems. The poem has always provided a supreme means of communicating

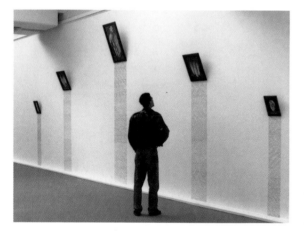

Lines of the Hand (Lignes de la main), 1988.
Exhibition at the Cornerhouse, Manchester, 1992.

Lines of the Hand (Meeting) (Lignes de la main (Rencontre)), 1988.
Overdrawn photograph and colored pencil on wall. 250 × 41 cm.

Lines of the Hand (Promise) (Lignes de la main (Promesse)), 1988.
Overdrawn photograph and colored pencil on wall. 162 × 41 cm.

le jardin du tendre

the miraculous. It is an art form that would occupy a growing place in the artist's work. It surfaced in modified form in the *Works*, which run over the wall like huge calligrammes, as well as in the tiny frames of litanies surrounding the *Vows*. Today, the poet has been pushed to the margins of society, to the margins of literature even. Poetical imagery has fallen into disfavor and is considered as little more than a form of facile fascination, the preserve principally of women and children.

Messager was thus once again engaged in appropriating a form discredited in the intellectual milieu. Playing on the spiritual and playful associations in the *Trophies*, and the relaxed gracefulness of the calligraphy in *Works*, she united the disparate human organs into a single poetical body. Annette Messager has something in common with the Nabis, those artists who enlisted modernism under the banner of the "prophets" (*nabis*), seeking, in the explosion of pure color, a painterly equivalent of Mallarmé's free verse. Gauguin's quest, for example, was for a body at peace, unified, draped in a scroll inscribed with an apotropaic spell. In the sculpted, naked bodies of the *Trophies*, feet, thumbs, and legs all stand out clearly against a black ground, their surface filled with bizarre color drawings reminiscent of vigorous and full-bodied wood carvings from an erotic and magical Tahiti. Its poetical suggestions introduce a sexual plenitude into Annette Messager's work that she had for long denied to her fictional doppelgänger and presupposes a possible reconciliation between mind and body. Pleasure can be had in a skin fold on a foot, in the wrinkle behind the knee or deep in the corner of the lip or in the swell of the hip: amusing, tender, sometimes caustic, these little notes on the erotic seem, like tattoos, to be ready to burst into life at the least twitch. Each *Trophy* offers a primitive vision, a brief replay from some original scene that only the amorous passion of the body can hope to revive.

IMAGERY AND THE *CARTE DU TENDRE*

That same year, 1988, Annette Messager presented *Le Jardin du Tendre* (The Garden of Tenderness, Centre d'Art, Castres), as well as two new "series." In a booklet she produced to accompany the show, she combined several *Trophies* reduced to the size of vignettes with an associated proverb. Under a new title, *Augures* (Auguries), these images of "tender feelings" made use of cryptic meanings: for instance, a hand on which lies a snow-bound landscape lets it be known, "If a young man pricks his left hand on some brambles by snowy weather, he will soon find true love," while a flexed thumb from which there emerges a threadlike volute informs us that "A thumb folded back over the palm is a sign of melancholy."

The shift of meaning from one end of the emotional spectrum to another that results from simply changing the scale of the image is a method the artist has often

turned to good advantage. In line with their traditional purpose, proverbs gave rise to the most unlikely meanings that fracture the hieratic signification of the *Trophies*. As with the illustrations for *Le Jardin du Tendre*, the eroticism of *Auguries* turns *galant*, with *préciosité* taking us far from the world of popular culture and immersing us in the subtleties of baroque femininity.

The *Jardin du Tendre* project arose from a commission for a site-specific piece in a garden. Following the seventeenth-century model of maps of the land of love and of the erotic emotions which had been much in vogue in *précieux* circles around Madeleine de Scudéry, Annette Messager came up with her own personal version that she then adapted to a real space. Having first created a psychological landscape in the park in which amorous conditions are indicated by a series of physical signposts, she let loose a number of tortoises whose shells were inscribed with drawings representing the constellations. These illustrated tortoises, wending their way between the "Path of Reconciliation" and "Tree of Shame" or the "Grass of Confidences," served as metaphors of the viewer's own wanderings through the artist's work. If Annette Messager has often expressed her fondness for this kind of geography of love and for the sentimental symbolism that extends to the least significant of its elements, it is surely because it corresponds so well to the palette of emotions she presents in her different series of works and, within these series, from one work to another, and finally within a given work, from one element to another. The garden incorporates interrelationships as intimate as those of the body, crisscrossed by a network, by a circuit, its separate parts differentiated according to function. Identifying the labyrinth of the body with the twists and turns of nature constitutes a symbolic transposition which, as with the model of the house before, conforms to the idea of "translation," of equivalence that underpins the artist's work. Mapping feelings, on the other hand, reconnects with the demarcation of various categories of work according to the rooms in the artist's apartment that persists today in the organization of her different studios and the position chosen for the body parts. Moving from one space to another is the equivalent of a shift from one emotional state to another that here takes on an active, initiatory meaning. As Annette Messager herself puts it, such circulation is as necessary as "the circulation of the blood." It is an agent of renewal for an artistic venture that had initially been thought out for the closed environment of the studio, a way of its being in the world.

The watchwords for each of these new series are separation and circulation. Like the throngs of ex-votos which inspired them, *My Vows* are pervaded by an emotional current; in *Works*, it is the word, the broad sweep of emotions expressed, that acts as the vehicle. Once again, the abiding thought is of fairy tales or magic spells that can transform commonplace objects into a coach and horses—brooms, pumpkins,

Preceding pages:
Project for *The Garden of Tenderness* (Le Jardin du tendre),
Centre d'Art Contemporain, Castres, 1988.

The Garden of Tenderness, Castres, 1988, details.

and seven-league boots—and to those heroic figures tossed from one emotional state to another who have to carve a path that finally leads, after various temptations and dangers, to their salvation. "I am very fond of those highly coded, highly fetishistic rituals in which someone has to find a foot to fit an abandoned shoe, or a golden ring,"[12] the artist has said, going on to stress the religious undertones of such ceremonies. For Annette Messager, it is a short step from the collective outpourings of religious fervor to blue-stocking sophistication, a step that bridges the dangerous precipice before the castle of salvation in fairy tales and that leads from the "Lake of Indifference" to the "Hill of Avowal" in *La Carte du Tendre*. The links between traditional oral literature and the kind of allegorical writing that Dante elevated to a pinnacle had already been brought out, first by the Symbolists, and then by the Surrealists. By updating superstitions and rehabilitating the secret signs of the zodiac, by raking over the flowery paths of courtly gallantry, by returning to the elegant world of the off-the-cuff epigram, Annette Messager is simply continuing a family tradition.

THE SHORTCOMINGS OF REASON

The idea behind *Trophies* is taken up directly in *Les Lignes de la Main* (The Lines of the Hand, 1988). Photographs of open palms, the fingers pointing downward, are overdrawn in watercolor with figures and scenes that follow the lines of the hand; hung high up in the gallery, the photographs top a "pedestal" of words written out by hand. Leaning outward from the wall, they tower over the viewer like a row of ancestral portraits, the column of repeated words seeming to flow down from the outstretched hand: "trust," murmurs one, "defense," says another, then "hesitation," "fear," "rumor." The voice waxes and wanes in time with the handwriting that changes color every so often, sometimes keeping to a single chromatic range, at others changing more abruptly. The words, as they unroll vertically, remind one of a scroll of holy writ, while the handwritten form harks back to the world of the manuscript copyists. The whole significance of the text is, however, centered on one single word, one chanted until it loses its meaning and resembles instead a proper noun (the title of each *Line of the Hand* conforms in fact to the word inscribed beneath it: the *Tolerance* hand, the *Trust* hand, etc.). As for the drawings, they are often humorous in tone, more like those in books for children than in palm-reading manuals. It is difficult though to make the connection between the smiling snowman on the palm of *Tolerance,* for example— the outline of the hand providing him with a kind of overcoat—and the word chosen. The palm reader involved here is more like a cartoon character, and the divination scenes she reads like a fantasy straight from the collective imagination is just a cliché, with something in common with the "modern pictures" Bertrand Lavier reworked

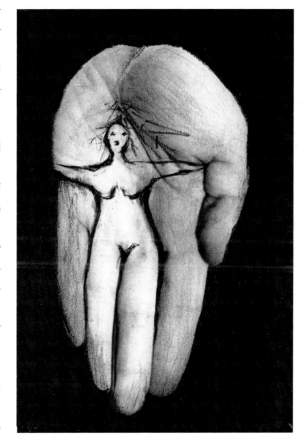

Facing page: *Lines of the Hand*, 1988.
Overdrawn photograph. 24 × 19 cm.

Above: *Lines of the Hand*, 1988.
Overdrawn photograph. 24 × 19 cm.

from images of Mickey Mouse. The idea of the artist jettisoning her personality resurfaces again, with the idea of an image being reflected, rather than an opinion being expressed. "I like to get viewers to feel sheepish, to place them in the position of a Peeping Tom who's been caught red-handed so they sense they might've come across some dreadful secret, where in fact it is only a distorted reflection of themselves. Annette Messager's fantasies are everybody's fantasies."[13]

Today superstition and religion are cloaked in mystery, being swept under the carpet far more readily than sex, for example. The artist zeroes in on the downfall of rationalism which, even though it has managed to encompass the machinations of sexual deviance and the various subversive strategies of "modern art" into its little categories and pushed the supernatural and the culpable sense of fascination it exerts to the fringes of society, has not succeeded in eliminating them entirely. It is a well-known fact that, although we live in a time when everything under the sun is scientifically analyzed, a time of polls and computer-aided forecasting, the great and good themselves are not above consulting the odd medium or chiromancer in secret, while "clairvoyants" of every stripe are enjoying a boom among less privileged sectors of the population. The artist confronts us with objects whose allure has been repressed, with a genuine modern taboo, one of those phenomena that cannot be addressed without a dose of humor, although by opting for what is a puerile stance and for infantile jiggery-pokery, she short-circuits the viewers' ironical detachment and deprives them of the "superiority" of critical voyeurism.

By pretending—deadpan—to be somewhat soft in the head, Annette Messager can treat her public as children and force them to deal squarely with the humdrum nonsense proffered in her works. This technique deprives them of the one and only weapon still available to the modern art audience, that of intellectual or physical "participation" on an equal footing with the artist. A "devalued" artist demands viewers who can take being belittled in their turn, who are ready to laugh at themselves. Moreover, whereas the artist is fictional, or at least hidden behind a mask, viewers have to come to terms with themselves. Paradoxically it is the self-centered position of a viewer who confronts the work but is not required to come face to face with an Other, without, however, feeling excluded or judged, that confers a popular dimension on Annette Messager's art. As in a parable from the Bible (a frequent Messager source), the last can be the first and "those hired about the eleventh hour" can receive their due. Upsetting every available hierarchy, her work has over time acquired a "facility" that is disturbing to those who wield power in the art world, though in fact it is probably its most original feature. *Lines of the Hand* succeeds in cornering the interpretative discourse which contemporary art seems to have happily settled into, trapping it between a totally fake delirium and the endless recycling

My Vows, 1989, detail.
Writings, drawings, string.
Musée d'Art Moderne de la Ville de Paris Collection.

My Vows, 1989.
Photographs, string. 350 × 130 cm.
Guggenheim Museum Collection, New York.

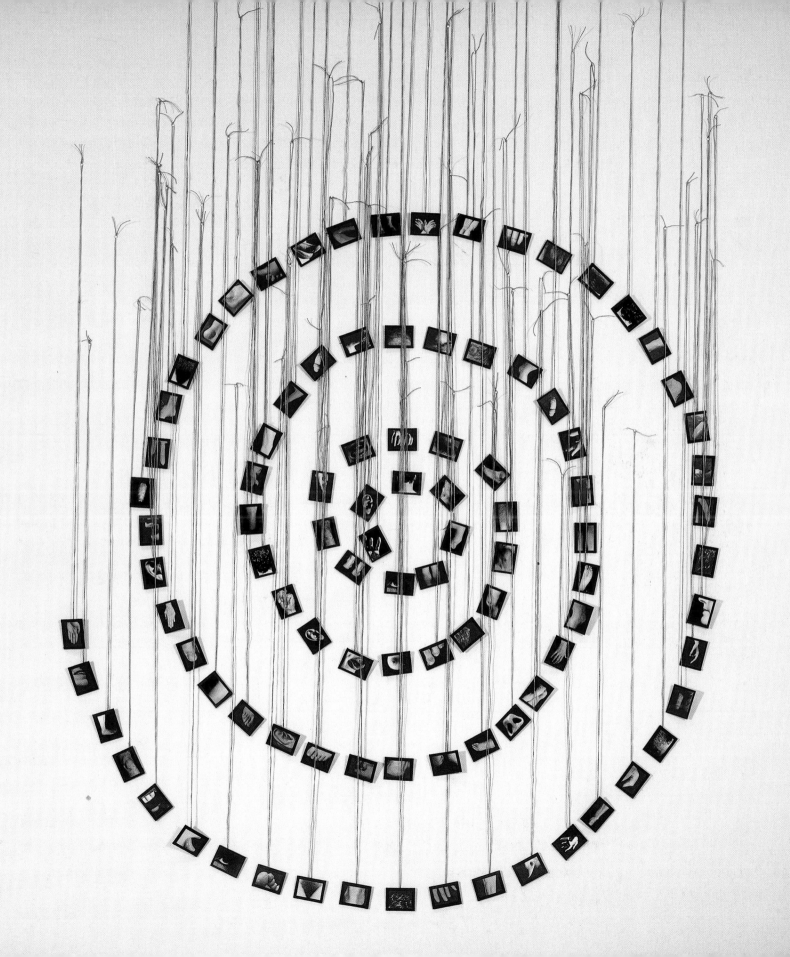

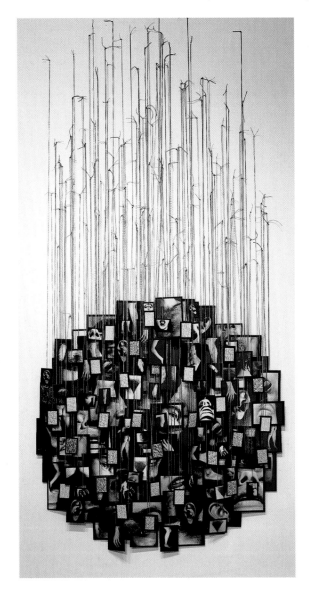

My Vows, 1988.
Photographs and writings under glass, string. 200 x 100 cm.
Museum of Modern Art Collection, New York.

of phony analytic ideas. The fact that a certain spiritual power can be conveyed by such commonplaces—just as truth lurks somewhere at the heart of the clichés that provided material for the *Collections*—is not one of the contradictions of Annette Messager's work as a whole, but rather one of its principal qualities.

HYPERTROPHY OF THE ACCESSORY

The two parallel series *Mes ouvrages* (My Works, 1987–88) and *Mes vœux* (My Vows, 1988 onward) were the object of wide-ranging and prolific developments. Both used as their source material photographs of body parts, black and white and no bigger than a woman's hand, under glass and framed with black sticky tape. In *Works,* the images are affixed to the wall so as to form a relatively geometric frieze whose structure is determined by a trail of words inscribed in color pencil; in *Vows,* the photos are suspended from lengths of knotted string into a mass that is carefully organized into simple, regular shapes. Though embroidery provided the model for *Works* and the ex-voto for *Vows,* the same commitment to rule-making, the same submission to a basic principle which generates variations is symptomatic of both. In both cases, amplification occurs in strict accordance with a guideline, with a framework whose underlying system is immediately perceptible. The work is only complete once this system has reached saturation point. The ideas of domestic tidiness, of order and distribution, so crucial in her earlier work, are once again in evidence. The artist intervenes so as to ensure that the rules are executed to the letter and that every element plays a useful part. The vocabulary of aesthetics has been abandoned and the logic of the work has more in common with that of economics. In both series, the separate elements are reworked, rewoven, and reintegrated according to a predetermined plan. In spite of the sorry state of these removed organs—genitalia for the most part—the manner in which each is recombined into a single entity and assigned a specific place is mildly reassuring. Just as coming together and collective fervor are necessary conditions for the existence and effectiveness of an ex-voto, so the reassembly of the fragments of the body and their organization in accordance with a predetermined system reconnects them with the community, with a history. Like the reiteration of words, the repetition of images accentuates the social character of the fragment and fosters its acceptance by the collective: "In the end, everything becomes inextricably mixed up: arm, thigh, promise, encounter, argument, arm, leg, mouth, arm, promise, return, suspicion, suspicion . . . Such superposition, accumulation, and overlap of image and word recall the successive strata of memory and time."[14]

The radical approach of the early *Vows,* which are composed solely of a multitude of tiny black-and-white pictures hanging from long pieces of twine, the upper part

bristling upwards from an otherwise relatively regular shape (circle or triangle), would be gradually clarified by the addition of new features that would introduce diversity into the votive function of the figures. The chains of verbal rosaries written in color pencil were followed by tiny identically framed colored drawings or pictures with real hair (*Mes Vœux avec cheveux* [My Vows with Hair], 1989). This new series went through a thousand and one variations—from covering the surface of an entire wall in the Musée d'Art Moderne de la Ville de Paris (1989) to, at the opposite extreme, a line of frames placed modestly in rows one above the other—each emblematic of the artist's new creations, yet, at the same time, managing to reconnect with the collections of years past. "It's true, and above all since 1988 with *My Vows*, I've gone back once again to my first love. Now, I've started doing drawings in color pencil again, hundreds of them, very like the *Collections*, but now I place them one on top of the other, and pile them up, frames covered over by other frames."[15] The composition consists of an arrangement of a plethora of tiny photos, and harks back to the primordial idea of reproduction as preferable to the original. "Duplicating or accumulating the same nose, hand, or profile—almost to the point of wearing out the negative— again, it is the idea of compiling an open-ended collection from the sixtieth part of a second . . . Today, 'real' photographers rely on the idea of a unique piece, they mimic painters. What interests me in photography is not texture or grain, not strictly photographic effects at all, but its extraordinary capacity to reproduce the same image to infinity. In this area, Warhol teaches us all a thing or two."[16] The drawings are thus copied out countless times, the words churned out, the pieces endlessly reworked. The prayers in *My Vows,* the incantations in *My Works* passing across thousands of lips, carrying thousands of meanings, are at the same time echoes of Warhol's soup cans, his Marilyns and *Disasters*. Here again, Annette Messager shows how proficient she is in keeping medium and meaning in balance: the work's effectiveness derives from repeating and amassing images, and from exactly how and on what the work is hung—but presentation does not simply vehicle meaning, it constitutes it. Even when photography—in the guise of the most carefully orchestrated shots—is the only means used in an installation, the temptation to categorize the artist as a "photographer," or the work as "photography," never even enters one's mind. By the same token, the pretty tales woven from color-pencil drawings do not emanate from pictorial practices: they are the exact equivalent of the photographs, of the lists of words and the hair— all "clues," as the artist christened them in an earlier series. Meaning is deciphered solely by interpreting a number of elements employed in what are sometimes contradictory variations. The central idea of the votive offering is superseded on numerous occasions by the more playful notion of the puppet. Other configurations would be produced using the same technique of suspension: spiral in *Le Bestiaire amoureux*

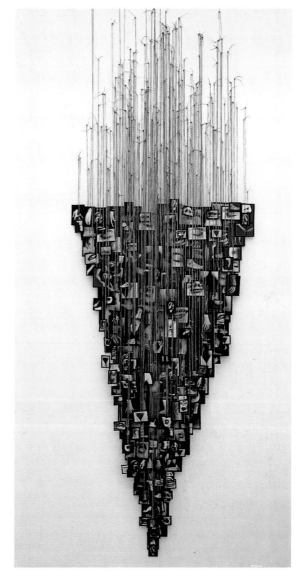

My Vows, 1988–89.
Photographs, string. 380 × 225 cm.
Musée de Peinture et de Sculpture Collection, Grenoble.

(Bestiary of Love, 1990), triangle in *Péché* (Sin, 1990), and the *memento mori* in *Histoires de robes* (Stories of Dresses). Whereas the twentieth century in general strove to cleanse picture-making of extraneous elements—such as frames, devices for hanging, pedestals, titles—so as to preserve the work's "aura" intact, Annette Messager has instead neutralized the image through duplication and promoted ancillary features. Her art is omnivorous in the sense that it escapes the borders of the image and extends beyond the frame, up the string, onto the nail or pin, and over the title, the whole wall, and into the exhibition space, overrunning it with interconnections.

Such hypertrophy of the tools of art, of its staging, or, better, of its architecture, finds a rare parallel in the art of the Middle Ages, and, more fleetingly, in Art Nouveau, which put it to more aesthetic use. Large-scale installations like *My Vows* and *My Works* are redolent of historic altarpieces, of ancient chapels. Indeed, Annette Messager's works adapt perfectly to religious settings, fitting into the architecture of such spaces as if they had actually been designed for them, rather than transported there (chapel at Saint-Martin-du-Méjean, Arles, 1987). The manner in which the artist uses areas situated at the limits of art as essential components in her work transcends aesthetics and theory, and possesses few points of comparison on the contemporary art scene. One might be reminded, in a very different register, of the overgrown frames produced by Robert Morris in the 1980s which reconfigured—with a strongly figurative bent—Symbolist retables in Art Nouveau Gothic. If formally quite distinct, in respect of the radical nature of the approach, Morris's work provides one of the closest equivalents to that of Annette Messager. More relevant in formal terms are certain Italian Arte Povera artists, notably Marisa and Mario Merz. Unlike a host of other practitioners working site-specifically, Annette Messager does not seek inspiration in the "genius of the place," since her ventures tend to create their own *locus* from the materials at hand, frequently working in spaces that are neutral or even starkly unprepossessing. The work creates its own "place" and imposes its architecture with equal success in the propitious space of a church or the standardized forum of the museum. In connection with *My Vows*, Sigrid Metken has written of "profane ex-votos," and it is perhaps not going too far to extend the metaphor and call Annette Messager's works "chapels," literally as well as figuratively.

My Vows, 1988–89, detail.

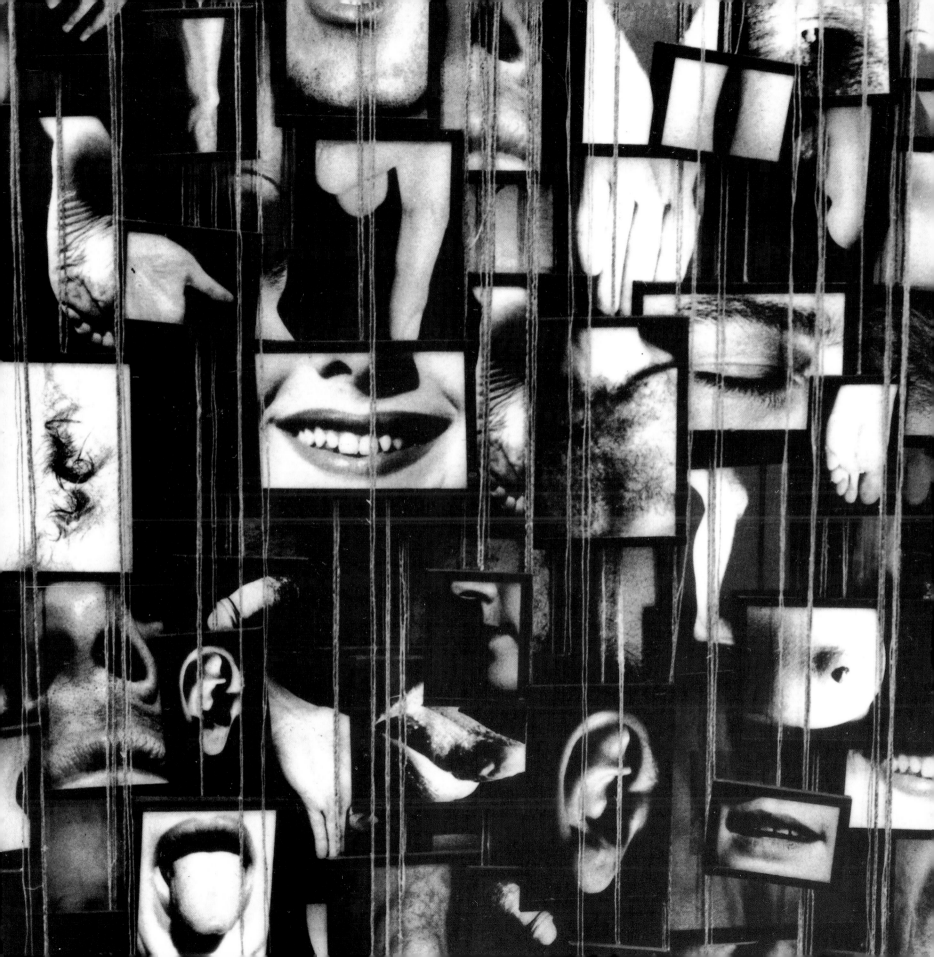

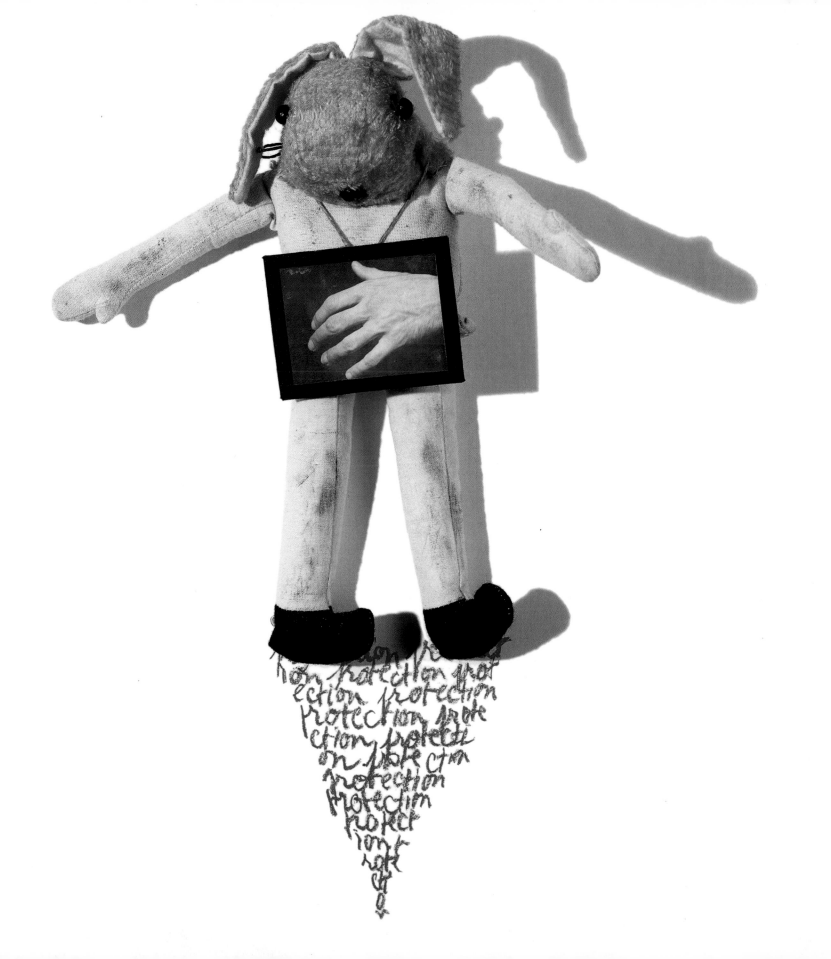

family stories

In 1988, preparations began for Annette Messager's debut retrospective to be held at the Musée de Grenoble the following year. The opportunity of revisiting her entire oeuvre, a process that entailed recapitulating earlier works, had a major impact on the more recent *Vows* and *Works*, which harked back to the *Collections*, and, above all, *Mes Petites Effigies* (My Little Effigies). The latter was a new series whose formal approach could be inferred from that of *My Works*, but whose stuffed animals presented in various scenarios clearly echoed *The Boarders*. Although it opened the door to fresh possibilities, the use of toys marked the reappearance of the notion of the doll, as well as of the animal-human metaphor. Pinned and suspended, skewered and flayed, these little figures—closer to the human world than the body-part photos could ever be—were to become a favorite source material for many series to come. In *My Little Effigies*, the animals are placed at set intervals along a wall in the style of an entomological collection. Projecting beneath them there extends a kind of shadow made of handwritten words repeated remorselessly, each animal being accompanied by a framed photo of a body part, often strung round its neck.

These stuffed toys exemplified a new operative component in Messager's work: the simulacrum. The title of "effigies" and the humanization of the toys, some of whom are even dressed in pocket-sized garments, carry connotations of magic. "In *My Little Effigies*, I hung photos of bits of the body around the necks of ordinary-looking cuddly toys on pedestals built up out of words. These ridiculous little creatures thus became disturbing, just like certain voodoo dolls."[17] "Ridiculous" and "disturbing" are specifically human qualities which both—though in very different terms—

My Little Effigies (Mes petites effigies), 1988, detail.
Soft toy, photograph, colored pencil on wall. Height 50 cm.
Musée National d'Art Moderne Collection, Paris.

My Little Effigies, 1988, detail.
Soft toy, photograph, colored pencil on wall. Height 40 cm.

designate a distance from the norm. Although today magic has lost much of the disquieting appeal it held in former times and in these works has been reduced to little more than an attachment to traditional folklore idioms, a genuine anomaly resides in the importance Annette Messager invests in these worn-out old toys, in the inclusion of their lifeless bodies within a symbolically charged environment. The semantic system stems not so much from the verbal pedestals or from the photographs of ears, eyes or sexual organs hanging round their necks like scarves, than from these animals manqués. Bunny rabbit, Mickey Mouse, Babar the Elephant—each creature conveys a different aspect of the human species, instruments in an anthropological study that taxonomizes every last detail of body and soul, limb after limb, emotion after emotion. Laid out in a continuous line against the wall, the piece resembles a scientist's test bench that can be extended *ad infinitum*: modern-day fetishes offering a résumé of a humanity severed from its sacred aura. For a show at the Musée d'Art Moderne de la Ville de Paris, they were placed in a vitrine in the company of a number of African carvings, where they appeared more paltry than ever, emblems of a world that has lost faith in everything, save in childhood.

CORPSES FROM CHILDHOOD

Soft toys were soon to acquire pride of place in Annette Messager's opus, as important perhaps as photography and drawing. Finding their way into *My Works*, as in the installation at Saint-Martin-du-Méjean, where they were housed in little cubbyholes of words, they are much like relics, expiatory figures that introduce a theatrical note into otherwise ornamental compositions. Hanging a picture of a questionable nature around the neck of some blameless cuddly toy taken away from a child as she outgrows it or pulled out from among the bric-a-brac at a flea market carries a strong connotation of morbidity, which the contrasting use of a black-and-white photograph from a scene in a fictional scenario only makes more intense. "For me the *Little Effigies* are mortal remains, little corpses from childhood to which people remain strongly attached."[18] Familiar-looking corpses they are too, like the stuffed animals she was to start using again around this time, and like the words endlessly recurring in the texts, repeated until they lose all meaning.

Another notion now became paramount in much of Annette Messager's work—that of sloughing off a skin: wearing frocks or gloves, sporting a mask or simply dissected, humankind is perceived though its envelope, the stages of its evolution seen as so many transformations of its epidermis. The predominant feeling is that it is impossible to know anything about what no longer exists, that Being is unintelligible and can only be comprehended through a multiplicity of fragments or through the intermediary of

My Illuminated Manuscripts (Mes enluminures), 1988, details.
Pencil and paint. Each letter 22 × 22 cm.

The Promise of the Little Effigies (La Promesse des petites effigies), 1990.
Vitrine, soft toys, framed photographs, writings.
Overall dimensions 225 × 169 × 14 cm.

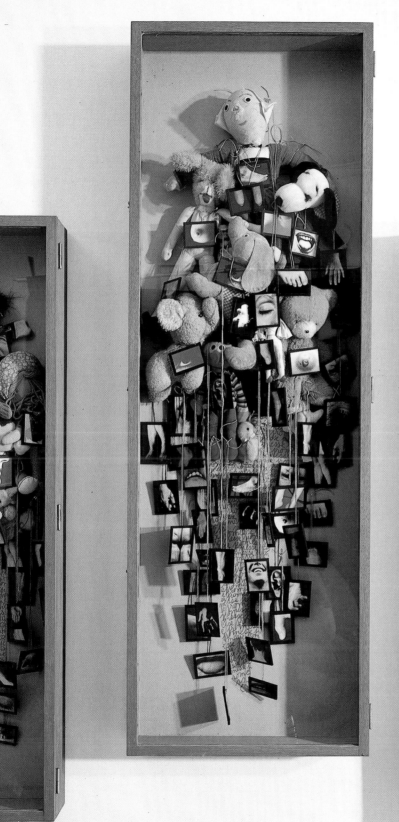
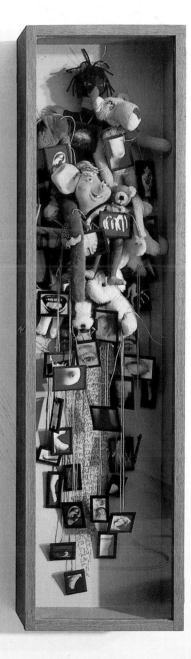

simulacra. Molting forms part of a particular register: signaling the death of a state of the living body—childhood, youth, virginity—it leaves behind it a residue (the plush toy, the wedding dress) into which the artist strives to breathe new life.

With photographic portraits thrown over their chests, the toys recall those assemblies of mothers—like the "Mothers of May Square" in Argentina—who march brandishing the effigies of their lost children. With the passing years, such portraits correspond to long-past stages in the lives of lost souls, who have been kept alive only by the determination of the mothers never to forget. The soft toys, on the other hand, as a dual projection of childhood, are decked out with the portrait of an adult organ, and thus have to carry the burden of an adult's death. The experience of death that is involved in every clean break and every shift from one state to another, that encumbers our lives with its repressed corpses, is here domesticated by the artist and settles into its rightful place in the everyday world. Thus her work, though sometimes tinged with morbidity, is never truly tragic, all dramatic tension being neutralized by the maternal feelings that surround her fetishes, her "things."

"ANSWERING BACK"

At the same time, Annette Messager's more positive side was expressed through other series that were infused with humor. *L'Attaque des crayons de couleur* (The Attack of the Colored Pencils, 1988) introduced a new element into her armory—the pencil, this time used as an object in itself. Stuck in the wall and sharpened to a fine point, the pencils are made to resemble weapons, arranged in battalions and organized into attack formations. This "pencil rebellion" (caricaturists imagined similar uprisings in the past) was made concrete in installations that reworked a schema very like that of *My Works*. Absurd yet playful, the pencil battle charge puts us face to face with an unexpectedly hostile and aggressive environment that is also, however, a patent spoof. Mimicking the self-referential attitudes of which the 1980s were so fond, Messager fell back on a tool that was scarcely used anymore except at school—although she had used it to draw all her little "paintings." *The Attack*, of course, provided yet another example of her predilection for pieces thrown together out of little or nothing, with materials found close at hand but employed in a counterintuitive manner. By multiplying congruent

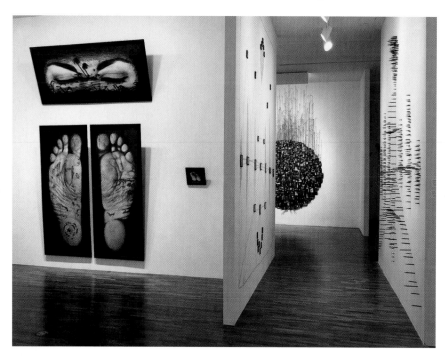

View of the exhibition at the Museum of Modern Art, New York, 1995: *My Trophies, My Works, The Attack of the Colored Pencils* (Mes trophées, Mes ouvrages, L'Attaque des crayons en couleur); at rear, *My Vows*.

The Bestiary of Love (Le Bestiaire amoureux), 1990, detail. Watercolors and string.

Sin (Péché), 1990, detail. Overpainted photographs and string.

elements, the artist transformed an object poorly adapted to functions other than drawing into a genuine "material," which was then arranged in multicolored compositions. These optical qualities that reconnect with the standardization of Kinetic art are invested with an intensity at once dramatic and comic. With its hackles raised against the viewer, the wall studded with pencils becomes a celebratory metaphor that shows the extent to which humor can inject new vigor into art and into the museum space.

Similar comic effects surfaced in *Mes enluminures* (My Manuscript Illuminations, 1988), a work that could easily have found a place in one of the *Collection* notebooks. In what is a reworking of the principle of ornamented medieval lettering, the illuminations for the alphabet each form the first letter of an uncomplimentary word. The fine gilt calligraphy of the "A" begins the word *âne* (ass), for example, and is composed of the animal adopting a somewhat improbable position; "B" stands for *brute*, "C" for *con* (damn fool), right down to "Z" which terminates the suite with *zéro*. All these pejorative expressions, including *voyeur*, *wasp*, and *yéyé* (teenybopper), are conveyed by flowery embellishments and illustrated with highly explicit images, generally with sexual connotations. The composition of facile and obscene sketches might appear a doubtful occupation for a woman, but such is the liveliness and lightheartedness that one is struck by the letters' ready wit. Once more, the artist has produced a cross between something "earnest"—a religious manuscript with its "regressive" features—and a book for children or young women that she has livened up with a copious helping of "cheek." Unlike the embroidered *Proverbs,* the unflattering terms used in *Mes enluminures* are those commonly applied to the male of the species, so that—going beyond the undifferentiated immaturity of childhood—the boot, sexually speaking, is placed firmly on the other foot. These "adult" (i.e. sex) stories remind us—be it with the softly spoken irony the artist knows so well how to adopt—that entering the world of adults also involves a crude, often aggressive, confrontation with the Other that even the carefully policed conventions of our time cannot stifle completely.

THE MUSEUM REINVENTED

The months that followed the Grenoble retrospective saw Annette Messager for the most part taken up with developing various series that she had already embarked on. The borrowings, cross-fertilization, and hybridization that affected each piece certainly had repercussions on the overriding principle of the series, but over time the main strategies of interrelation remained constant. *My Vows, My Works* and *My Trophies* endured as benchmark "families," within which new subjects or favorite

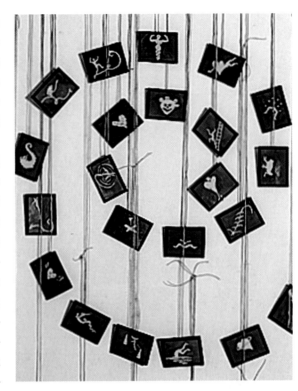

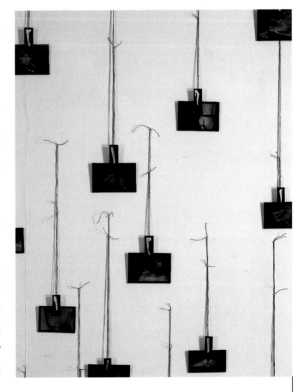

materials—the *carte du tendre*, the soft toys, the pencils—might become involved. Suspended units, wall pieces, and manuscript illuminations continued as the basic paradigms from which forms and meanings could be generated, leading on occasion to the creation of new sub-groups. Just as the *Bestiary of Love* had been a cross between *My Vows* and *The Map of Tenderness*, *Péché* (Sin) introduced into the same series reminiscences from *The Horrifying Adventures of Annette Messager, Trickster*; *My Little Effigies* derived from *My Works*; *My Manuscript Illuminations* and *The Lines of the Hand* from *My Trophies*; and *The Story of Dresses* introduced a new contextual element to *My Vows*, triggering a fresh series.

If filiation of this type is discernible in the work of many other artists, with Annette Messager it takes on a particular coherence and regularity over a large number of concomitant, parallel series. It is the product of a process of specialization that is translated into concrete terms through the various topologies to which each piece is assigned. This is reflected domestically in the increasingly complex multiplication and dissemination of studio spaces within and around Annette Messager's house. Each studio is devoted to a specific activity, with each new work being arranged on site before being installed in the exhibition space. Kept apart within the house, the various series are later juxtaposed within the structure of the museum. The order in which the pieces are integrated within the space of the exhibit is not predetermined, but the guiding principles are prescribed. *The Attack of the Colored Pencils* is to be placed opposite *My Works*; *My Little Effigies* shares a wall with *The Lines of the Hand*; several motifs from *My Vows* combine in a single large-scale installation. This approach is similar to that of Marisa Merz, for instance, whose pieces do not exist as separate entities, but are rather built up into a wholly new entity, since each new exhibition incorporates all the materials made by the artist. The division into series in Annette Messager's oeuvre, however, means that each piece possesses a self-governing logic that preserves the elements individually, the relationships between them resulting less in a feeling of totality than in a force-field of tensions. The concept of a total artwork, if tempting in the context of infinite proliferation and of an ongoing creative process, does not, however, correspond to the principles of division and demarcation of activities, nor to the duplication of different facets of the artist's personality. Her work is not powered by an overarching project but by an ever-growing number of sometimes contradictory plans, the viewers being encouraged to find their own interconnecting path. As with various chapels in a church or with a garden subdivided into different vistas, our impressions are contrasting, our experiences constantly new. Both the church and the garden are composite sites, with extreme variations in atmosphere, where organization into a single whole in no way clashes with the independence of the parts.

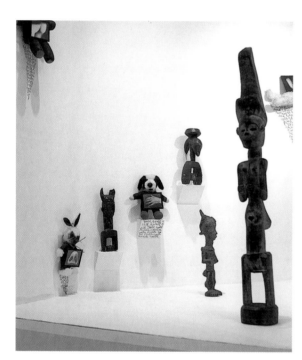

My Little Effigies and African carvings at the Musée d'Art Moderne de la Ville de Paris, 1989. Musée d'Art Moderne de la Ville de Paris Collection.

Annette Messager views the spatial arrangement of her exhibitions in precisely such terms. With scant regard for chronology, recent elements are often juxtaposed with older pieces as distinct but related entities. This also explains why the whole space is invaded by writings or by elements that hang or lie flat, that are affixed to the wall or stand in vitrines, all differently lit, the whole layout conveying a sense of carefully orchestrated disorder. In this sense, each new exhibition is transformed into a kind of personal museum, each component of which the artist oversees. Combining the exhibition practices of a fine art gallery with those of a natural history collection, she reconfigures the encyclopedic utopia of the museum and produces from it a uniquely individual type—the transient museum.

This reinvention of the museum is one of the more unlikely consequences of the way contemporary artists have questioned the normative authority of gallery institutions. Having entirely abandoned conventional structures and countered the model and the philosophy of the museum system, artists were at first keen to install works in spaces entirely foreign to art, borrowing models of exhibiting from other institutions as varied as the archeological site, the natural history museum, the advertising space, the department store and the flea market. The museum became a ready subject for parody, indeed becoming one of the favorite themes of the post-Duchamp period in the wake of the *Boîte en valise*. Marcel Broodthaers, Robert Filliou, and Claes Oldenburg, for instance, each developed ideas concerning the museum which led to proposals for "anti-museums." Other practitioners, such as Boltanski in his *Inventaires* or certain members of Fluxus, were to co-opt the convention of the museum as a place where artworks were validated, redirecting its authority onto everyday objects. The museum and museographical procedures more generally have become guarantors of the authenticity of the object, and now afford the precepts for the legitimization of artistic value. Unlike operations designed to deprive the museum of its power to certify authenticity, such artists proceeded by hijacking its power and appropriating the methods and tools inherent in the institution.

An echo of these reflections can be picked up in Annette Messager's early shows. She had already displayed her attachment to such box-like structures as conferred special status on the objects within them, whatever they might be, and she has regularly used showcases to present her works, notably in the case of *The Boarders* and the *Albums*. She has always chosen stands and cases similar to those found in museums. Whenever possible, these have been second-hand vitrines unearthed from museum storage or borrowed from natural history collections. In the handwritten explanations on the cards accompanying *The Boarders* and in the montages made for her catalogs that are included among other objects in the showcases, one can even come across the equivalent of the kind of pedagogical

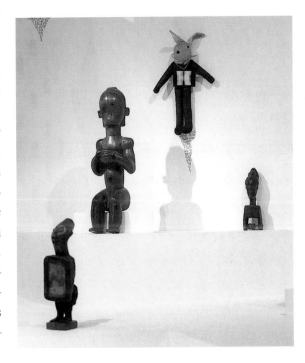

material popular in museums. In all these installations, the museum itself is treated as an exhibition object, by the same token as the artwork whose status it guarantees. Once complete, the process of "museification" culminates as an exhibit in its own right, though in a discreet fashion, without overdone demonstrativeness.

More recent installations by the artist have betrayed a more concrete, less theoretical, relationship with the museum space. Questioning the museum is no longer a transgression or even much of a challenge, and far-reaching transformations have led institutions of this type to abandon their position of authority, and increasingly adopt the trendier approach of the "art center." The museum hardly attracts attention from artists except in an iconographical context. In her exhibitions now, Annette Messager thinks less about the museum per se, although her work draws closer to the idea of the museum in general. Conveying a message, laying out a route that connects separate entities, spotlighting the value of individual objects while relating them to others, and developing from these interconnections a body of knowledge and enjoyment— these are all guidelines typical of museum environments, which she now co-opts for her own ends when setting up a show. The polysemic and heterogeneous nature of her work, the way it unfolds in different "collections," the deliberate confusion between image and viewing, the inclusion in the artistic process of all the parameters surrounding the work's display (including those that are customarily the preserve of the museum staff) and which are subjected to an ongoing revision that takes account of the conditions arising at each new exhibition, and finally the desire to forge interconnections between other works and, in consequence, to reflect how artworks are perceived as they circulate—all conspire together when the works are put on display to make for a very personal museum. This highly individual concept of the artwork *as* museum, not in the sense of doubling the outward form of a museum or merely using its tools, but in the integration of the museum project into the very constitution of the work, makes every Messager exhibition into a very special event, one that forms a latent, yet open facet of her oeuvre.

TWO-HANDED, FOUR-HANDED

The Castle Attic (Le Grenier du château), 1990, with Christian Boltanski. Sheet, wedding dress, photographs, drawings, embroidery, blood. 20 × 10 m. Musée Rochechouart.

On a few occasions Annette Messager has taken part in group exhibitions, and she has also collaborated on works with Christian Boltanski. Her very first museum exhibition in 1973 was a joint venture with Boltanski and Jean Le Gac, but the demarcation between each of the artist's works was clear. In 1975 in Venice, they produced a joint work with parodic overtones that recorded the ups and downs of a (mock) honeymoon. In 1976, the Bonn Rheinisches Landesmuseum staged a joint exhibition, "Model Images," at which the two series—Christian Boltanski's *Model Images* and

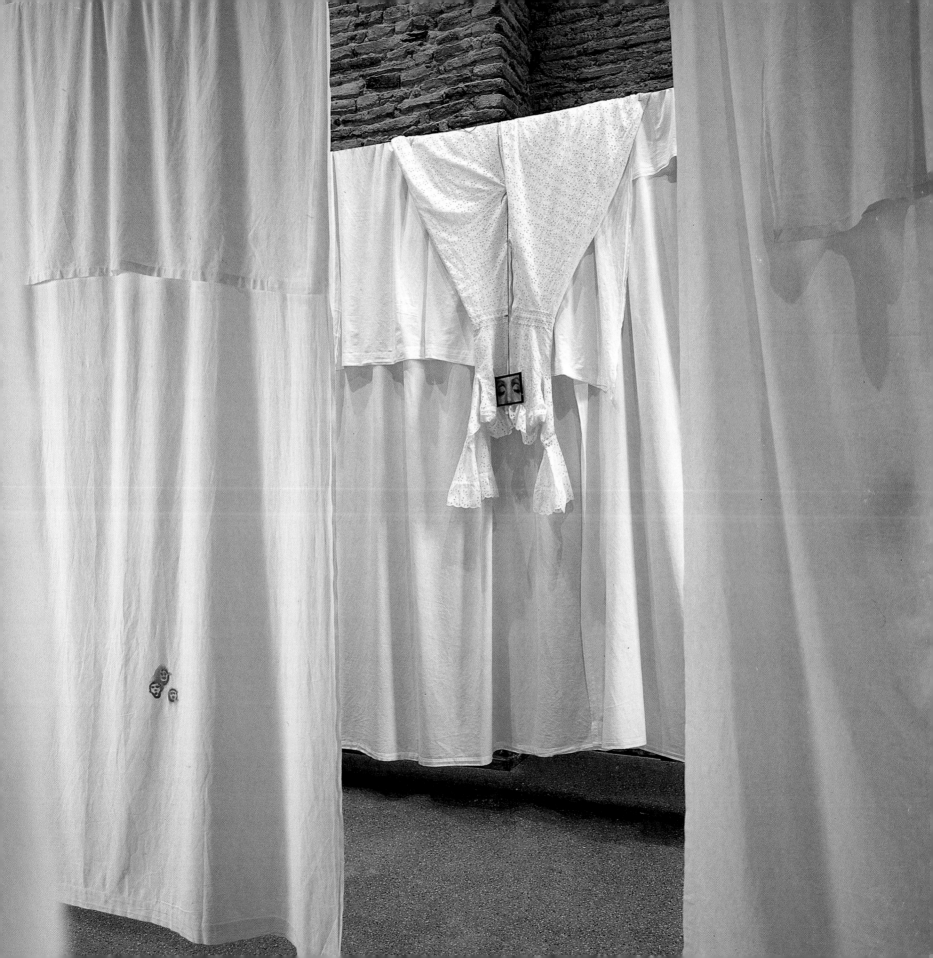

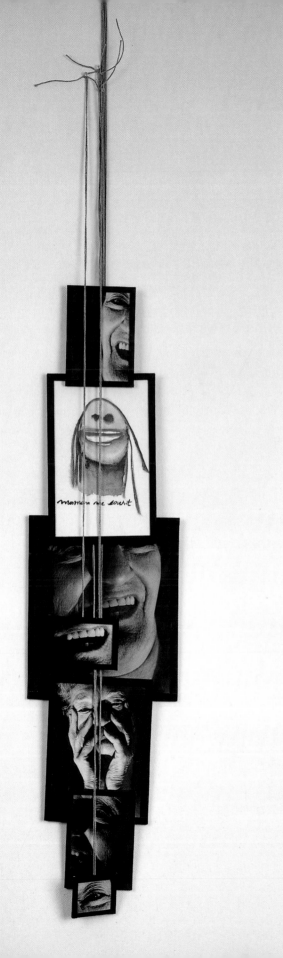

Annette Messager's *Happiness Illustrated*—were set side by side. Many years later, in 1990, the two artists exhibited together once more and made new interconnected works, some of whose elements were constructed jointly on site at the museum in Rochechouart. *Le Grenier du château* (The Castle Attic), a structure conceived specifically for the roof timbers in the museum, is composed of large folded sheets hung over a strut stretching across the attic space. From these sheets that are speckled with little drawings in blood hang various *Vows*, while tiny figurines and objects collected by both artists stand in nearby vitrines. This installation is a slightly anomalous work in Annette Messager's oeuvre, even if it makes use of many ingredients from her vocabulary. The familial, or more specifically household, appropriation of the loft by a generous expanse of sheeting, to which essential elements from her oeuvre are metaphorically connected, indicates a realm in which her work differs markedly from Boltanski's: the affirmation of femininity.

Links between the work of these two artists have frequently been highlighted and they have often been judged in relation to each other, though explicit comparisons are rarer. A first demarcation line between them appeared plainly in their early works. Femininity runs through Annette Messager's entire work, its essence oozing from even the most trivial stereotypes, and the construction by her of an artistic personality entirely determined by femininity feeds a narrative and creates a highly personal sensibility. Christian Boltanski's work, although it is not wholly free from the issue of sex and although it too employs a mock-autobiographical voice, starts out from very different principles. Identity is only crucial to Boltanski's work in that it lies at the core of a feeling of vertigo, that it is the focus of a mortal terror. Boltanski's world is predicated instead on an impossibility—the impossibility of identity, of bodies generally, of any construct. While Annette Messager gets to grips with the body—pulling it apart, turning it over, crossbreeding it with other entities and refashioning it with her own hands—Boltanski's work points to a void, to a vanishing act that only afterwards mutates into an identity. The formative works of both artists—*Collections* and *The Boarders* by Messager, *Vitrines de référence* (Reference Vitrines) and *Saynètes comiques* (Comic Sketches) by Boltanski—are at first sight close in spirit. They all make use of similar ordinary materials and similar vitrines, and all proffer elements for an imaginary autobiography. But these works already contain the seeds of an essential difference. Whereas Messager seems wedded to the domestic world, to the cradle, to the chosen realm of an oeuvre that brings the whole world back to itself, Boltanski manifests a desire to escape—be it through madness or lies. Throughout Boltanski's work, from the *Inventaires* (Inventories), *Suisses morts* (The Dead Swiss), and *Vêtements* (Clothing) up to more recent works, the everyday serves as a tomb in which every memory is buried, a trap which the world springs on the individual.

The contradiction between, on the one side, an intimacy that is created for one's own devices or for one's protection, and, on the other, something that is imposed and that functions as a trap, highlights two very different relationships to the world and to events in general. In one, the world is taken captive and transformed, prevented from clumping around the house unthinkingly; in the other, the house serves only as a sounding board, the better to drum out the follies of the world, its furniture and its contents that amount to little more than guilty accomplices of history. The correspondences, borrowings, and complicity that might be said to link Boltanski and Messager's parallel careers in fact simply show the heightened ambivalence characteristic of both bodies of work. The differences between two such singular artists, who are as implacable as they are close, will remain significant.

PORTRAITS

Up until 1990, Annette Messager's private life had had few direct repercussions on her work, the "false lives" of the artist having obfuscated the image of the real one. But in that year, she was willing to admit that two pieces—*Maman* (Mummy) and *Maman, histoire de sa robe verte* (Mummy, Story of Her Green Dress)—concerned the figure of her own mother. The first was in the discreet if direct form of a *Vow*-like portrait, and the second, more allusively, involved the use of a dress that had belonged to her mother, providing an autobiographical backdrop for the whole series of *Histoire des robes* (Story of Dresses). Memories concerning her father were rapidly invoked whenever she talked of her beginnings, her artistic discoveries, her interest in a type of Romanticism and in Art Brut. Her mother, on the other hand, was a more shadowy figure—self-effacing and resigned, preoccupied by a home intended for her husband yet possessed of great practical savoir-faire. Annette Messager's likeness, *Mummy*, is built up from a collection of photographs of her mother when old, hanging, like the *Vows,* in an unassuming column. It has all the appearance of a secret portrait, a phantom body studded with colorful amulets in no respect different from the other *Vows,* except that the face is a complete whole, for the first time unfragmented, its photographic truthfulness being captured by simple expressions, without theatrics, grimacing, or melodrama. *The Story of Dresses* has its source in *Vows,* its first concrete form being a piece itself entitled *Vow* (1988) that incorporates little pendants and photographs of fragments of the body hanging by strings from a highly ornate dress spread generously over the wall. In *Mummy, Story of Her Green Dress,* the work that inaugurated the sequence, a piece of clothing is used as a support for the "vows": spread out and peppered with tiny pictures, the dress appears under glass in a box and is exhibited on the wall like a painting. The box, which resembles cases built to

Mummy (Maman), 1989–90.
Photographs, watercolor, string. 220 × 24 cm.

store or exhibit ecclesiastical vestments, endows the dress with a relic-like aura that is reinforced by votive offerings of the most varied kind (photos, drawings of every sort) under which it is almost entirely submerged. As indicated by the reference to the artist's mother, the work can also be read as a proper portrait, one reminiscent of those symbolic representations that, through the use of various objects and clues pointing to a particular life, evoke a specific individual. The mother's frock, covered by a black veil laid over a green satiny ground on which the other items are arranged, is like an old portrait in halftone obscured by the veil—a keepsake-portrait. The photographs, ordinarily anonymous and of diverse provenance, all show the artist's mother, presenting fragments of a body in which one can make out her profile and her smile, as well as other facial expressions. As for the drawings, they are "children's drawings," tiny watercolors with captions that candidly convey an infant's view of her mother ("Mummy has had her hair cut," "Mummy is waiting for me," etc.) This worn-out dress chastely embodies a confrontation between childhood and death by dint of a relationship that, even after a protracted period, is still that between an aging mother and her infant. It is one of the most moving and dramatic of a series that throughout relies on melancholia and emotion.

Every story the dress recounts and every portrait it accords possesses its own distinct tonality. A black dress is laid out with ten ink drawings in the shape of a bone. A white frock is peppered with cut-out letters spelling the word *promesse* (promise). Another dress, green this time, is decorated with eight watercolor drawings of the heart. A blue one has dozens of colored-pencil drawings that depict various symbols of happiness. A pink and black frock is, on the other hand, accompanied by images of torture, while a white one displays the picture of a clown. All these elements hang from a piece of string attached to the dress by a safety pin. The whole is then enclosed in a long oblong case with a detachable glass cover, like a coffin. These boxes are presented, either fixed horizontally on to the wall, or else, as in a display at Trinity College Dublin in 1992, in which twenty or so dresses were exhibited, stretched out on the ground like tombstones. Reminiscent of saintly relics on which votive offerings or amulets might be placed, all reference to their customary use and to their place in the history of fashion has been expunged, leaving only a whiff of a bygone age, as if they had been recently exhumed from the catacombs.

This feminine social group composed of a rich variety of personalities, each with her own life story, ranging from the most joy-inspiring to the most harrowing, delineates the plural identity of womanhood. As in the "autobiography" of multiple personae presented in the *Albums*, or in the torn-up portraits of *Vows*, *The Story of Dresses* relates to an identity divided, evoking, through its many tableaux, a timeless feminine entity. Already, the detailed photographs of the naked body had signaled the

Story of Dresses (Histoire des robes), 1990.
Exhibition at the ARC, Paris, 1995.

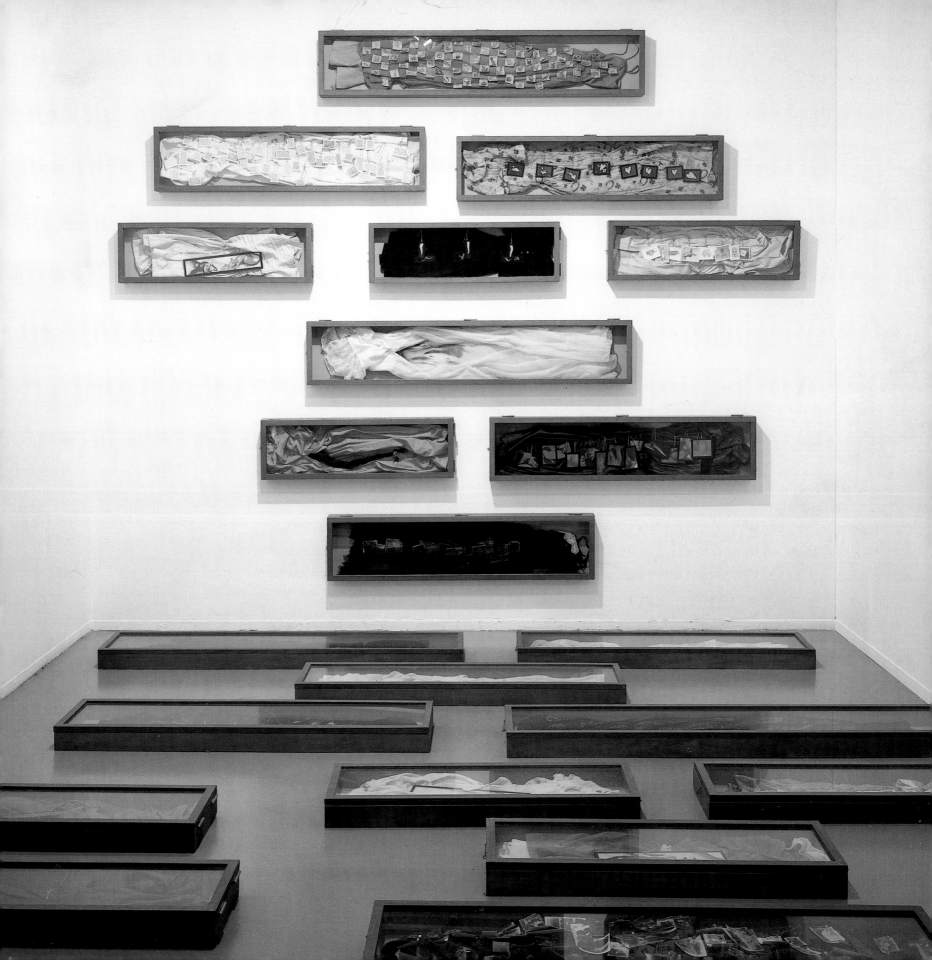

disengagement of the model from the dominion of time and had conferred value on each fragment as an original. The photographed palms are echoes of the handprints in the caves at Lascaux; the humanity associated with these powerless bodies, childish drawings, and stammering words is indeed timeless. Depriving a body of its clothes, extracting a word from a sentence, drawing a picture without the requisite technique, are acts that peel away, that lay bare, actions depicting mankind as stripped down to its essentials. The artist has replaced History with "stories," as at the time of the founding myths. The stories she tells resemble parables in the Bible, tales from *The Thousand and One Nights*, or accounts of dreams. *The Story of Dresses* is of the same family—stories about women that have been recounted in one unbroken thread since the time of Genesis, stories about Eves, both pure and impure, about Sardanapalas, about Lolitas, or about nameless females, wretched or more fortunate,

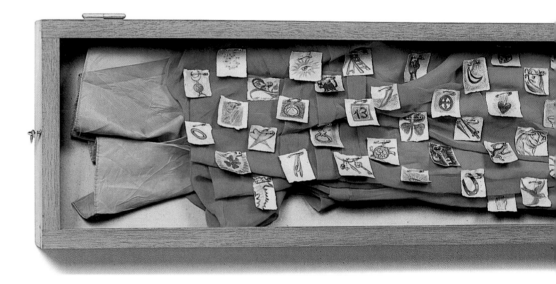

wreathed in smiles or spoiled by frowns. In some vitrines, the story almost smothers the dress: the one belonging to a woman who believed too blindly in happiness is covered with a latticework of drawings of four-leafed clovers, lucky numbers, and animal charms; the one for whom life was a torture chamber is bedecked with pictures of battered wives. Others seem to have little or no story to tell, such as the one with a parti-colored clown—dumping on life or dumped on by life? Who can say? Others have passed through their existence reciting a prayer: "Promise, promise . . . " The expression of femininity from beyond the grave, as in Al-Fayum portraiture, medieval tomb statuary, or Romantic Ophelias, is multiplied as if through a kaleidoscopic prism, each facet readily discernible, each detail as clear as day, the shadows and highlights

Story of Dresses (Histoire des robes), 1990.
Dress, colored crayons, vitrine, 30 × 160 × 9 cm.

Following double page:
Mummy, Story of Her Green Dress (Maman, histoire de sa robe verte), 1990.
Dress, photographs, watercolors, vitrine. 113 × 178 × 7 cm.
Indianapolis Museum Collection.

crisply drawn. These dresses are yet another example of Annette Messager's long-standing interest in studies of hysteria, in portraits of women whose life story is imprinted on their very bodies. *The Story of Dresses* is written on the skin. It utters what remains unspoken, things that can be confessed only in a place beyond consciousness, the minor dramas, the great sins of now disembodied women.

Typically, when in these works Annette Messager graces femininity with a sacred aura, it is done with humor, by exaggerating the pinched-faced religiosity of these remnants, by dramatizing the ready-to-wear relics. *Story* may express the essence of womanhood, but it does so with a half smile, with a tolerant eye for overdoing things, a liking for self-ridicule that parallels the dutiful efforts of a housewife as she indulges in a painstaking bout of tidying up. Everything conspires to confer on these works an anti-heroic cast in which no memorial function can survive, from the stories of

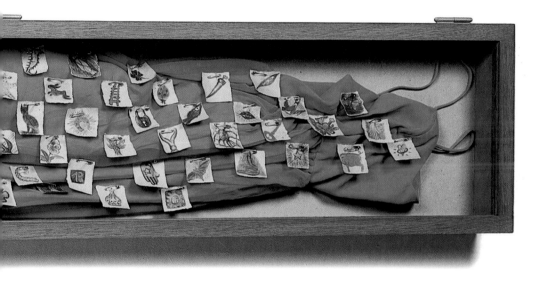

these women with their tawdry vices and virtues, their equivocal, piecemeal restitution, their presentation under glass laid out horizontally and not mounted on the wall. These coffins-cum-reliquaries put one in mind of a subterranean world: the atmosphere is straight out of the fantastic literature of Edgar Allan Poe. The premature burials, the exchanges of identity, and the fetishism that haunt Poe's *Tales of the Grotesque and Arabesque* find an echo in Messager's disincarnate identities awaiting new occupants, the swathes of past destiny unrolling over their shrouds. Her subsequent *Piques* series was a continuation of this macabre vein that relates to the "voice of strangeness" evoked by Stéphane Mallarmé, whose work, consummately realist in its inflexions, also contained fantastical undercurrents.

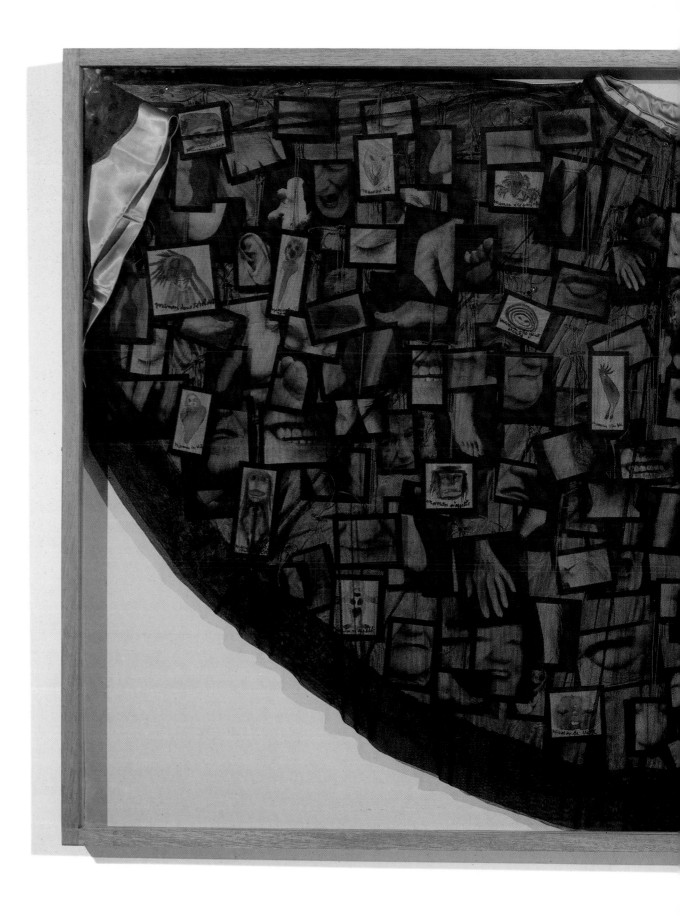

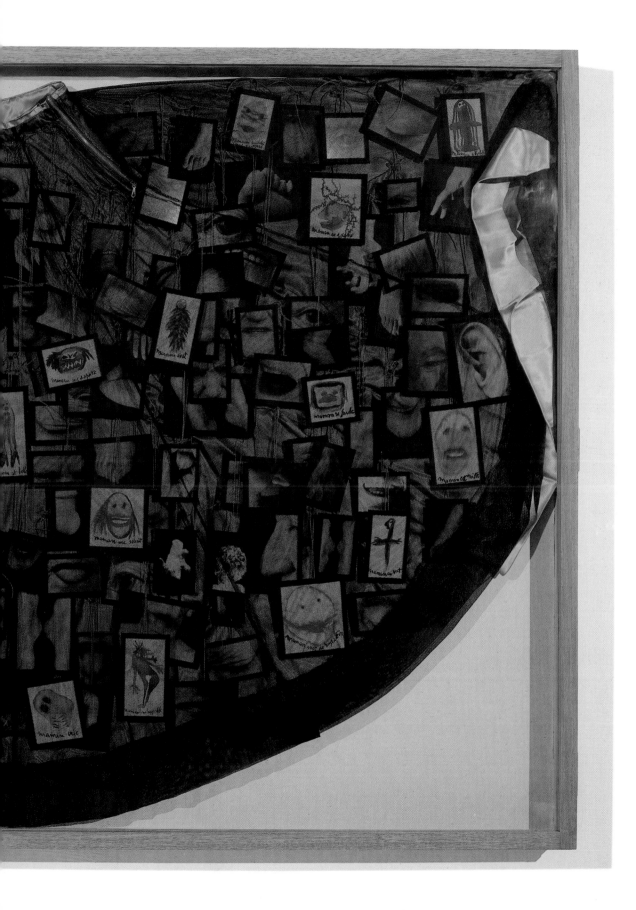

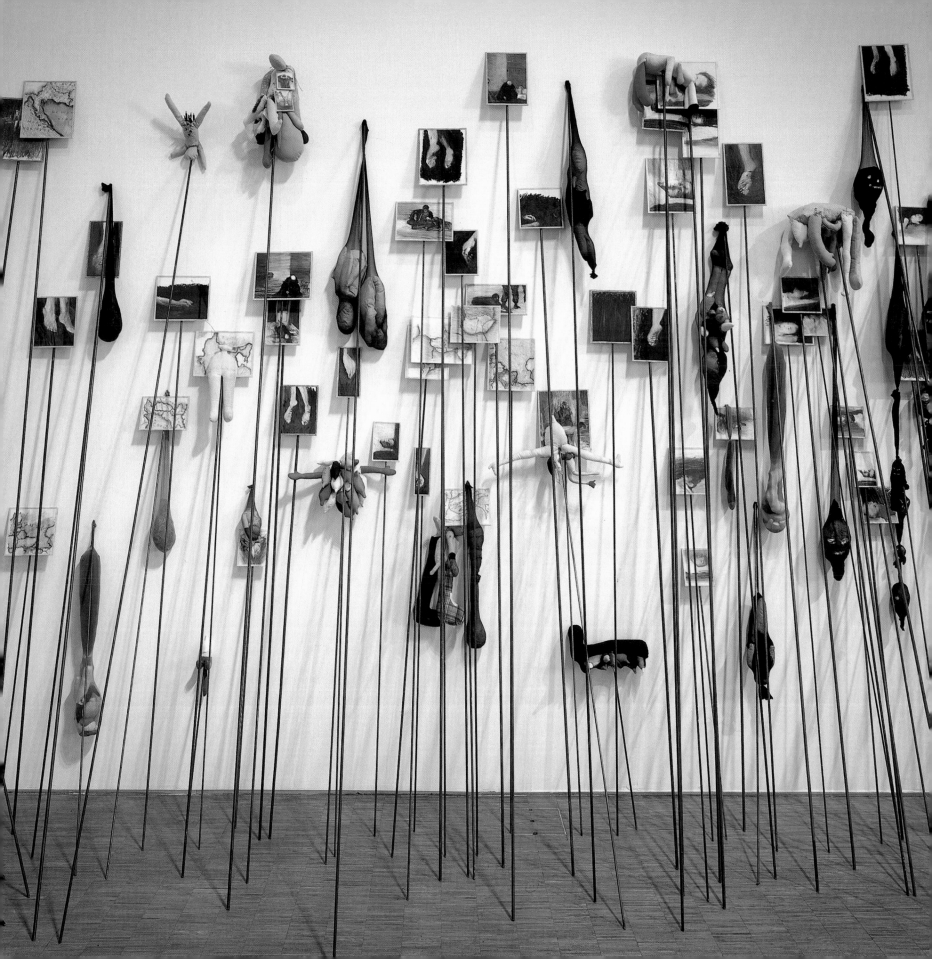

secret societies

Révolution, also known as *Les Piques de la Révolution française* (The Pikes of the French Revolution, 1991), was the first in a *Piques* (The Pikes) series that marked a dark and violent turning point in Annette Messager's work. The title alludes to the period of the Terror during the French Revolution, with its execution processions, impaled heads paraded through the streets, and end-of-the-world atmosphere, and introduces a dramatic touch which its other components do little to dispel. The pikes themselves are long metal staves on which various objects have been impaled: plush toys and stuffed animals in the opening sequence, then, in the large group of *Pikes* (1991–93), drawings, paintings, and other objects made by the artist—bloodthirsty images, disjointed bodies, and maps of places devastated by natural disasters. The dense mass of spikes and the images shown bring to mind all the nameless butchers of the period, just as the density of *Vows* suggested a mass of people pleading for their lives. With *Pikes,* Annette Messager began her exploration of the dark side of humanity, its farthest reaches, its soft underbelly. These images are variants on the themes of dissection, evisceration, and decollation reproduced after models taken from anatomical plates and photographic illustrations from medical textbooks. Others, news pictures she retouched, are on the more general theme of destruction and show battlefield scenes or bombers dropping their payload. The bodies made out of fabric are hybrids and their organs composite. Some of the legion of figurines which resemble monstrous rag dolls are stuck with colored pencils, while others droop like clusters of grapes, the organs simply pinned to the trunk. Others are clad in black stockings and impaled on the sharpened points. Other stockings, dangling ruefully like old wineskins, are shaped into grotesque, sagging heads, the mouth and eyes cut out to reveal an inner core of printed cloth.

The Pikes, 1991–93.
Musée National d'Art Moderne Collection, Centre Georges Pompidou, Paris.

The work has room for exorcism as well as for denunciation: errant humanity appears in the guise of a group of ghosts, exhibiting its wounds, cavorting in its fears. Victim and executioner are one and the same—there is no way of telling truth from falsehood or the afternoon play from the daily newsline. As in horror films, one cannot divorce one's disgust at the crime from the fascination it exerts—one can choose to identify with the creator or with the creature. The violence of the work teaches a salutary lesson: there is something epic in the sheer power of a subconscious given free rein and held up as triumphant against all-comers. The artist plays on this paradox, since on her own admission the poles were inspired by newspaper pictures showing demonstrators waving protest banners. Be it an image of liberation or oppression, such realist theatrics express above all the duality of a body torn asunder by power and impotence, dependence and independence—a theme the artist would return to on numerous occasions.

FROM THE BODY TO THE SUBJECT

The Pikes provided the artist with an opportunity to present a number of new types of figure: chameleon-like dolls, purpose-made, sewn, and stuffed, of every imaginable shape, from the easily recognizable to the most hideous; threatening, hallucinatory bodies resembling multicolored balls of wool punctured with pencils; humanoid-looking stuffed tights, like eviscerated innards or a face in a stocking-mask. The images too become more diverse—hand-copied illustrations, geographical maps, and images of war or of the homeless. Above all there would be more pictures taken from newspapers and magazines and reworked, colored in or scribbled over, sometimes to the point that the original illustration is unrecognizable beneath an "excess of figuration." In formal and interpretative terms, they convey a new complexity that would have major repercussions on her subsequent work and result in the creation of new "subsets." With man, it is now the whole realm of the social that joins the disturbing cortege and plays its part in a sinister modern-day Dance of Death. For the first time, Annette Messager's fictions were affected by political and social events. Human conflict is illustrated by images lifted wholesale from the news media and doctored. The switch from a purely domestic dimension to a more sociopolitical one is also conveyed by the pikes themselves. Connected, not perhaps to any one event, but to the prevalent and increasingly inflammatory social unease of the 1990s, this new openness redirected the artist's creative energies toward themes with more direct links with the community and with social interactions, in which stuffed animals, cuddly toys, and bolsters would be used as substitutes for human beings. Each of these ersatz beings vehicle not so much the

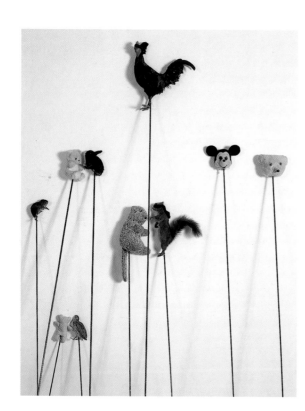

The Pikes of the French Revolution (Les Piques de la Révolution française), 1991, detail.
Metal poles, stuffed animals, soft toys.

affirmation of a body as that of a subject: figures of the body therefore become more allusive and increasingly monstrous as they inform representation and then become its object. In *The Pikes*, it is a passive subject, a victim, one which nonetheless retains its own identity, its components each serving to designate a particular feature: the body without a trunk, a body with ten legs, with breasts, with bristling pubic hair. The group forms a crowd of figures that can be distinguished one from the other and can moreover be organized into "families": for example the stocking family, the family of figures made out of cloth, the family drawn in pencil. This reconfiguration of the social body, each of whose members possesses its own specific attributes, would prove to be the principle underlying many subsequent works in which the models of the secret society and the family predominate.

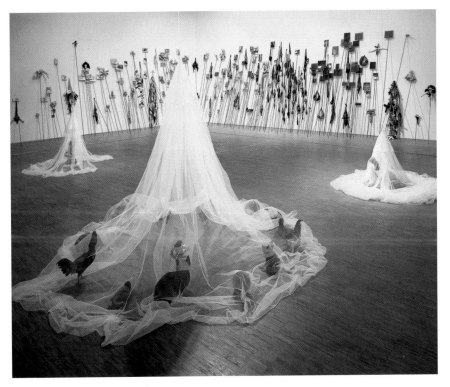

In their 1993 presentation at the Centre Georges Pompidou, the by now dense forest of pikestaffs laid along two long stretches of wall was accompanied by several groups of figures beneath broad bolts of white tulle placed here and there in the vast hall (*Les Moustiquaires* [The Mosquito Nets], 1993). Resembling a close-knit group of conspirators, the various ensembles each feature a different stuffed animal—cat, duck, rabbit, cockerel—their heads swathed in a balaclava. In the midst of each party sits a piteous-looking soft toy, a victim or the accused awaiting its verdict. The flowing net that cascades over the figures, the grotesque and comic appearance of domestic animals wearing face masks out of which peeps a beak, a pair of ears or a snout—everything suggests a parody in the manner of George Orwell's *Animal Farm*. This farmyard rebellion offers a counterbalance to the more harrowing uprising taking place among *The Pikes*. Parody, satire, gorefest, horror show—the artist plays every trick in the street theater book in her dress rehearsal for an updated *Human Comedy*. Once more, everything is transposed theatrically, the stage being set for a sequence of tragicomic tableaux in which both artist and creation are protagonists.

The artist's thespian vein that surfaces in her liking for unrealistic, special effects cinema and which feeds much of her work is not simply the flip side of a sense of realism. If, at the moment of representation, the real body is indeed replaced by a puppet of sorts, it is only because the truthfulness of the latter is still more radical: the puppet does not playact—the puppet *is* the figure, corresponding visually to

The Pikes; The Mosquito Nets, 1991–93.
Exhibition at the Centre Georges Pompidou, Paris, 1993.

a specific psychological or behavioral type to an extent that no real body could possibly achieve. The puppet is a signifying body, whether associated with an identifiable referent, as is the case with animals endowed with human qualities that remind us of ourselves, or else created like the "homonculi." It is a refinement new to Annette Messager's palette that conveys composite characteristics. The puppet is a mental construct, the incarnation of the delirium the soul instills in the body. It restores one to hidden truths and voices intentions yet to be realized. An instrument of analysis, it enters the core of substance, projecting the interior toward the exterior, a vessel for every humor. The fact they are handmade—stuffed, padded, and sewn up—confers unique status, a special corporeality, on the figures. Even when the artist exaggerates their hybrid nature or stresses the effects of grafting and proliferation, they still retain their individuality, and become more suggestive in character. They are akin to a mutilated human body that manifests pain through a missing limb and expresses the physical fragility that a complete body conceals, while yet remaining a body. In fact, beyond the horror of amputation, it is more than ever a body, recomposed, reduced to redundantly expressing just one of its parts that finds itself filled with the spirit of a naked, unadorned humanity.

THE THEATER OF THE WORLD

"Happiness," the artist has claimed in reference to *Happiness Illustrated* and her earliest *Collections*, "can only be talked about in clichés."[19] These works rely on the conviction that one can only address the question of human relationships through the theater. *The Pikes*, although initially denoting the staves that impaled the victims, can also be seen as sticks used for puppets standing in the wings patiently waiting for the next stage appearance. Succeeding works took this connotation a step further. In one amusing family, *Gants dans les piques* (Gloves in the Pikes, 1991), for instance, the figures are made by cutting a pair of eyes and a mouth in the palm of differently colored stuffed gloves, the fingers arranged into a punkish hairdo. *Je* (I, 1992) returns to the principle already used in *Vows*: a face is reduced to just three photographs, the two eyes and the mouth, fastened to three staves laying across each other in a triangle. It is easy to imagine someone picking up these sticks and performing a comic sketch, the eyes staring out blindly in different directions, the mouth silent. In a similar vein, she created works incorporating strange animal groupings that refer more directly to stage productions: in *Les Masques* (The Masks, 1991) and *The Mosquito Nets* that followed, one stumbles across a clandestine gathering, reminiscent of both an arcane ceremony and a trial. Although there is no stage set to speak of, the circle of animals wearing the

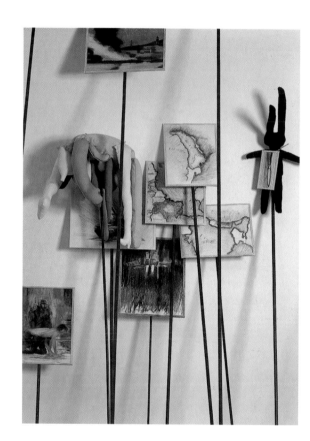

The Pikes, 1991–93, detail.
Metal poles, fabric, colored-pencil drawings.

balaclavas that make them look so human are arranged in a way evocative of human actors interrupted during a performance, stock-still, the words expiring on their lips.

These works evolve in a world in which time's advance is suspended; not in the undefined and immemorial temporality typical of *Vows* or *Works*, but where time has simply stopped. "I think that today, the theater hardly exists at all, but painting has become more and more theatrical. It is not a play as such, but fragments of a drama, an installation."[20] The artist deliberately places her work under the aegis of "representation"—not representation as in "painting," but representation as in "dramatic performance." This shift in the mimetic field toward theatricality has parallels in a corresponding mutation from the flatness of painting to the third dimension of space—an arena formerly the preserve of sculpture proper—the earliest effects being discernible in *The Pikes*, and confirmed in *The Masks*. The masks are installed directly in the exhibition space, between the public's feet as it were, figures over which we tower as over a miniaturized human population, whose lives are suspended in a kind of *tableau vivant*. The work marked the first time that the artist had exploited such obvious differences in scale between viewer and exhibited doppelgänger. The soft toys and stuffed animals, now laid out on the gallery floor, are absurdly small and vulnerable. The situations shown seem both comic and ridiculous—all the more so since their theatricality is accentuated. The mere sight of their supposed leader—a little squirrel rearing up on his back legs—is enough to defuse any drama lurking among the huddle of masked figures, providing a caustic satire of the "terrorist" behavior fostered by the dynamics of the group. Viewers are called upon, literally in fact, to "rise above" the reality represented over which they soar like giants. This Gulliver-like view turns one into an observer of a humanity that is both powerless and fragile, a humanity that wastes its life in internecine strife (like that between the sect in Swift who advocate starting an egg at its point and those equally committed to the round end), in what is a simple transposition of daily life. It should also be remembered that in Lilliput, the animals talk and are endowed with superior powers of reason to the human population.

VOYAGE AROUND A ROOM

The idea of displacement noted earlier as providing a possible metaphor for a philosophic journey into an "animal society" met with further expression in *Les Bâtons de pèlerins* (The Pilgrims' Staffs, 1992). An offshoot from *The Pikes*, the staffs are comprised of sticks from which hang little cushions resembling small

The Pikes, 1991–93, detail.
Metal poles, fabric, colored-pencil drawings.
Tate Gallery Collection, London.

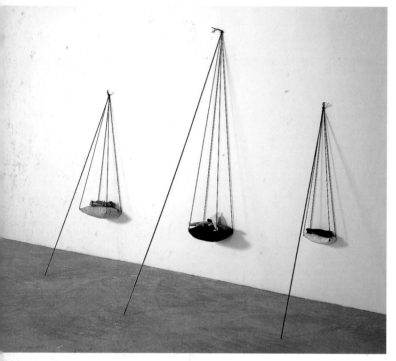

shrines. On each cushion lies an amoeba-like form bristling with pencils (one, made of a skein of cloth stuck with pencils, reminds one of the Crown of Thorns). This new family of fabric creatures harks back to an extremely primitive life form. In subsequent installations, they would be arranged on the ground like a colony of animals, but in their first manifestation they looked like strange multi-colored gifts or jewels. The allusions to pilgrimage make the protozoan repositories seem all the more precious; they transport the viewer to distant lands of Oriental sensibility, or to a world of unfamiliar creatures. Brought back home as valuable relics, these monstrous primordial forms—with their pedestrian allusions to art in the form of the pencils that transfix them—are a caricature of the very idea of a "spiritual journey," undermining all ambitions to shake oneself free from the cares of the world and run off to a place where what awaits are one's own imaginings. Once more, it is the notion of a "voyage around one's room," or even of a voyage through one's subconscious, that comes to the fore. Unity of place and time once again provides a basis for a theatrical principle. On seeing these stripy creatures reposing on silky cushions suspended from four lengths of twine attached to a metal pole like a kind of censer, the viewer has a fleeting vision of the painstaking, almost ritualized operations such an arrangement demands: the mind wanders to a procession of pilgrims and one imagines the action taking place in an imaginary world. Unlike the static *Vows*, these works have a dynamic force that represents an action, an interrupted act that meant the staffs were left behind and now wait to be taken up again. The uncertainty of their situation—before or after movement?—and the indeterminacy of their nature bestow on them a special status: as objects which have to be handled mentally, they encourage dreaming and spur the imagination. Such mediation allows viewers to slip out of their own personality and into the story, to answer the "invitation to the voyage." This metaphorical invitation to the spectator to intervene and breathe life into the voiceless objects will, in later works, take the form of a universe that can be bodily penetrated.

The Pilgrims' Staffs (Les Bâtons de pèlerins), 1992.
Cushions, fabric, colored pencils, metal poles, rope. 250 × 400 cm.

Untitled (Sans titre), 1992.
Installation at the Galerie Chantal Crousel, Paris, 1992.
Fonds National d'Art Contemporain Collection.

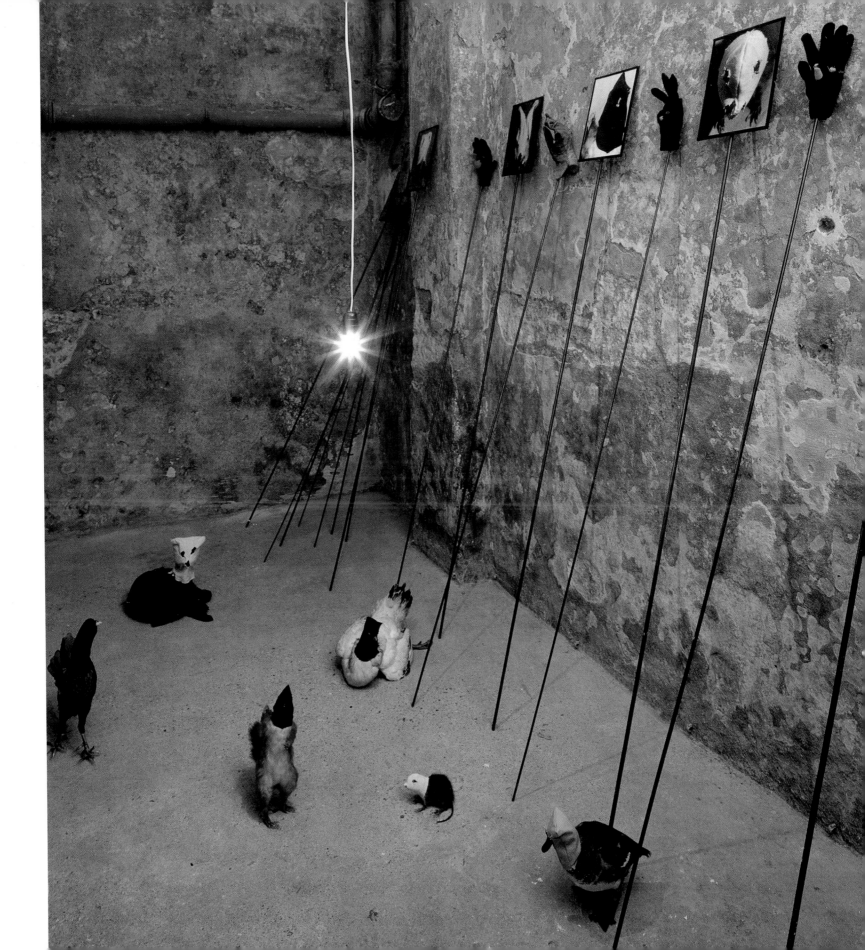

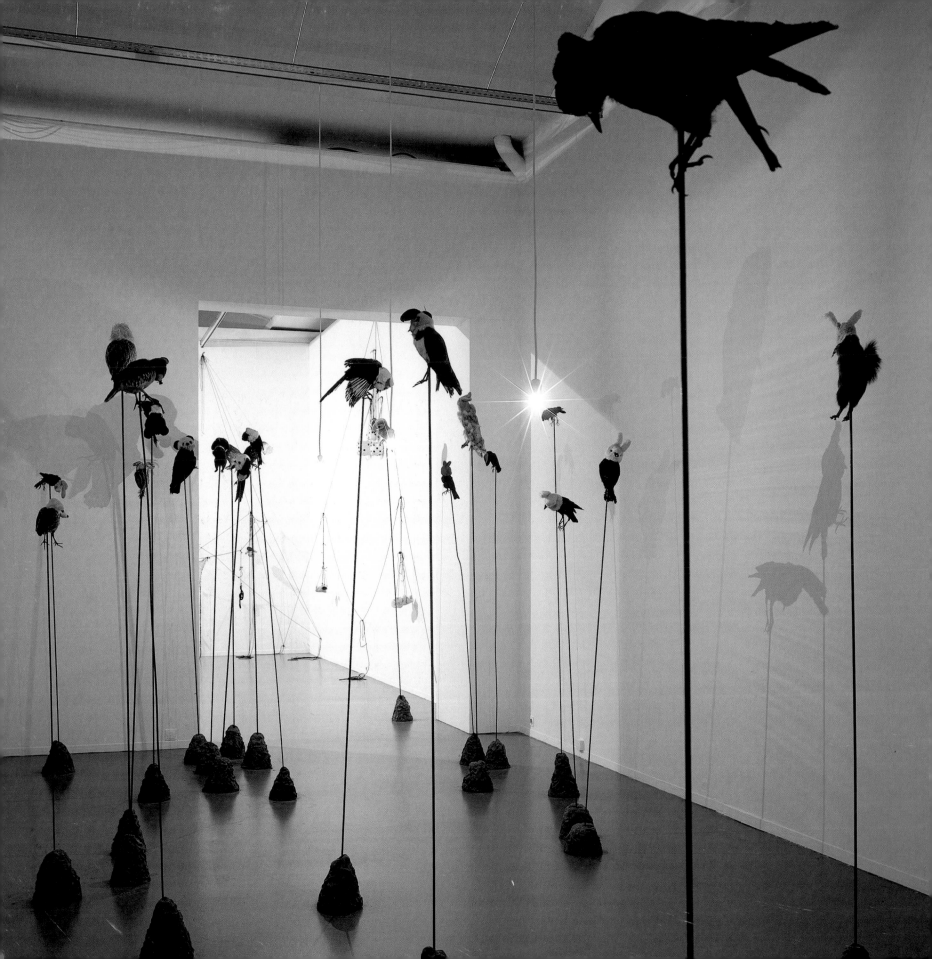

body and decor

Anonymes (Nameless Ones, 1993) was the first piece by Annette Messager which the viewer was expected to enter physically, requiring the participation of their whole body. The work is composed of a group of hybrid animals constructed out of stuffed bodies topped by heads taken from plush toys and stuck on metal poles planted in little heaps of earth scattered over the exhibition space. The viewer cannot take in the whole piece without entering it and making their way between the vaguely menacing and somewhat morbid figures. Exhibited in relatively subdued lighting, the forest of staves is like a substance that engulfs the viewer, the hellish figurines submerging them in their shadows.

This rather macabre experience—a contemporary equivalent of visiting Goya's "House of the Deaf Man"—was to be reconfigured in later works of an equally somber and oppressive ilk. In *Pénétration* (Penetration, 1993–94), the viewer is permitted to wander between various internal organs and viscera made of material hanging from the ceiling on lengths of string. If the colorful hue and silky texture of the fabrics dilute the installation's gruesome feel, the drooping forms, the horrifying organic quality of the hearts and veins, kidneys and intestines, their shadows dancing as one brushes up against their soft bodies, fuse to create a situation of indeterminacy, unease, and discomfort. In *Penetration*, the sensory experience proposed by Kinetic art and the phenomenological approach of many Minimalists is replaced, or supplemented, by a psychological ordeal. The viewer is asked to enter into the substance of the work, to meet its instability and contingency head on, even though the material itself may be no more than a dissemination of his or her own body, a projection of the intimacy of the ego into a public space.

Nameless Ones (Anonymes), 1993.
Stuffed animals, heads from soft toys, metal poles, lamps, mounds of earth.
Overall dimensions 10 × 5 m.
Musée Cantini Collection, Marseilles.

Nameless Ones, 1993, detail.

In *Dépendance Indépendance* (Dependence Independence), this type of experience reached new heights. Here, the introspective approach is no longer confined to the exploration of an organic body, but opens the door to the depths of the unconscious. Deep within the obscure abyss, one discerns a host of what appear to be blood clots in suspension: organic forms, an assortment of cloth, wool, or tulle, banners carrying inscriptions, colored pencils, photographs, numbers, substances stuffed into nets, plastic bags, stockings, etc. The swelling mass—evocations? ghosts? memories?—is almost impenetrable; moving noiselessly, it totally absorbs the body of the viewer. Images from *Vows*, words from *Works*, the harpooned marionettes in *Pikes* are here swept up into a Dance of Death that reaches from floor to ceiling, the whole space forming a sanctuary, penetrating it like a quasi-religious act.

AN ART OF "LEFTOVERS"

Although it was to find its culmination in the pieces mentioned above, the total invasion of space by the artwork had already been foreshadowed in earlier pieces. From this point on, however, this process was to become the guiding principle behind entire exhibitions that were envisaged as one vast single "penetrable." The major retrospective she prepared at this time for the Musée d'Art Moderne de la Ville de Paris (held in 1995), entitled "Faire Parade," was basically designed as one huge installation incorporating early and more recent works that fused elements from various series and then rebuilt them into a whole, reworking the trademark elements into a new choreography. Employing a culinary expression which translates as "rustling something up," Annette Messager herself referred to an "art of leftovers": "More and more, probably because I am having increasingly to confront the passing years, I work with leftovers from my leftovers. I take an element from a series, *Chimaeras* or a photo from the *Trophies* cycle, and hang them above an area of netting, I enclose them, protecting them again. There are elements such as large cushions stuck with color pencils juxtaposed with stuffed birds dressed in Barbie doll-type clothes. Everything is cobbled together, bits and pieces are entwined on string or thread, like in the circus where people handle ladders, cables, nets, and trapezes—it all seems thrown together out of odds and ends, without technical virtuosity, to suggest something of a regression, or perhaps an absence of progression."[21]

The whole exhibition was presented as if it were the synopsis of some far larger performance, as suggested by the word *parade* (parade, show, display). This new formulation of the exhibition concept, abolishing time, unifying space, and upsetting the accepted norms, undermines the whole concept of the "retrospective," since for Annette Messager it remains "in progress" and made up of pre-existing elements

Annette Messager setting up *Penetration* (Pénétration), 1994.

Penetration, 1993–94.
Various fabrics, rope. Overall dimensions 20 × 15 m.
Installation at the Monika Sprüth Galerie, Cologne, 1994.
National Gallery of Australia Collection, Canberra.

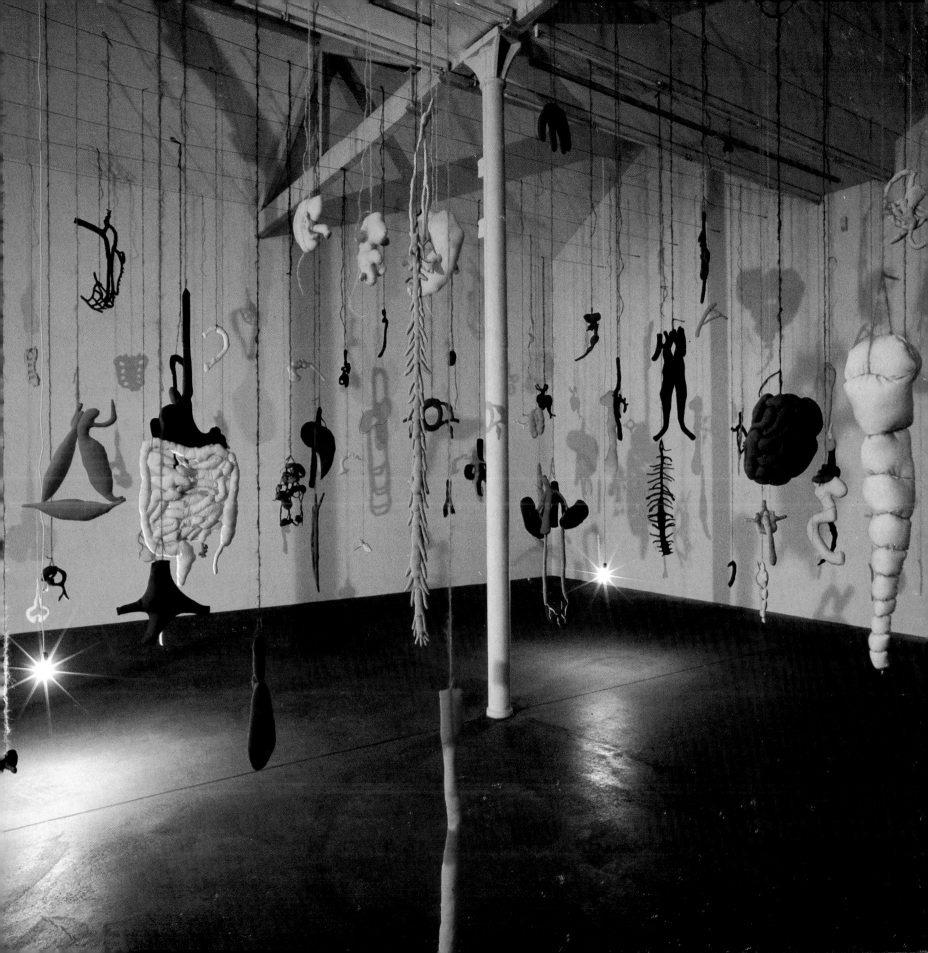

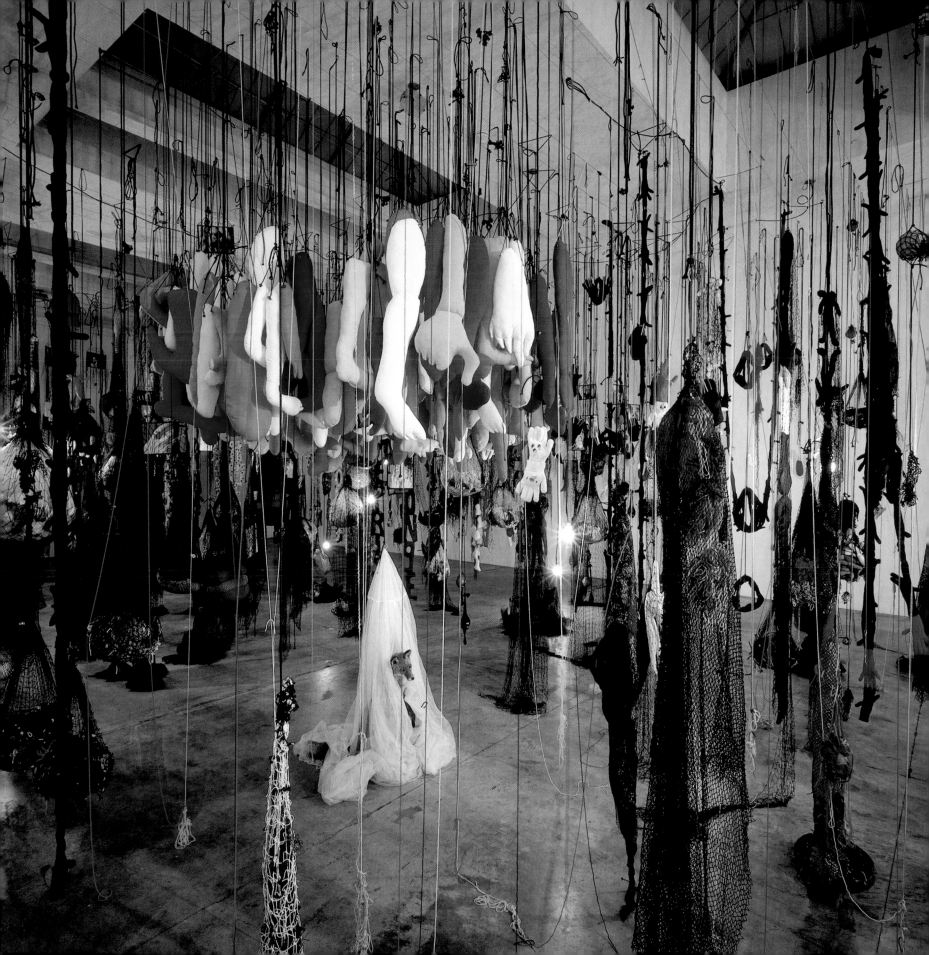

which will reach completion only at some future date. This indeterminate state, to which the artist referred in talking of "rustling up" a work from the odds and ends "left over" from earlier pieces, is a way of holding the exhibition in abeyance and relates to an idea of deferment inherent in the works themselves. As in a theatrical production, especially in the circus to which the artist refers, the here and now is what counts, repetition is far from certain, and the danger of falling is in direct proportion to the magic of the moment. Unlike her earliest works, in which fiction threatened an insidious takeover of reality, her more recent ventures leave illusion prey to attack from the here and now. The whole exhibition is a *tableau vivant* in which the works furnish both actor and decor. The lack of differentiation between body and backdrop first introduced by the penetrables makes both work and exhibition into a single, gigantic organism that communicates with the world through a kind of osmosis as the visitors come and go.

DISCONTINUITY

The "Faire Parade" installation featured an original element that very soon became crucial for the artist's future work: black netting. Made to both capture and defend, to veil and unveil, to stand for both mourning and protection, this surfaceless material, in covering objects or circumscribing space, can also lay down symbolic barriers between viewer and artwork. By protecting the piece from the visitor's gaze, by filtering without destroying vision, the artist introduces a vector of antagonism into the viewing and enjoyment of a work. Thus the most eye-catching component of the "Faire Parade" installation, and one which supplied the keynote to the whole exposition, was paradoxically an element that hindered viewing: a stretch of netting that ensnared the telltale soft toys as they teemed forth, pouring out of an inaccessible room through an open door that gave onto the exhibition space, before snaking along the floor and forming little heaps. The netting entrapped an organic mass of multicolored forms, enmeshing and concealing them under one vast dark cope. Above, suspended from poles, were various types of figures: gruesome effigies made from the same stuffed black stockings seen in *Pikes*, photographs of grimacing children sporting wigs, or outlines derived from *Chimaeras* (keys, scissors, stars, etc.). The net introduced an immediate sense of interposition and opposition. "The black netting protects and hides the secrets in order to show them better."[22] Once again, the artist had laid down a frontier enclosing a territory filled with meaning. As always the truth of things is stated on the surface, and meaning is superimposed on matter.

In *Jeu de deuil* (Game of Mourning, 1994–95), a coarse-mesh net cascades like a waterfall over a wall and floor installation of *Vows* combined with stuffed toys. Due to the

Dependence Independence, 1996.
Stuffed animals, photographs, woolens, ropes, fabrics, netting.
Installation at the Gagosian Gallery, New York, 1997.

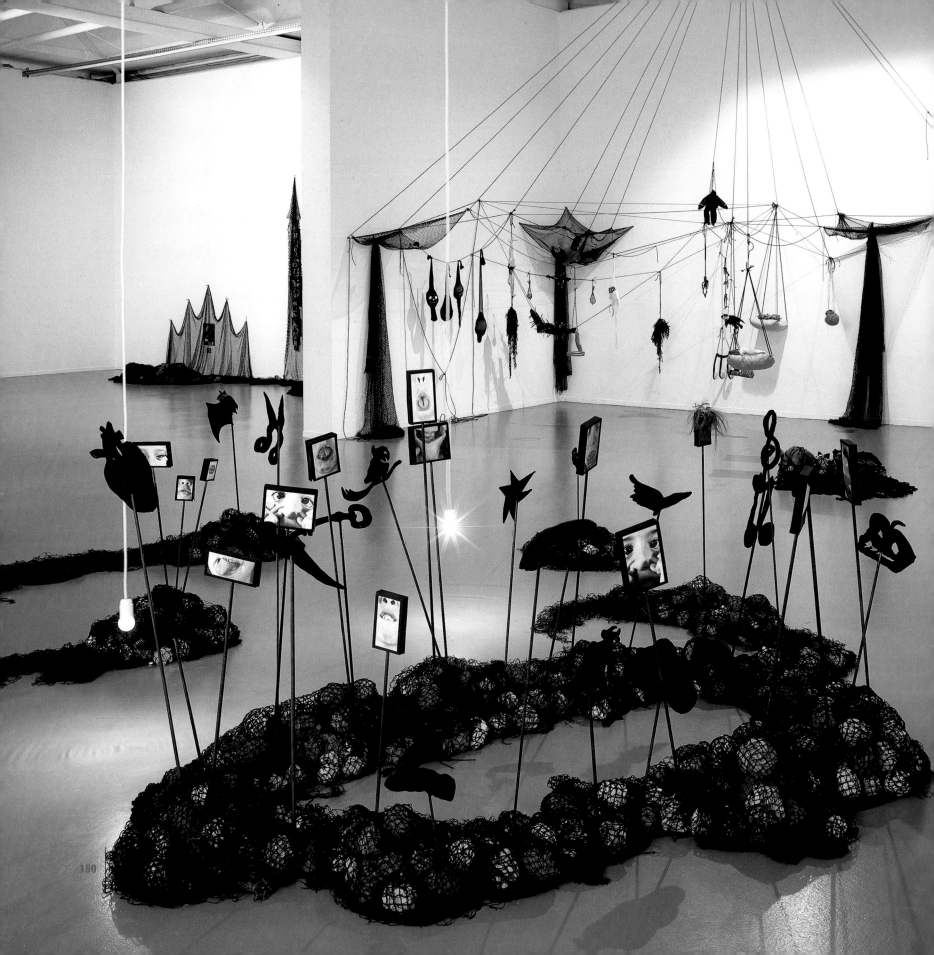

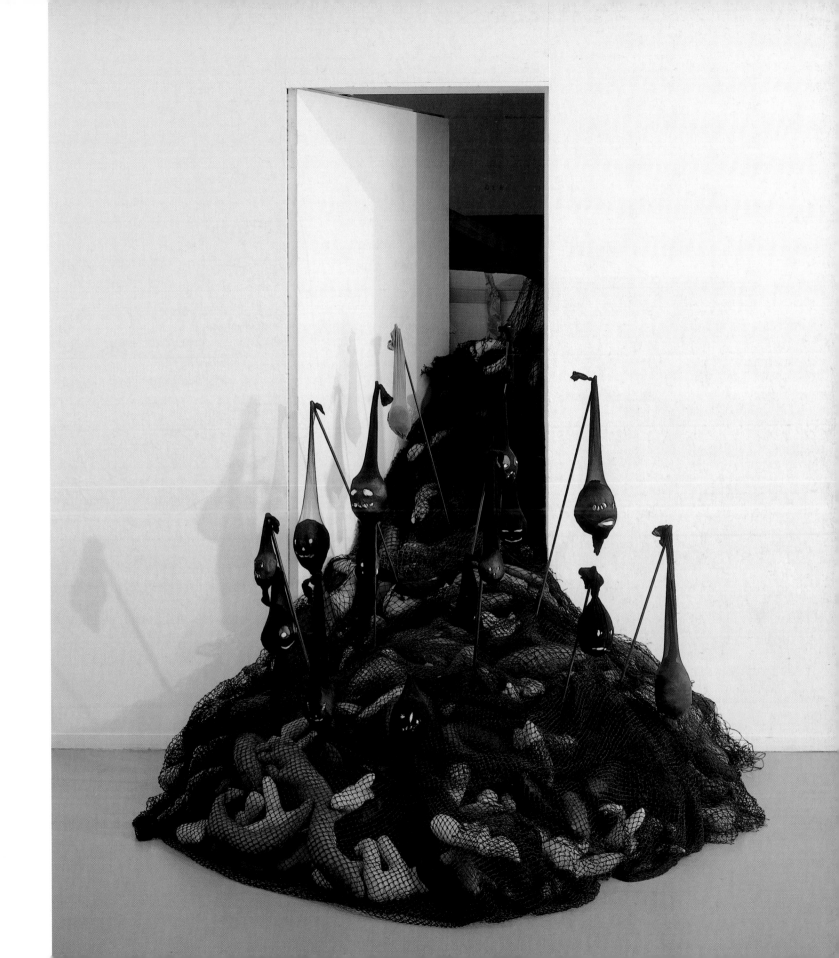

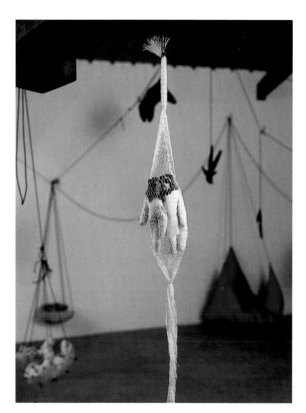

dramatic placing of the black netting over a composition centered around the dismembered portrait of a child, the work is transformed into a kind of memorial, the space of memory becoming a space for mourning. The netting traps the understanding of the artwork itself, actualizing it by fashioning connections to something real from a lived experience. A sign of mourning, the net forges a tangible link between the disparate elements—the pictures of children, the masked animals, the soft toys—and thus corresponds exactly to the material form of a veil. Mathematically discreet and regular, a net is a combination of empty space and substance which confines without concealing. The sense of mourning at play is not the moment of loss, but rather an enigmatic presence, the opacity of an object made permeable by its celebration.

The darker tonality of Annette Messager's work from this period, the freakish and pitiful character of the new installations, and the focalization on regressive images in the form of carnivalesque figures stemmed from the distressing and uncertain social malaise into which the last decade of the twentieth century seemed plunged. Betraying the state of powerlessness felt by those artists who offered such a cruel contrast with the revolutionary euphoria of the 1960s, she confirmed the repercussions of this general unease on her work, on her position as an artist, and, more generally, on the role of creative art. Although it did not have deleterious effects on her creativity, it did impinge on the harmonious unfolding of an oeuvre that had previously progressed by regularly splitting off into different ongoing series. Now, different works tended to be embarked on simultaneously, the areas of research became more diverse, serial development was frequently replaced by the adumbration of less formal "families" building connections between newer and less recent works. In addition to this general mood of social crisis, the artist's personal situation had changed, since she was constantly dealing with propositions for retrospective exhibitions. The rethinking that this entailed incited her to extend these new-found perspectives to her life's work, thereby refocusing it in the light of more recent preoccupations. "The general anxiety and, in personal terms, the unease that came from having to prepare several retrospectives at once in 1995, meant that I felt unable to work peacefully on a fresh series (something that had never really happened to me before!). I felt as if all these flashbacks were diluting me. In a sort of defensive regression, I had to cross various interwoven periods in my work and get to grips with them . . . making it into a rather lousy display [parade]."[23]

This underlying crisis and re-examination of the past was, however, to be paralleled by a renewal in both media and structure. By reusing images from earlier works such as the *Chimaeras*, which had tended to vanish from her work, and by adopting novel images and materials (netting, mattresses, bolsters, etc.), processes (soft toys

Preceding pages:
"Faire Parade" exhibition at the Musée
d'Art Moderne de la Ville de Paris, 1995.

Parade (Parade), 1994–95, detail.
Birds' heads, fabric, netting.

Parade, 1995.
Fabrics, colored pencils, lightbulb.

dismembered, flayed, or turned inside out, unraveled knitting), and forms (heart, death's-head, etc.), her whole artistic vocabulary was enriched, reconstituted, and problematized. While preparing for "Faire Parade," Annette Messager expressed the feeling that she was floating within an oeuvre which, since it was now over-flowing its natural boundaries, was imposing itself on her. Very soon, however, the

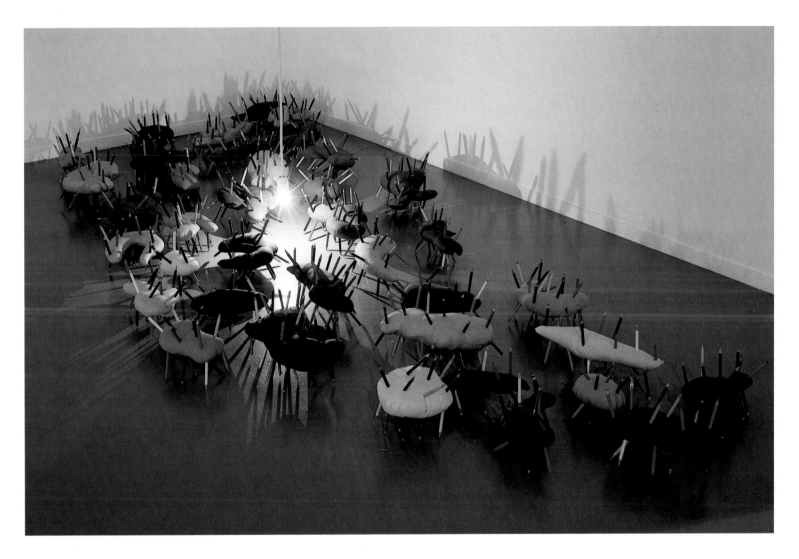

process of free fertilization was structured, the artist integrating it within the logic of organization that studio work entails. "Starting out with things put together in the studio, I work on pieces of paper, with notes when I'm not at home—on the subway, or on the train. You've done this. What can you do with that? It's like a piece of math-ematical reasoning. There are ten propositions, I select one of them, one and half.

Following pages:
Anatomy, 1995–96, detail.
Unpicked woolens, framed drawings in colored pencil.

Unknitted woolen, 1998.
Unpicked woolen. Overall dimensions 172 x 45 cm.

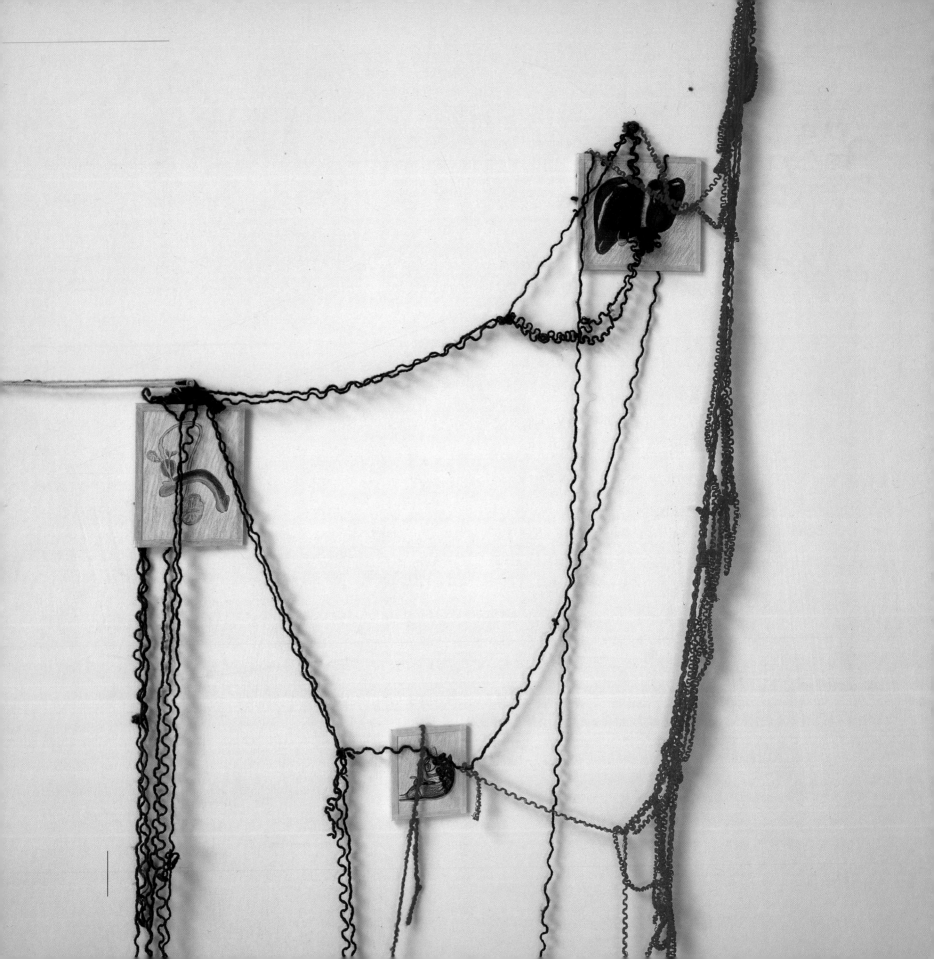

I don't do this in the studio staring at things, but a little farther off, at a distance, as if I were someone else weighing up my work." This doubling up of the artist's persona, in combination with the distance that allows her to consider diverse facets of her work and the different experiments undertaken, contributes significantly to a conception that envisages various multiple outcomes as parts that go to make up a single "production." The earlier notion of series that develop in parallel, mutually enriched by cross-fertilization, is replaced by distinct if intersecting experiments undertaken sporadically, but always attached to a central core, a "text," that guarantees the coherence of the work. Though totally invading the exhibition space, these new works were by no means monumental, but constantly evolving, involved, and dynamic. The mutation of forms had become the central concern of her work, which was now a theater whose phantasmatic order conflicted with the disorder inherent in the play of life. Essentially poetic, artistic creation had once again recovered its capacity for revealing the extraordinary, for extracting the marvelous from the most tenuous materials. The mid-1990s saw ventures that unpacked, emptied, and reversed the body and language. Like her unstitched pullovers whose threads unravel into space, her work as a whole could capture only an absence, a desertion of life.

"UNKNITTINGS"

Anatomie (Anatomy, 1995–96) was the first work to use unstitched woolen yarn, long dyed skeins that are draped and twisted around small colored-pencil drawings. Although the title refers to illustrations which each show a detail of a physical feature, the overall impression arising from these chaotic twists, this monstrously disheveled network of veins suggests a human race that has lost its bearings. The artist has let it be known that one of the ideas behind the work, whose use of wool is so different from the protective knitwear of *The Boarders,* was the devastating effect of AIDS. Although the unstitched pieces of knitting are indeed a simile for a despairing skein of life slowly unraveling, the brightness and lightness of the material implies a freedom from self-pity. These "unknittings" were to be used in a number of room installations, such as *En balance* (In Balance, 1998), without anatomical references this time, but with the "residual" impression of this recycled, entwined, and knotted yarn—now a collapsed, pullulating substance—intact. "The wool was used to warm and protect our bodies and organs. Unraveled, it becomes a network of vessels, veins, and arteries which covers and joins the anatomical fragments I draw. The whole of it becomes a mass of vegetation that won't stop growing, propagating itself in our bodies . . . on the walls."[24]

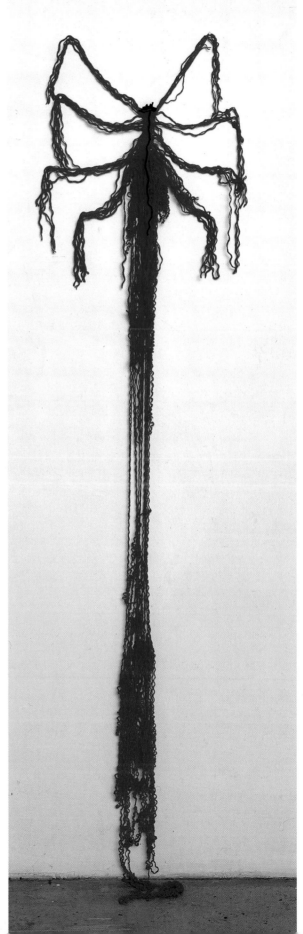

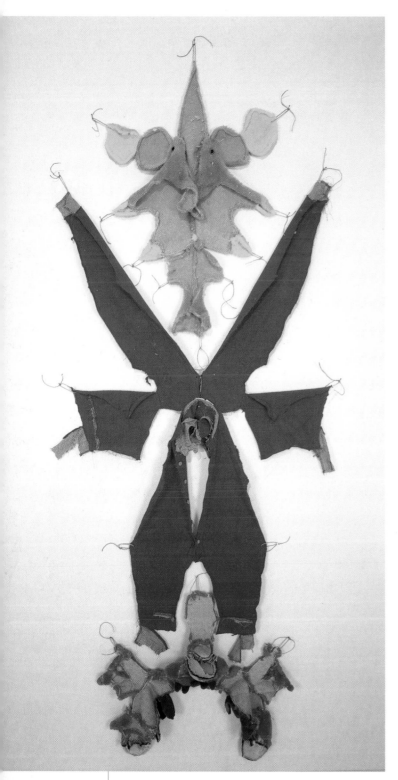

This vegetation hangs on the swings formed by the photographs suspended horizontally in space (*In Balance*) and on walls, where it forms colorful designs (*Laine détricotée* [Unknitted Woolen], 1998). It serves as extensions of the fingers of a colony of gloves that reach down to the floor (*Les Doigts de laine* [The Woolen Fingers]). Poured into space, rooted in chance, it forms a web without beginning or end that grows out of formlessness. At this stage, the work of art corresponded simply to a state of decomposition. Ephemeral, it was also incontrovertibly unique, a pure one-off. Never before had the artist's work arrived at such dematerialization—yet never before had it been more embodied. All subsequent works followed this paradoxical lead, at the fulcrum between two contrary positions. The artist, edging perhaps toward aporia, was thus drawn to take up a more radical position still, to abandon all attempts at conciliation through form or storytelling. The work informs by omission alone, either through direct inference from the method, as in the "dissections," or else by vaporizing into space as in *Dependence Independence* and *Plaisir Déplaisir* (Pleasure Displeasure, 1997).

DEAD SKINS

Dissections (Dissections, 1996) and *Dépouilles* (Sloughs, 1997–98) are made out of plush toys which the artist has emptied of the stuffing, flattened out and stretched, inside-out, onto the wall. The exposed loose threads form a haphazard pattern on the surface of firmly symmetrical shapes that are reminiscent of those in Rorschach tests. Although different, these forms all conform to the same structural schema and are used in simple compositions determined by their analogical features. Evocative perhaps of childbirth, a bunch of flowers or a mask, these skins guide the artist's work and condition what viewers see as they scrutinize the figures or hunt for other images. The diversity and inventiveness of these shapes made from simply flattening out a surface or enveloping a body is a source of constant surprise that contrasts with the uneasy sense that one is looking at a hide, a wretched yet comic hunting trophy. It is no longer a body, but the imprint left by a body; but it is not yet an image, rather the embryo of an image. This indeterminate object that turns into a sign, an "image of naught" (as the Romantics would have had it) that summons up other signs and other images, is typical of the artist's pieces in which stripped and slashed toys, cushions, bolsters, or unpicked woolen gloves serve as relays for the imagination, exposing the potential for other images within the form. Two combination works, *Histoire des oreillers* (Story of Pillows, 1995–96) and *Histoires des traversins* (Story of Bolsters, 1996–98), are based on the potential of their chosen raw material—the pillow—to be arranged and reshaped into figurative, meaningful forms without severing connections to its original shape or

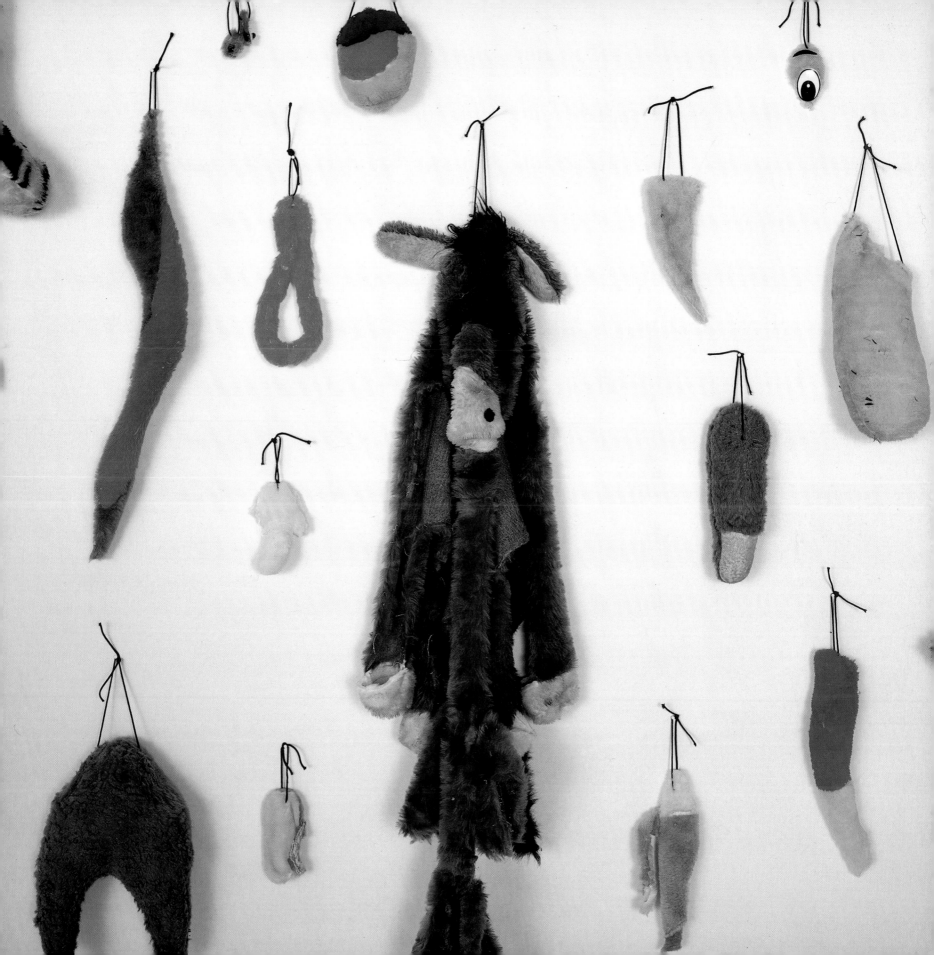

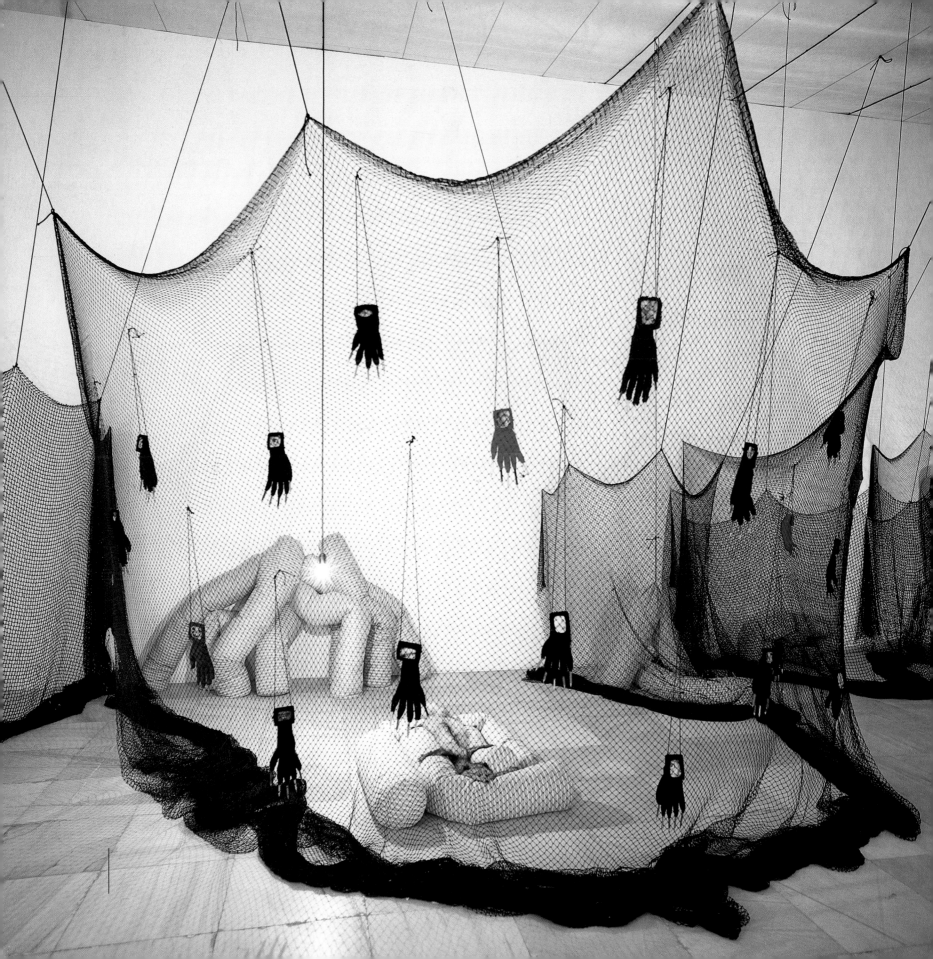

removing every last trace of its individual history. Like a sloughed skin, a worn old pillow conserves a disturbingly powerful emotional charge, its appropriation being of itself something indecent, like a violation of someone else's private space. Paradoxically, its softness and pliability allow for every reconfiguration the artist demands—decorative figuration in *Story of Pillows*, or as furniture in *Story of Bolsters*.

Little by little, the artist managed to convert her entire vocabulary of solid, regular shapes into an alphabet of soft, pliable forms. Progressively, what had had a name became unnameable. Erection (in *Piques*) had been followed by the drooping *Bolsters*, the geometrical *Vows* by the deliquescent "penetrables" and the scattered "unknittings." If some elements from earlier idioms survived, they were for the most part overrun and absorbed by the soft forms, as in the case of the photographs from *Vows* nestling under a heap of bolsters or stuck into folds in pillows. The grimacing children that appear in a number of installations also possess this malleable body, the type of identity that children happily distort. The motif which formed the starting point for the majority of these compositions has become imperceptible, as in *Dependence Independence*, where the installation's large size makes it impossible to fully take in its heart-like shape. One *Story of Bolsters* depicts the kind of domestic interior which the artist had often explored in the past, but in a collapsed version that calls to mind Oldenburg's soft sculptures. This deflation, softening, and indetermination exemplifies our contemporary inability to frame certainties, to devise systems, or to forge clear-cut distinctions. The piece echoes a world that may not have fallen when the utopias were overturned, but which has lost much of its solidity, and no longer has the strength to resist the gaze of the viewer. The new environment in which Annette Messager places humanity resembles a cave. Most of her more recent installations are set up within the space of primitive man, from the "penetrables" to the mixed-media room installations she has created in Venice, Bordeaux, and New York, incorporating elements as diverse as bolsters, hangings, netting, wool, and soft toys. Human presence is reduced to an allusive hollowed-out being, every element of which harbors a memory. In a period that has been called "post-human," in which the human is being ousted by the artificial, Annette Messager invites us to slide back into the uterine matrix of the primitive family, to reawaken a nomadic memory from the depths of humanity.

ON PRIMEVAL CHAOS

The work *2 clans 2 familles* (2 Clans 2 Families, 1997–98) introduces two parental lines, two groups of adults and youngsters which reflect that primeval family. The bone structure of each figure is comprised of a wooden cross, the body being

Preceding pages:
Three Dissections (Trois dissections), 1997.
Children's clothing, soft toy with stuffing removed, string. 200 × 100 cm.

The Remains (Les Restes), 1998, detail.
Soft toys with stuffing removed, soft toy. Overall dimensions 290 × 540 cm.
Kunsthalle Collection, Hamburg.

Story of Bolsters IV (Histoire des traversins IV), 1996–98.
Bolsters, gloves, colored pencils, rope, netting, fox fur.
Exhibition at the Palacio de Velázquez, Madrid, 1999.

formed either from a plastic sack or, in other cases, from the emptied-out skin of a soft toy. The face consists of a photograph of a grimacing child. It is just visible under the main attribute that physically embodies the differentiation of the two groups into the "bag" family and "toy" family. In both cases, however, animal and human features intermix, as if their imprecise shape was intended to offer proof of an equally imprecise nature, the traces of a human race not yet freed from the animality which lies deep beneath. Although colorful and fantastical, both groups are gripped by a sense of foreboding. As well as the fearsome appearance of the faces that crown the pared-down body and of the sepulchral crosses stuck in little mounds of earth, the pathetic nature of these everyday consumer articles evokes the wretchedness of present-day culture. Absurd yet tragic, the two clans square up to one another with no hope of reconciliation, the expression of a deep-seated violence.

After a sequence of works based on fusion, these pieces once again introduced the notions of separation and polarities. Wherever identities can be discerned, confrontation lurks: differences necessarily engender divergence. Her new work does bear comparison with earlier endeavors, however, through the re-emergence of the human face. This was especially noticeable at the 1998 exhibition in the Musée National des Arts d'Afrique et d'Océanie (MAAO) in Paris, which marked the debut presentation of *2 Clans 2 Families* when it was shown in conjunction with a number of other similarly "humanized" interventions placed here and there throughout the museum and in the aquarium in the basement. It is hard not to compare the two "families" with *The Boarders* (and the same might be said of the hybrid animal brotherhoods that starred in an installation at Cluny in 1999). There is something here of the spirit of the *Collections* too, for instance in the care taken over taxonomic classification, the minute pieces of soft toys selected, then formed into basic shapes (*Le Coeur* [The Heart], *Protection* [Protection], 1998), the photographs of contorted faces (aquarium installation, MAAO, 1998), and in the much-used plastic bags and teddy bear eyes.

The late 1990s then would be marked by a strong duality, as demonstrated by *Pleasure Displeasure* on the one hand and *2 Clans 2 Families* on the other. The artist's striking refiguring of primitive thought, evident in her "penetrables," in the net

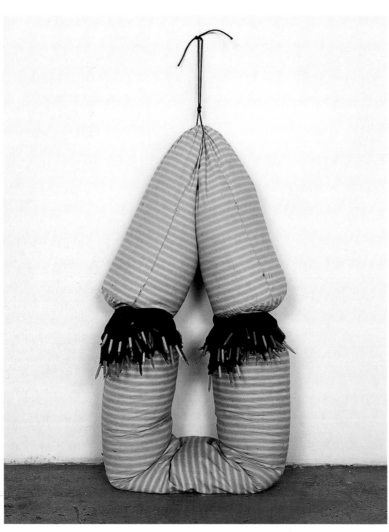

Story of Bolsters, 1996–98.
Bolsters, gloves, colored pencils, rope. 137 × 160 cm.

Story of Pillows I (Histoire des oreillers I), 1996.
Pillows, photographs, rope. 400 × 500 cm.

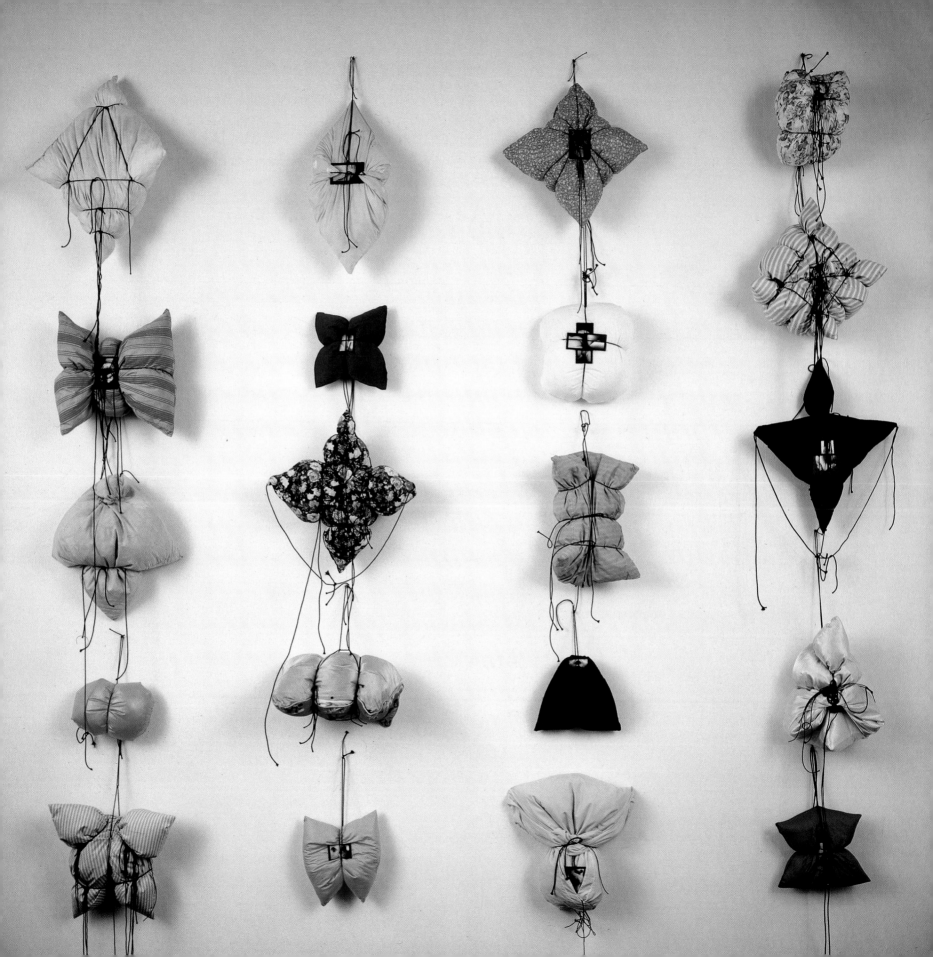

installations and the new components for the "formalized" works, generated two types of pieces of widely differing appearance and connotation. The penetrable environments, scatterings, and more complex installations are amorphous. They are poured into space so as to engulf the viewer. Disintegration gets the better of composition, and the third dimension is invaded by what is an equivalent to all-over painting, the work no longer being built up into an image, but generated at the locus where representation falls short, a regressive path back to primeval chaos. These pre-human pieces are offered up as territories without a place, the visitor

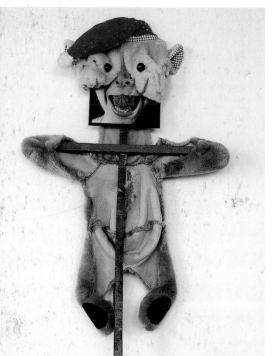
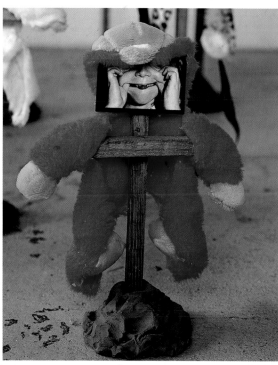
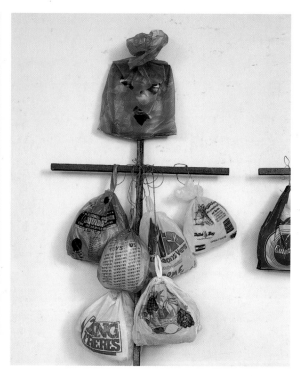

being invited to enter a twilight zone. On the other hand, works such as *La Croix* (The Cross, 1993), *Mes Vœux avec pénétration* (My Vows with Penetration, 1994), *Rencontre* (Meeting, 1996), *Séparation* (Separation, 1997), *Le Cœur* (The Heart, 1998), *Têtes de Mort* (Death's Heads, 1999) are, like *2 Clans 2 Families*, variants on portraiture, investigations into human nature that rekindle the subject and reinforce the authority of representation. Shifting between disappearance and appearance, object and subject, doubt and belief, the work weaves in and out between various discrepancies, and switches back and forth, as the artist herself has said, from laughter to tears and from tears to laughter. The artist's perplexity that crouches, as she puts it, "in the unease of her own contradictions" makes her work both profoundly and superficially human, an oeuvre less unpredictable than improbable.

2 Clans 2 Families, 1997–98, details.
Wood, plastic bags, photographs, soft toys, earth.

2 Clans 2 Families, 1997–98.
Photographs, soft toys, wood. Overall dimensions 15 × 12 m.
Installation at the Musée National des Arts d'Afrique et d'Océanie, Paris.

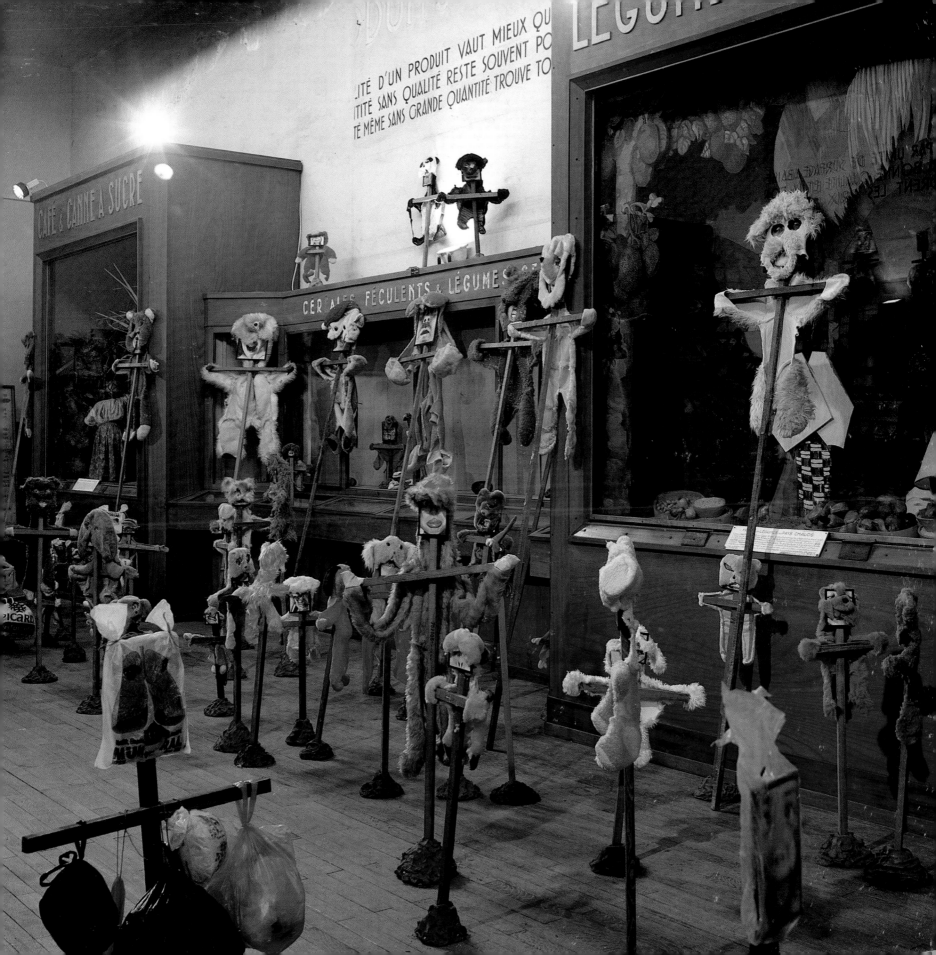

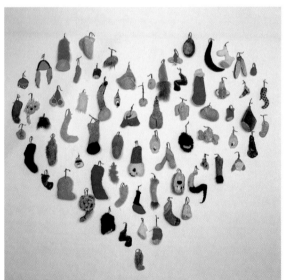

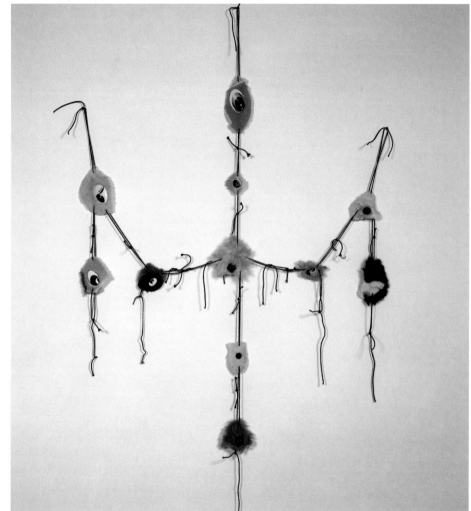

The Heart I (Le cœur I), *Les Restes* series, 1998.
Parts of soft toys, rope. 210 × 230 cm.

Untitled (Sans titre), *Les Restes* series, 1999.
Eyes from toys, rope. 195 × 100 cm.

The Star (L'Étoile), *Les Restes* series, 1999.
Parts of soft toys, rope. 330 × 320 cm.

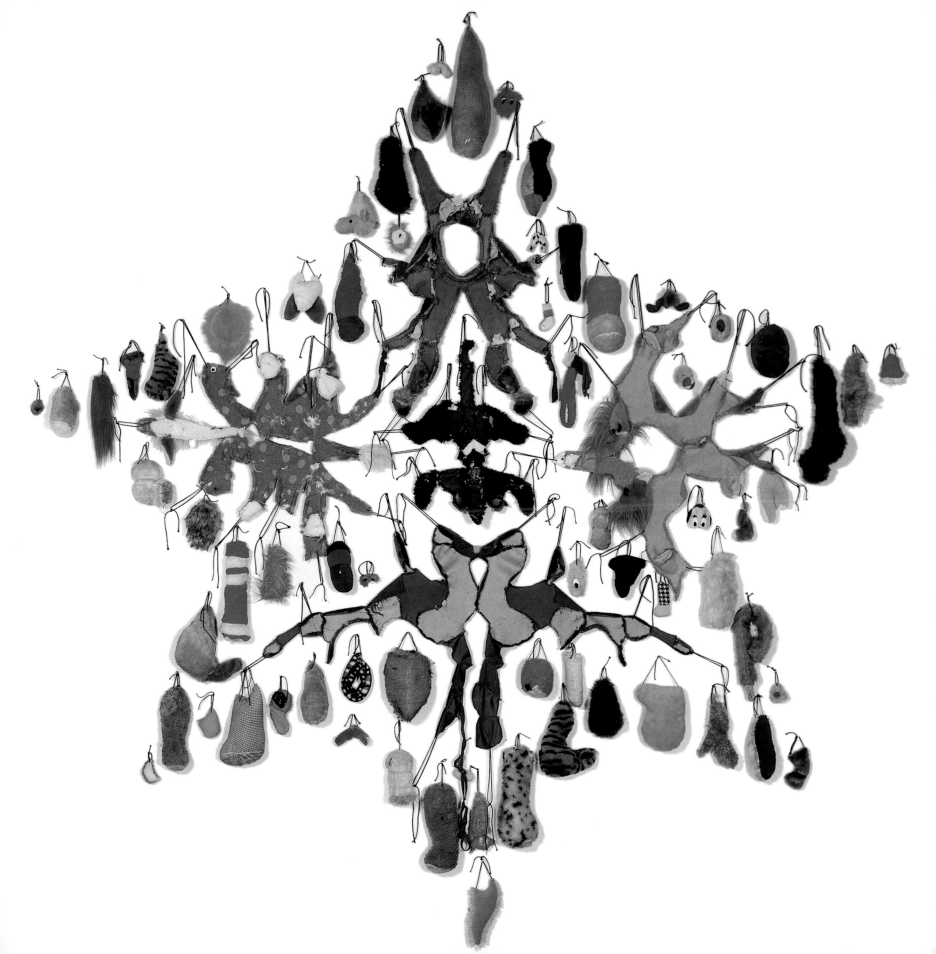

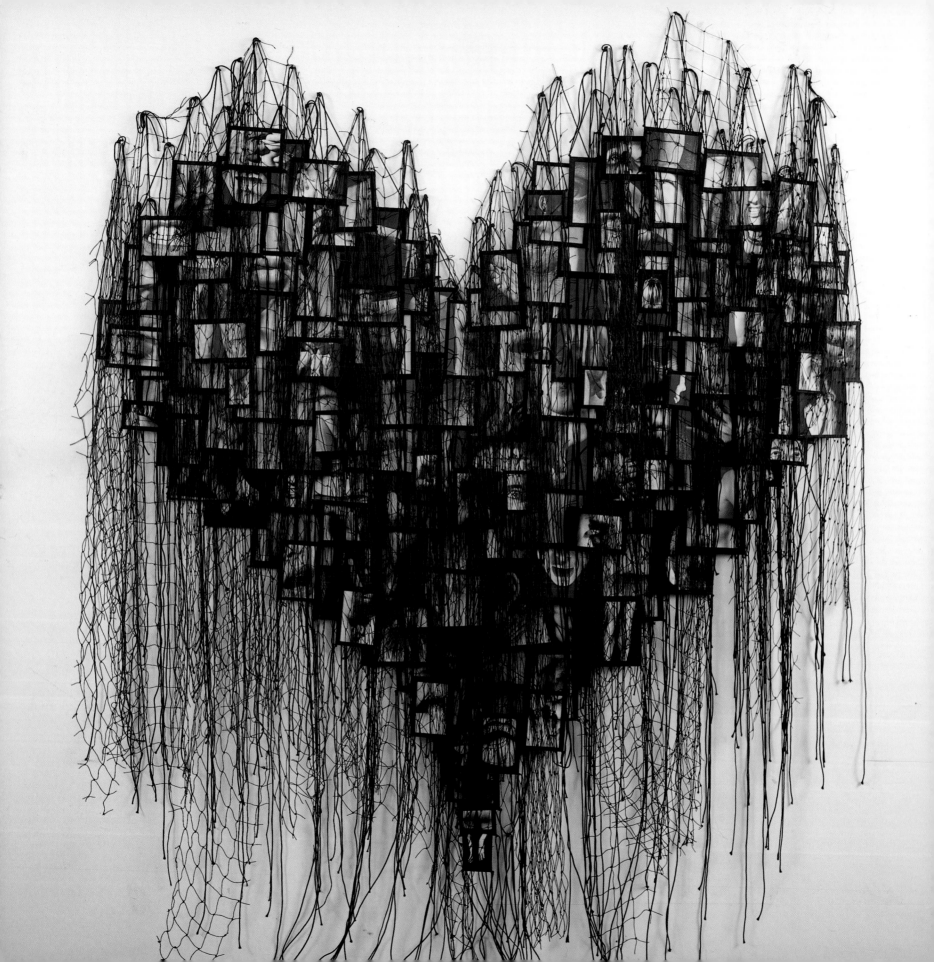

realism and the fantastic

One of the most original aspects of Annette Messager's work is its amalgamation of realism and the fantastic. Far from conforming to categories that set up oppositions between them, her conception is that one is simply the dark side of the other. What, in literature, creates suspense, a slow shift from verisimilitude guaranteed by naturalism, a move away from the rational to the irrational, becomes active in her work as a dynamic polarity that runs through her whole oeuvre. Like a couple of inseparable friends, the real and the fantastic feed each other, sparring, collaborating, or fusing to the point of eventually impregnating the various identities the artist has devised for herself. From the earliest pieces, she oscillated between the realm of the everyday, bearing witness, and maniacal madness. The day-by-day story of a simple-minded young woman written in a journal unknowingly revealed appalling personality disorders, although in the end the whole process was exposed as a ploy. Later, the artist started collecting newspaper and magazine pictures, cutting them out and classifying them for her own devices. Such a practice is hardly shocking in the context of twentieth-century art, but is rarer when combined with picking up dead birds off the sidewalk (or so she implied), or at least making them out of feathers, birds she then nursed, took on walks, taught, and christened her "Boarders," and for whom she knitted little trousseaus, composed an alphabet, constructed toys. At the outset, the artist's "lives"—the ones she built up and the other one that can be read between the lines—provided a backdrop to her ongoing oeuvre. These lives are torn between a normality which is too ordinary for the image that she wanted to create, supposedly that of an artist, and an equally ordinary abnormality, a release for a frustrated

My Vows under Netting 1997-99.
Photographs, netting, string. 213 x 180 cm.

woman exercising her perversity on tiny ersatz creatures, which would be that of a typical, resolutely conventional figure. Although continuing to assert control over the objects in her art, an enduring interest in the creativity of the insane has accompanied an effort to blur the border between her creative work and the territory of madness.

In *The Boarders* and in the *Collections*, the fantastic and realism alike are at work both in the details and in the way the various elements are amassed. The impression of documentary truth and the sense of the unreal both derive essentially from the sheer number of notebooks, the extraordinary diversity of the activities laid on for the birds. If the fantastic had not come to the surface, the feeling of voyeurism that compels us to participate in the work would not have developed. If realism had not extended to every event in everyday life, the phenomenon of identification—aided and abetted by the first person narrative system of the intimate journal—would never have coalesced. In a work balanced on the point of instability, it is the underlying structural equilibrium, the specially devised and preplanned combination of two irreducible worlds that guarantees both the coherence of the conception and the adhesion of the viewers, who are themselves absorbed into the constructs of the fictional narrative. Annette Messager achieves this by regimenting the work according to the elementary rules of dramatic composition, and giving her protagonist multiple and contrasting personalities, placing the scenario in real time, organizing it into several sequences, and by setting herself up as narrator-cum-actor. There is a concealed plan behind this semblance of trust, and it is this secret project to reconcile reality and the fantastic that confers such strangeness and uncanny freedom on her pieces.

By evolving in a public arena, subsequent works such as *Happiness Illustrated*, *The Portrait of Lovers,* and *The Series*—all of which leave off the romanticized self-portrait and take as their standpoint the illustrated magazine—depict the very same real world that lives on the fringes of the absurd, all the more true-to-life and alluring since it borrows features from fiction and presents itself as daydream fantasy. Advertisements, police reports, and TV serials are all enlisted to introduce greater coherence in a reality experienced as discontinuous and heterogeneous. Each offers the model of how to transform insignificant but actual objects into elements for a novel. During such conversion, appearances are manipulated or unmasked, and images gathered en masse as concrete proof. All these models are based on principles of focalization and exaggeration that do not undermine truth completely, but redirect it in a specific direction: toward seduction, deduction, or dramatization. Annette Messager makes the most of these highly integrated systems, allowing the images created to speak for themselves. In parodic fashion, she organizes the disparate

Man-Gloves ("L'Homme-Gant"), 1999.
Gloves, colored pencils, photographs. 195 × 135cm.

The Replicants ("Les Répliquants"), 1999.
Fabric, pieces of soft toy, string. 325 × 510 cm.

elements, unifying them under the pretext of collecting or telling stories, and arranges them for our interpretation. By comparing images considered as significant, reality, now overdetermined, seems unreal, the hypothesis imposing its own sort of order, truth and falsehood mutually annihilating each other.

BETRAYAL

Thus, by contaminating the narrative system, the image is overplayed and sabotages its original purpose of truthfulness. Piling up such alluring images can give no idea of the world's beauty—on the contrary, it betrays the vulgarity of human feeling; the meeting of two lovers does not represent love, but the suspicion that taints all relationships; those serial dramas that culminate in screen-filling close-ups are merely tawdry stories which make the most of our unhealthy schadenfreude. The dramatic mainspring of Annette Messager's oeuvre resides precisely in this "act of betrayal" organized by the artist. The images she replicates so slavishly do not show the world but reveal our being to ourselves. As in *The Portrait of Dorian Gray*, our failings and vices are unbeknown to us, imprinted on our very image, distorting our relationships with the world. The display of commonplace images exposes as little more than duplicity the supposed blamelessness of our intercourse with others and with reality. The most fantastical of these sequences of pictures—albeit the least indebted to fiction—is the incongruous portrait of *Happiness Illustrated*. Beneath its Technicolor blandishments, every facet of happiness betrays the ostentatiousness of pleasure, the garishness of taste, the acceptability and legitimacy of white lies. Generally considered one of the artist's most difficult works, and thus quickly linked to "Conceptual" approaches, it remains sufficiently beguiling for the suspicion to dawn that the artist's ready indulgence has been designed to expose our own, the illustrations of happiness being above all an enumeration of the generally accepted canons of Beauty. Rejected by modernism and vulgarized by the media, feelings for beauty, however, have been blemished with the stain of corruption. An apology for beauty amounts only to a betrayal of the "modern spirit." The "fantastic" flavor derives from the slippage that allows a cycle of trivial pictures to discharge the suppressed tensions between life and art. The grotesque in the original sense of the word—the cross-fertilization of every genre, the monstrous grafting of different categories, the hybridization of the ugly and the beautiful—are here all pressed into service. The grotesque in the modern acceptation of the word too, though: nothing is more grotesque, that is to say more inappropriate, than for an artist to take pleasure (this much is clear in the attractive and far from clumsy way the drawings are executed) in recopying all these fun things that make our holidays

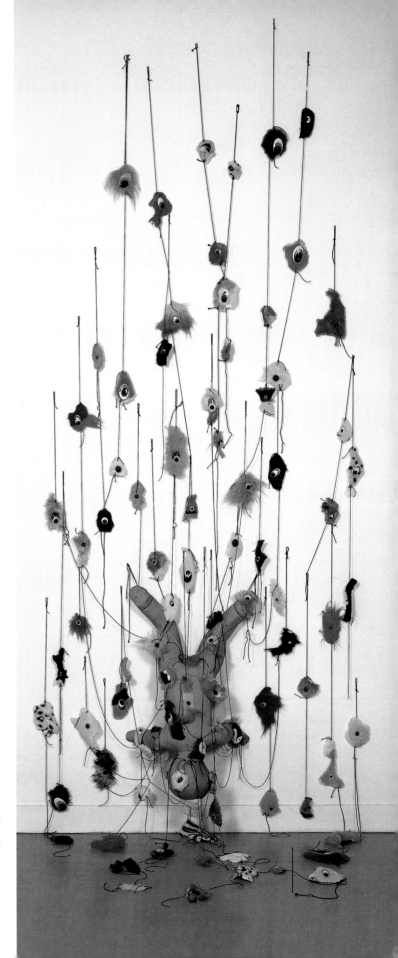

go with a swing but which appear so tawdry in a picture. Even fiction—in which the artist paints the portrait of the *midinette*, the girl with big dreams, while ostensibly presenting her own self-portrait—is not enough to reassure us as to the meaning of the work, to allow it to be reabsorbed into an acceptable system of values.

DISLOCATION

The Clues and *The Cubist Portraits* were the first pieces to disconnect the body from the surrounding world, to bring out the fantastic lurking at the heart of reality. Representation through fragmentation and the reconstruction of ill-fitting elements became all-important in the works of the 1980s, culminating especially in the large cycle of *Vows*. The references to police enquiries were confirmed in *Clues*, while the reference to the portrayal of likeness in *Cubist Portraits* had the purpose of recombining the images into a complete entity, relying on the fundamental principle that, hiding behind the facade of chaos, coherence subsists. Unlike early works that were concerned with tearing away the veil over everyday existence so as let in the strident cry of the irrational, these throwaway visions, which at first sight appear predominantly fragmentary and composite, overlay an unusual but effective system of enduring order. The reference to a hierarchical system that does not conform to natural laws, instead borrowing from structures in the fictional and theoretical realms, is a process that can be compared to those in fantastic literature. If reference is made to the two categories of the arabesque and the grotesque, for example, the classification Charles Baudelaire used for Poe's tales, grotesque leads to the pieces based on accumulation, while arabesque has its place in the *Chimaeras* and *Trophies*. More real in the former, more artificial in the latter, both display the same inextricable mix of the conscious and the unconscious, of reason and unreason, that emerges clearly at the surface of each work. The importance of mastering form, in *Portraits* as in *Vows*, in spite of the way the images are disjointed and conflated, has parallels in one of the rules of the literary grotesque: "to maintain a tension, a distinction, between *heterogeneous substance* and *coherent expression*."[25] Heterogeneous substance, as in the grotesques of the ancient world, is born of mixing genres so that elements of representation are no longer separated into man and woman, young and old, sexual or other organs. The same is true of the repetition of identical images, because they lose all status as representations and become rhetorical figures of the body. The artist, by concentrating solely on human anatomy, by dismembering it and selecting the elements endowed with a personality (for this is no collection of skins, like that assembled for example by the artist Patrick van Caeckenberg, but a collection of organs), by dramatizing them, accentuates to the

The Replicants, 1999.
Netting, fabric, taxidermized animals. 500 × 500 cm.

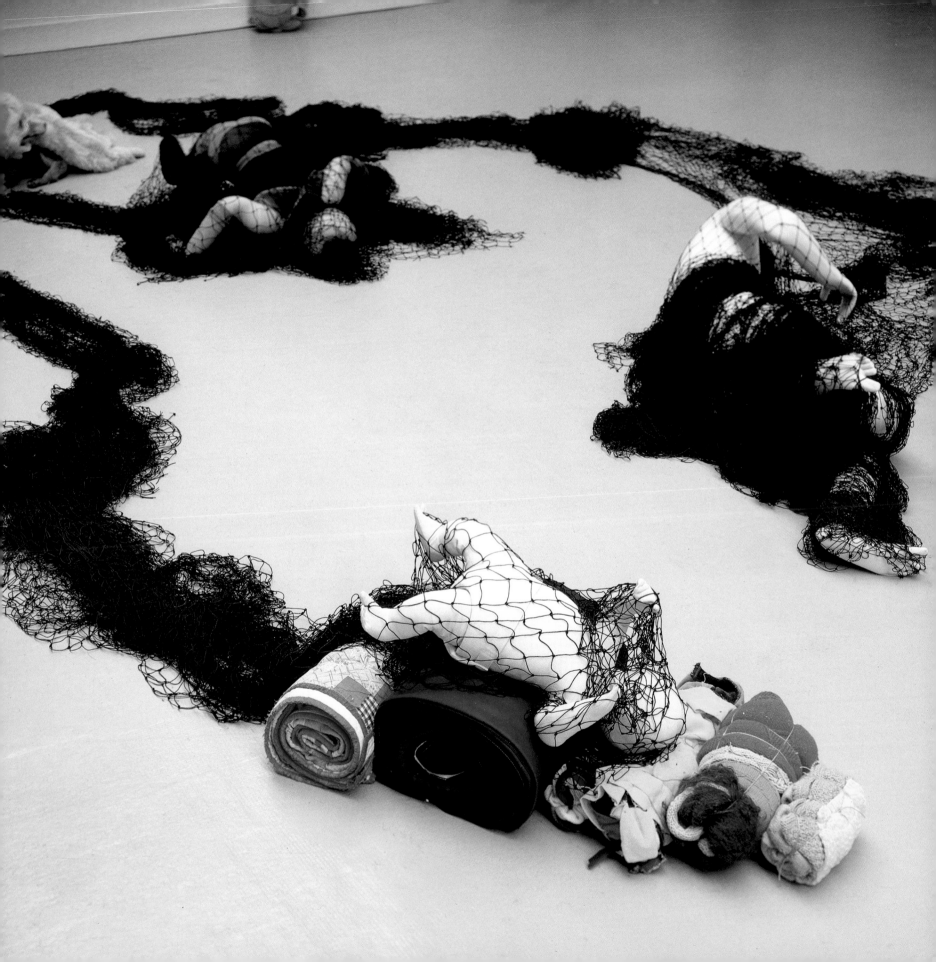

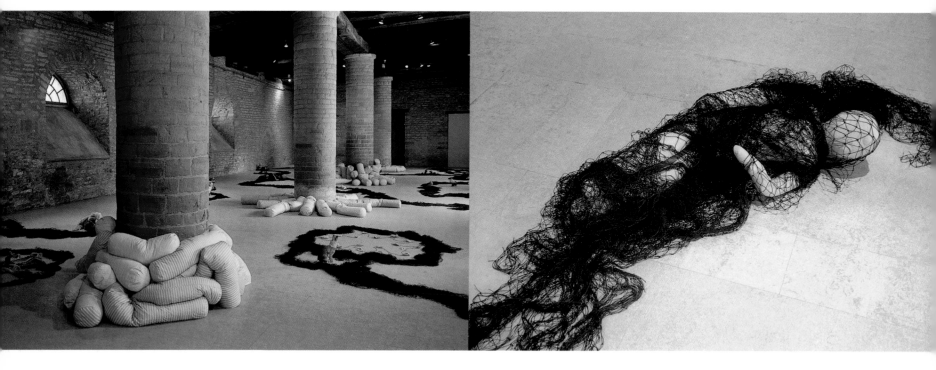

extreme the theatrical power of the grotesque, displacing it from the area of fantasy to that of subversion. By breaking with the natural order and breathing life into an impossible entity, the composite body—a fact that at bottom we all acknowledge—Annette Messager disturbs the all too uniform and unruffled surface of the world as conveyed by the body, and exposes a more ambiguous, multiple, unstable reality beneath. This relational body, which can only be reconstituted by activating the relationship between its disjointed parts, is in itself a theatrical construct of a fantastic type advanced by Annette Messager as a theater for her whole oeuvre.

DISSECTION

The grotesque, it is said, is exemplified by the work of Rabelais, Bosch's paintings, the character of Sancho Panza, Erasmus's *In Praise of Folly*, Shakespeare's world picture, Edgar Allan Poe's tales, and Franz Kafka. Annette Messager would be the last to repudiate such a lineage, and she has commented fulsomely on her affection for that particular family, the family that derides, that parodies, that turns values on their heads. Less a genre than a state of mind, the grotesque has been propagated down the centuries, pointing up the ridiculous and tragic nature of the human condition, taking us beneath the surface, and exploring the nooks and crannies of the soul, the diverticula of the viscera, the hidden mechanics of insanity. Concerned above all with the study

Views of the exhibition, "Les Messagers de l'Été,"
Écuries de Saint-Hugues, Cluny, 1999.

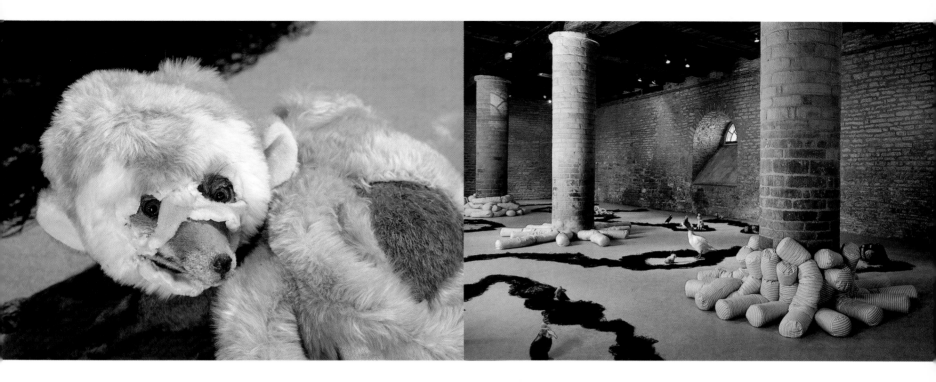

of humankind, the grotesque saps our certainties, disentangles the false from the real, lays low our myths. An artist like Annette Messager, who inaugurated her oeuvre with a hymn of praise to the undervalued, who set about publicizing her own regressive pleasures, who is not above "answering back" like a naughty child, could never wander far from these anti-heroic conceptions of the world, from these forms of logic extrapolated *reductio ad absurdam*, from this raillery that cocks a snook at the eternal void. Once again, it is the relationship between our artist and an essentially literary form of artistic expression which is most in evidence. At its very outset, her oeuvre could be seen as an ongoing fictional biography couched in reality, the realization of a necessarily literary project. In rejecting mere illustration, perhaps her real purpose has been to present an absurdist demonstration of the truthfulness of a type of literature that is closer to the real than any accepted method of recording "life."

Starting out from the paradox that life has nothing to tell, and even less to show, about itself, Annette Messager uses a literary type of approach to locate her work at the heart of reality. These "approach" maneuvers, which connect in one way or other to all her work, have few if any points of contact with the history of twentieth-century art, which has revolved entirely around the questioning of representation and debates over meaning. Telling the truth about humankind has no place in the project of modern artistic practice, and yet one of the most original things about Annette Messager is that she confronts the question without ever abandoning the avant-garde's impulse to

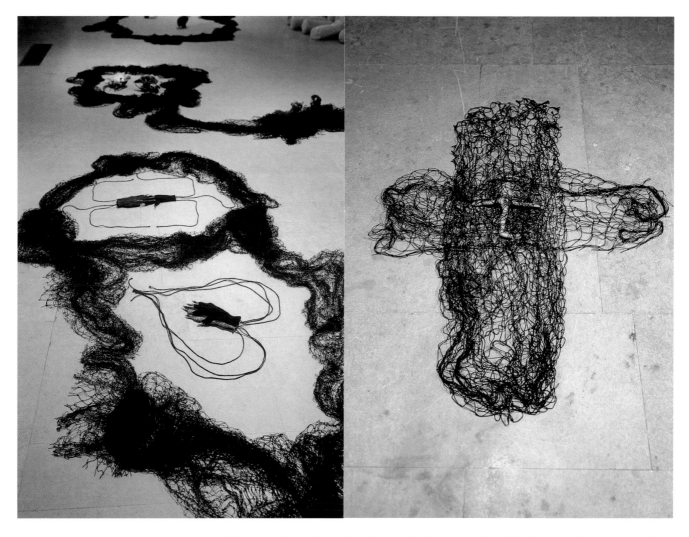

Views of the exhibition, "Les Messagers de l'Été,"
Écuries de Saint-Hugues, Cluny, 1999.

rethink art. Her work is closer in point of fact to authors like Georges Perec, Jorge Luis Borges, or, more recently, Elfriede Jelinek, than to visual artists, even though she might share some of their ideas in matters of form. Similar affiliations might be drawn up connecting her work with that of numerous filmmakers, the cinema having taken up where literature left off as regards the bothersome chore of dissecting and assessing the real.

The humorous side, which finds expression for the most part in the grotesque and in black humor, makes the protagonist known as "Annette Messager" a clandestine counterpart of Alfred Jarry's Père Ubu. The latter was always on hand to "slice off someone's lugholes," "debrain" passers-by, or turn a caustic eye on the world around him—all activities hard to square with the self-reflective practices of artists during the 1970s. Annette Messager's feeling of allegiance to Surrealism is a symptom of the same tendency, and it is amusing to see *The Cubist Portraits* hailing not Picasso the

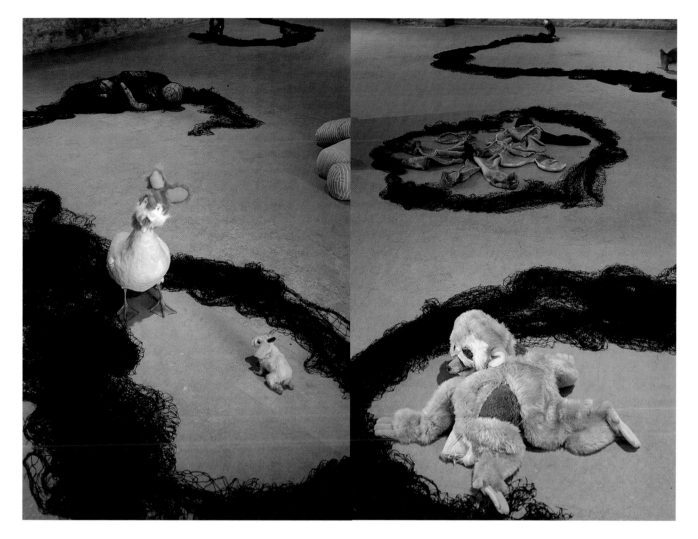

inventor of the methods of Analytical Cubism, but instead Picasso the Surrealist happy to hijack his own system, the Picasso who penned the theatrical squib, *Le désir attrapé par la queue* (Desire Caught by the Tail/Prick). There is something of Picasso's liberty, Picabia's spirit, and Max Ernst's delicacy in much of her oeuvre, but the comparison stands primarily with those facets of their work that have links with the world of the Surrealist theater. By prematurely burying Surrealism because it is most readily accomplished in literature, many artists have cut themselves off from the nerve center of the imagination and the unconscious which Annette Messager exploits so fruitfully. By tailing Mr. Hyde through the backstreets of mankind (and first and foremost through her own), by summoning his image on top of a portrait of Dr. Jekyll, she has reinvigorated representation as the generator of novel systems and forms. Annette Messager places the manipulation and hybridization of the real at the center

of her artistic practice, thus forging links between the object and its discourse that have driven her to engage in an ongoing renewal in the very forms of art. The effects of this process emerge throughout her career, right up to recent pieces such as *2 Clans 2 Families*. With its figures made out of heaps of plastic bags stuffed to bursting, thrown together from the detritus of the trashcan, this portrait gallery, one of the largest in the twentieth century, would raise a laugh were it not that it also reminds us of the throngs of street people that fill our cities, flying the flags of our well-heeled consumer society printed on the "bags" that give them their name. Rather than aiming to transpose one into the other, each element of the work appears after a disturbing juxtaposition of reality and art. The characteristic stitching together of reality and art forces the viewer to pay attention and leads them without transition into a zone where they are immediately abandoned to their own devices, bereft of their usual points of reference. Having much in common with the tricks of fantastic cinema that filmmakers like David Lynch have made their own, Annette Messager's work makes greatest impact in third-dimension installations through the unrivaled power of real objects.

HYBRIDIZATION

In the shape of two opposing families, like specters in a churchyard, the grotesque leads us to the frontiers of horror and the Romantic fantastic, in which several woman authors proved illustrious. Marie de France in the twelfth century, Ann Radcliffe, and of course Mary Shelley and the Gothic novel embraced supernatural beings and horrid monsters, and their work corresponds to the age-old propensity of women to note down dreams, fairy tales, and other imaginary events. Together with poetry, this type of literature represents the most fertile terrain for a meeting of masculine and feminine minds, appearing in the arts at a time when the empire of rationalism was crying out for an antidote and when the spirit of medievalism found a new lease of life in opposition to classicism. Although rarely conveyed in the media of visual art, the tendency did surface in the work of Gustave Moreau and Odilon Redon in France, and with the Austrian draftsman and etcher Alfred Kubin, as well as appearing spasmodically in the twentieth century too, among Surrealists like Max Ernst and Salvador Dalí. Closer to our time still, idiosyncratic contemporary artists such as the Austrian Günter Brus have deliberately positioned their work in opposition to their time. In itself, the arabesque is a non-temporal form, knowingly anachronistic, a stylistic departure that restores the piece to its sense of selfhood. Whereas all its salient characteristics go against the grain of modernity, Annette Messager's oeuvre—through an approach based in a new-found notion of what constitutes the feminine and with the purpose of integrating popular culture in art—manages to reintroduce

a sense of the phantasmagorical in a resolutely contemporary artistic context. Following a path she shares with Paul McCarthy, Mike Kelley, and Cindy Sherman, she makes much of the causticity and inappropriateness of the fantastic as it defies reality, bringing out all the more clearly life's quintessential banality.

It is no surprise then, in spite of the apparent discrepancy with the willfully ano-dyne universe in which her pieces evolve, that the fantastic was soon to permeate Annette Messager's oeuvre as a whole. Noteworthy features of her "confessions," such as feminine inquisitiveness, a certain indecorousness, a desire to break taboos, and a fascination with details, have been further developed in the visual and literary areas through copious reference to supernatural domains. *Chimaeras* follow the path opened up by *The Horrifying Adventures...*, in which the young woman was subject-ed to diverse forms of sexual predation, and the *Serials*, illustrations taken from cut-tings of stories from the kinds of magazines that revel in crime, torture, rape, and road accidents. These bathetic imaginings, these *delectatio morosa* of suppressed thoughts, were succeeded by madcap fantasies brought back from the other side of the looking glass, images of a transformed or hybridized world, where the bizarre detail and the abhorrent have pride of place. The *Chimaeras* seem to have been caused by the constricted and repressed world of Annette Messager's young woman exploding and spattering all four walls of the gallery with fragments from an amplified, bent, and twisted reality embedded in accepted symbolic forms or grafted onto tra-ditional supernatural creatures. The license unleashed by the fantastic bestows a sin-gular liberty of style and composition: the entire space is invaded by shapes that go it alone, ostentatiously dilating and deflating with wanton disrespect for due sense of scale. The "picture" is thus metaphorically assimilated to the spider's web drawn over the wall in *Chimaera Traps*: painting is above all a process of ensnaring the world, the images leaping onto the gossamer's sticky surface of their own accord, the phan-tasms feeding the artist like a spider crouching in the center, queen of the web.

Another example of this is the preparation of photographs for future pieces within the space of the studio. In ghoulish lighting, the artist makes outsized enlargements of parts of the human body—eyes rolling in every direction, gaping mouths, bared teeth, lolling tongues seen from below, hands like claws, faces in anamorphosis—then spreads them over the workshop walls so that her senses are assailed by the images she has produced. The transformations at work in the *Chimaeras* are patently not about dramatizing the image still further, but, on the contrary, about a "dedramatization" of the wild, aggressive, vampire-like figures that will only regain their form once insert-ed in the outline of a key or the shadow of a pair of scissors, thereby returning, if not to normality, than at least to a universe with a more familiar feel. These bits and pieces of humanity—cut up or shackled together or else stuck into an object from a symbolic or

oneiric order—are dragooned into a fabulous bestiary that may evoke dread, but which instills no real fear. The register is anyway less of fear than of "terror" as a genre, one whose every form of expression the artist has been busy cataloging: literature, film, illustration, cartoon, comic strip. All the requisite ingredients of the genre play a part: every conceivable species of monster, demoniac signs and symbols, bloodletting and gore, acidic color schemes, the black and gold highlights on the figures that spurt up onto the walls. The mixture blends together elements from the diurnal world with others from the nocturnal, as well as combining every type of artistic technique (painting, photography, drawing, cut-out, collage, etc.) in an unholy alliance. In what is a waltz between ill-suited partners, a Dance of Death on the floor of our own culture, Annette Messager's *Chimaeras* take advantage of every phobia imaginable, including—as befits an artist of her generation—painting, figuration, and fantasy.

MIXTURE

"I really like Méliès at the moment," she confided in the catalog to the *Chimaera Traps,* "because his sets seethe with life, but at the same time they are shabby, the photographs retouched, the colors false, the women phony, the butterflies piteous-looking."[26] By concentrating on what is patently false in the realm of the fantastic, on its makeshift, garish backdrop, Annette Messager voices the pleasure we can all feel in being taken for a ride, the delight in illusions that her work seeks to recreate in transcending the bogus materiality of its effects. In the fantastic genre, everything is "flagged"—the teratologies are duly examined, the decor (old castles, dense forests) are routine, the mechanics of illusion rigidly identical. Rules and codes govern a fiction organized in the way of a game, in which the spectator fulfills an intrinsic part and where poetic power has more weight than form. This is probably the reason why the guide that accompanies this piece is the first to contain a description of the ingredients and recipes for her "concoctions": "There's a lot of cooking involved. I feel a bit like a witch preparing her magic brew. I start off by taking pictures of friends or other people around me, with very deceptive lighting, very powerful spotlights pointing straight into their eyes that reinforce the shadows and the pallor of the face. I have to photograph real people, although I can't stand so-called 'realist' photography. Next, on the contact print, I isolate certain bits, enlarge some of them and project them onto various slanting surfaces that distort the details. I have the impression of truly possessing my models. I act on them. I 'anamorphosize' them. After that, I put them up on the wall, cover them with sheets of transparent plastic, and draw over them. Only when the forms are finished, cut out, mounted, and glued do I paint them, and this too is a way of manipulating them. I can thus transform my lovers into

Details from the exhibition, "Les Messagers de l'Été," Écuries de Saint-Hugues, Cluny, 1999.

the bats that come and see me every night in my sleep. I use a 'bric-a-brac' made up of diverse techniques, just as I use the 'bric-a-brac' of my culture, of my life. I rummage through it like an attic. It makes for a clash of styles, but I'm looking for the associative images they create, as well as for overprintings, special effects, and distorting lenses, since for me an image is also an illusion."[27]

Already, before she has even thought up the "grand picture" into which the *Chimaeras* are to be inserted, the basic scenario has been decided upon: "For example, a vast hand-drawn spider's web encloses a group of little animals, butterflies, that will seem snapped up by the big fat chimaera-cum-spider, then, following a thread back, one passes through a forest and comes to a castle—and doubtless we'll end up being led to something resembling death."[28] The fantastic is not only the point that anchors the imagery; it is also the narrative strand to which the images adhere. Topography is determinant, the symbolism of place and objects dictates the order of the things, temporality underpins the drama.

CRISIS IN THE EGO

In the *Chimaera Traps* project, the artist selected a model well known for its imaginative richness: that of a stroll through the picture space. Tried and tested in the world of literature, the theme has been treated in picture form a number of times too, especially in the cinema. The intimate mixture of the real and its mimetic translation, of truth and the construction of truth, upsets established norms in a fashion particularly conducive to the fantastic. Experience and representation meet head-on in a paradoxical universe containing a heterogeneous reality, where person and persona are muddled, where the environment is just waiting to be "activated." The ambiance created by the *Chimaera Traps* is enriched to the point of breaking down the barriers separating two orders of reality in between which the artist acts. By transposing life into the midst of an imaginary world that takes on bodily form, the confusion between the world and art (two mirror-image views of the same territory according to the artist) expels the viewer from their ego and installs them as the main protagonist in a dream-like narrative. Time and space open up into a labyrinth with no way out, entirely in the thrall of a world of nightly visions.

The sleepwalking state conjured up by the *Chimaeras* was to become still more acute in *Penetration* and *Dependence Independence*. Whereas the *Chimaeras* bore singular resemblance to a backdrop designed with the viewer's own reality in mind— very like the painted decors that send Expressionist and Surrealist films lurching into the fantastic—the 1990s penetrables present a world that can be quite literally explored on foot, a zone for sensory stimulation. Close in spirit to the "hall of mirrors" and "ghost

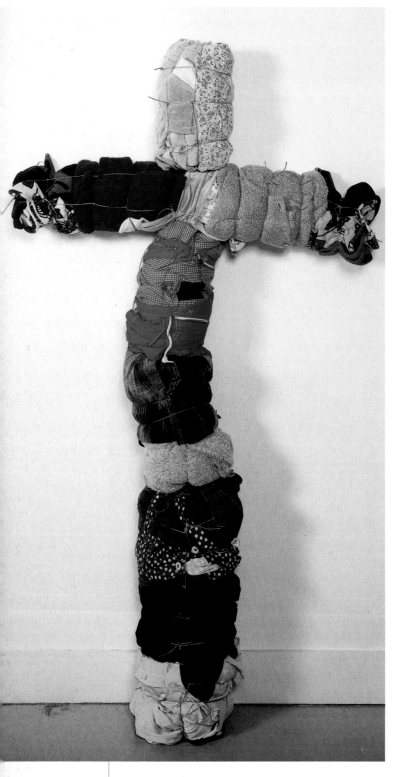

train" at the funfair, the pieces issue forth into phenomenological space, threatening to bump into the viewer. The tactile nature of three-dimensional art forms here hits home: aesthetic pleasure is aroused by a series of shocks, the spectator being buffeted, destabilized, disorientated. As an unheard-of type of internal logic replaces the natural order of interdependence, the body finds itself at a loss, insecure in its points of reference and sensing its reflexes running amok. Transformed into one vast sensitized zone, the body is witness at once to the experiments undertaken on it and to its own reactivity. Impossible though it is to enter fully into the mechanics of the arcane logic at work, it is equally impossible to escape without abandoning all experience of the image perceived. Unstable and discontinuous, the exposure of this image consolidated by the effects of a moving body is naturally conditioned by time. In the simultaneous ordeal—of appearance and disappearance—the body is expected to see and feel between things, to become aware of the discrepancy which mutates the forms.

The inner sensory states characteristic of the sleepwalker here focus on real objects whose very strangeness exacerbates our feeling of unreality. All these simulacra through which the being has to wend its way are "object-bodies," cadavers bent on attacking the living. The kind of specters that often loom out of the pages of Romantic literature are here projected into the real world. Such outlandish creatures, bred to make humankind face up to its own disjointedness and to the incoherence of the notion of self, are made concrete in a dazzling variety of forms, from hybrid animals to mutant dolls. The crisis of the ego is embodied by a form in crisis: unstable, composite, uncoordinated—such a form entertains equivocal relationships with the subject. The organs coursing down in *Penetration* are the objective incarnation of thoughts that have got under the skin and into the flesh, and that banish the human subject to life in a dismembered carcass reduced to mere physiological elements. These organs swamp the viewer in the squalor of the base mechanics of life that the body does its best to camouflage. The organic pullulation that affects words and forms, and the slithering ooze that surrounds the viewer in *Dependence Independence,* bear witness to the dispersal of the subject through a reality fashioned in the image of the body's own repressed interiority. The threadbare, ghostly universe through which the viewer's body passes as through a maze recalls the types of artificial life (golems, doppelgängers) evoked in Romantic literature that introduce doubts into men's minds concerning their own selfhood. Annette Messager has adopted several images, widely disseminated by popular culture, but, more than that, she continues to ask the fundamental questions they pose and give them material substance.

Annette Messager makes forms that correspond closely to the images of alienation, obsession, transformation, and non-relatedness that haunt Romantic writing of this kind, and lends them bodily shape. Devising a construct of indeterminate

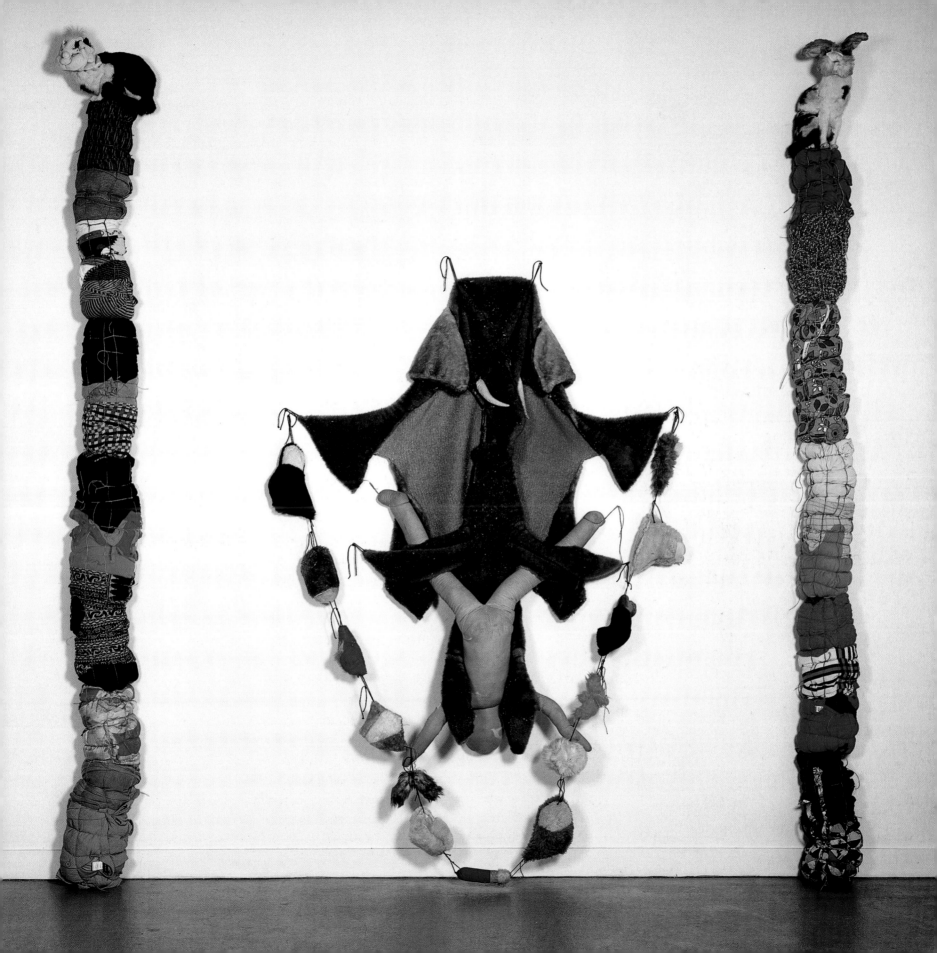

form, a set of possible states, she sets up a parallel to Romantic doubts as regards the nature of humankind. She uses the phenomenon of the resistance of physical bodies to the spirit that Bernhild Boie has brought out so clearly in her study of German Romantic literature, that is to say the experience that shows "that what man believes he knows most intimately, that provides his firmest source of strength, loses as it takes on objective form, not only its familiarity, but also its very intelligibility."[29] This enables her to bring man face to face with an objective reality he would sooner reject. From this arises the unease, the discomfort, viewers feel, since, ill-equipped to ask questions of the work, it is they who have to undergo the interrogation. The pleasure it affords has the same origin, however: as can be seen in numerous public expressions of popular culture, the world of the effigy is also the ideal territory for play, the attribute of celebration.

Like the Marvelous, with which it shares many features, the fantastic belongs to the distant history of man. It provides us with ancestral experiences that belong to a common store in our culture and which have been co-opted by many creative artists. Kafka insisted that his stories were all "narratives which have come down to us from far off," inspired by books (in his own case the Talmud notably), which themselves "only tell us age-old stories," and which are scarcely comprehensible to modern eyes. Similarly, Annette Messager's work refers us back to experiences already lived through, stories with which we are already familiar, words uttered countless times, whose origin and meaning we can no longer recall. If her work outstrips the real it is because she invests the actual with a memory that makes it resonate as one with an often legendary, primeval body of knowledge. By choosing reminiscence as foundation and vector for her creativity, by identifying the role of the artist as that of a "peddler," her work turns into a sinuous path that crisscrosses the course of history and paces the frontiers of the unconscious. Her work resembles an oft-repeated refrain, the themes coming and going, always familiar even in the most disconcerting forms. Emerson nicknamed Edgar Allan Poe "the jingleman," the man who repeats the same refrain, the same old tune. The simile might well be applied to Annette Messager: paradoxical though it may seem for an oeuvre that never imposes itself from "above," but which instead etches itself on our mind, her work has its searing moments, like a catchy but melodious poem. Be it pleasant or enervating, touching or scary, its very familiarity, its posing of the question of aesthetics always in relation to private life, is like that of a little tune that one mouth starts to sing and which is then taken up by others, a song that is then forgotten, only to return, its words swelling in volume, then dying away, without losing anything of their power—a voice that has become our own.

Preceding pages: *Untitled (The Cross)* ("Sans Titre (La Croix)"), 1999. Fabric, string. 142 × 82 × 22 cm.

The Replicants, 1999. Fabric, soft toys, stuffed animals, string. 320 × 315 × 30 cm.

Them and Us, Us and Them, 2000, detail. Gloves, colored pencils, mirrors, stuffed animals, heads from soft toys. Project for the exhibition, "La Beauté," at the Palais des Papes, Avignon, 2000.

Following pages: *Protection* ("Protection"), 1998. Pieces of soft toy. 100 × 440 cm.

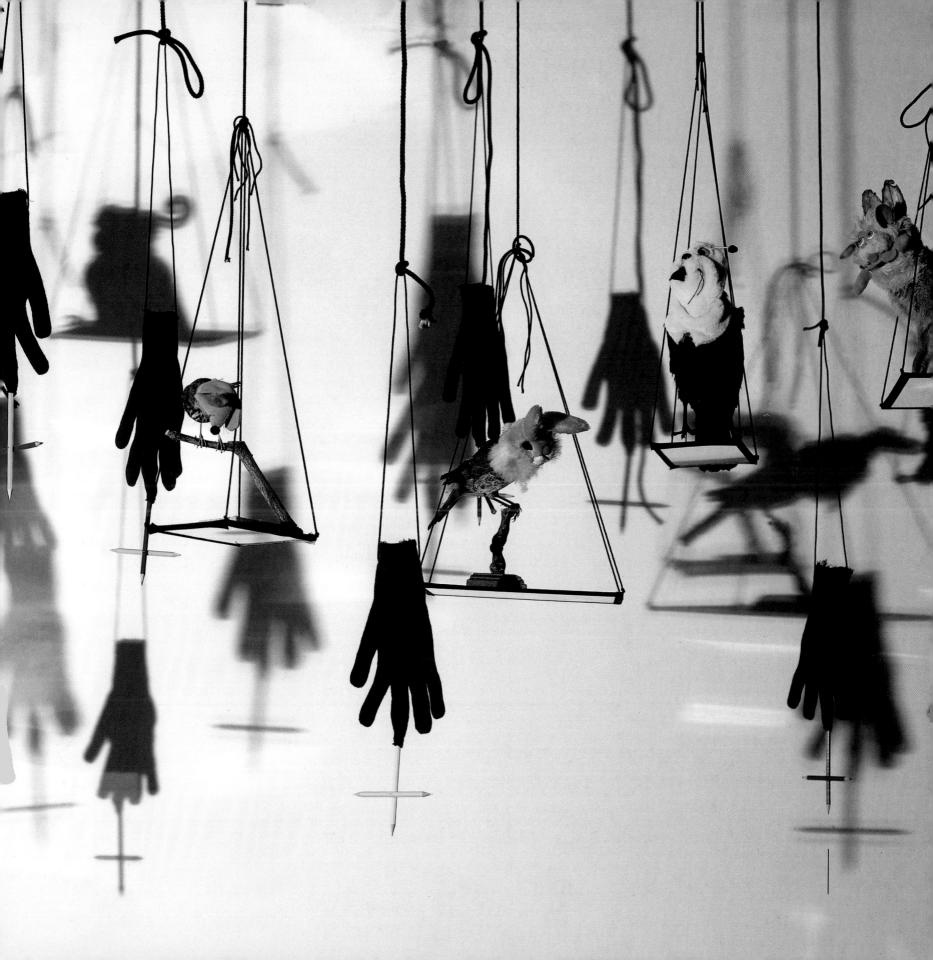

notes

1. Quotations by Annette Messager which do not cite a source come from interviews with the author in 1998 and 1999.
2. Interview with Bernard Marcadé, *Annette Messager, comédie, tragédie* (catalog), Musée de Grenoble, 1989.
3. Quoted from Tilman Osterwood, *Pop Art*, Taschen, Cologne, 1991.
4. Interview with Bernard Marcadé, *op. cit.*
5. Interview with Robert Storr, *Annette Messager, Faire parade*, Musée d'Art Moderne de la Ville de Paris, 1995.
6. Quoted by Bernard Marcadé, "Je crois pas au fantômes, mais j'en ai peur" in *Annette Messager Chimères* (catalog), Musée des Beaux-Arts, Calais, 1983.
7. Ibid.
8. *Annette Messager* (catalog), Grenoble, *op. cit.*
9. Gilles Deleuze, *Logique du Sens*, Minuit, Paris, 1969.
10. Johanne Lamoureux, *Annette Messager, Faire des histoires* (catalog), Mercer Union, Toronto, 1991.
11. Quoted from Marcel Duchamp, *Ingénieur du temps perdu*, Belfond, Paris, 1977.
12. Interview with Robert Storr, *op. cit.*
13. Interview with Bernard Marcadé, *op. cit.*
14. Ibid.
15. Ibid.
16. Ibid.
17. Ibid.
18. Interview with Robert Storr, *op. cit.*
19. Ibid.
20. Ibid.
21. Ibid.

22. Interview with Jean-Louis Froment, *Annette Messager Pénétrations* (catalog),
 Gagosian Gallery, New York, 1997, p. 71.
23. Interview with Robert Storr, *op. cit.*
24. Interview with Jean-Louis Froment, *op. cit.,* p. 73.
25. Michel Zéraffa, preface to a translation of Edgar Allan Poe, *Histoires grotesques et
 sérieuses*, Livre de Poche, Paris, 1973.
26. Interview with Suzanne Pagé in *Les Pièges à chimères d'Annette Messager* (catalog),
 ARC, Paris, 1984.
27. Ibid.
28. Ibid.
29. See Bernhild Boie, *L'Homme et ses simulacres*, José Corti, Paris, 1979.
30. Marthe Robert, *Kafka*, Gallimard, Paris, 1960.

*PROVERBS: (p. 70) from top, left to right: *Il faut craindre la femme et le tonnerre*/Fear woman and thunder; *Chez la femme les dents de sagesse ne poussent qu'après la mort*/In women, wisdom teeth only grow after death; *Si la femme était bonne, Dieu aussi en aurait eu une*/If woman were good, God would have had one; *La femme est un être qui s'habille, babille et se deshabille*/Woman is a being who gets dressed, babbles and gets undressed; *Quand la fille naît, même les murs pleurent*/When a girl is born, even the walls weep; *Les femmes sont pleines de sagesse, et folles quand elles réfléchissent*/Women are full of wisdom, and insane when they think; *La femme est un mal nécessaire*/Woman is a necessary evil; *Aime ta femme comme ton âme et bats-la comme ta pelisse*/Love your wife as your soul and beat her like your fleece; *C'est la femme qui a fait pousser les cheveux blancs du diable*/It is woman who made the devil's hair grow white. (p. 71) *Prends garde d'une mauvaise femme, et méfie-toi de celle qui est bonne*/Be careful of a bad woman, and beware of one that is good.

1973
"Annette Messager Sammlerin, Annette Messager Künstlerin," Städtische Galerie im Lenbachhaus, Munich*; Musée de Peinture et de Sculpture, Grenoble.
"Annette Messager collectionneuse—Mes clichés-témoins," Galerie Yellow Now, Liège.*

1974
"Annette Messager collezionista," Galleria Diagramma, Milan.
"Annette Messager collectionneuse—Les tortures volontaires," Galerie Daner, Copenhagen*; Galerie Sankt-Pétri, Lund (Sweden).
"Annette Messager collectionneuse," Arc 2-Musée d'Art Moderne de la Ville de Paris.*

1975
Galerie 't Venster, Rotterdam.*
"La femme et … Annette Messager truqueuse," Galerie Écart, Geneva.*
"Annette Messager—Mes jeux de mains," Gallery of Contemporary Art, Zagreb; Galerie Space, Wiesbaden.
"Annette Messager collectionneuse, artiste, truqueuse, femme pratique," Galleria Diagramma, Milan.*

1976
Galerie Multimedia Arte Contemporanea, Erbusco (Italy).
Galerie Grafikmeyer, Karlsruhe.
"Messager/Boltanski, das Glück, die Schönheit und die Träume," Rheinisches Landesmuseum, Bonn.*

1977
Galerie Isy Brachot, Brussels.
Galerie Seriaal, Amsterdam.
"Annette Messager—Les vacances," Centrum für Kunst, Vaduz (Liechtenstein).*

1978
Holly Solomon Gallery, New York.
"Les feuilletons," Rheinisches Landesmuseum, Bonn.*
"Serials," Galeria Foksal, Warsaw.*
"Annette Messager Kolecje 1972–1975," B.W.A. Lublin; Salon Krytykow, Czerwiec.*

1979
Galerie Gillespie-Laage-Salomon, Paris.

1980
Galerie Gillespie-Laage-Salomon, Paris.
Saint Louis Art Museum, Missouri.
Le Coin du Miroir, Dijon.
Galerie Maeght, Zurich.

1981
Fine Arts Gallery, University of California, Berkeley.
San Francisco Museum of Modern Art, San Francisco.
P.S.1, Long Island City (New York).
"Les variétés," Galerie Hans Meyer, Düsseldorf.

1983
Galerie Gillespie-Laage-Salomon, Paris.
"Annette Messager—Chimères 1982–1983," Musée des Beaux-Arts, Calais.*

1984
"Annette Messager—Les pièges à chimères," ARC-Musée d'Art Moderne de la Ville de Paris.*
"Annette Messager—Chimères," Galerie Grita Insam, Vienna.*
Galerie Elisabeth Kaufmann, Zurich.

1985
"Chimères," Riverside Studios, Hammersmith, London.
"Effigies, 1984–1985," Galerie Gillespie-Laage-Salomon, Paris.

1986
"Annette Messager—Peindre, photographier," Galerie d'Art Contemporain, Direction des Musées de Nice.*
Artspace Visual Arts Centre, Surrey Hills, Australia.

1987
Vancouver Art Gallery, Vancouver.
"La ruée vers l'art," Ministère de la Culture et de la Communication, Paris.
"Mes trophées," Galerie Elisabeth Kaufmann, Zurich.

1988
"Mes trophées," Galerie Laage-Salomon, Paris.
"Mes enluminures," Le Consortium, Dijon.*
"Annette Messager—Augures, Comédie Tragédie 1971–1989," Centre d'Art Contemporain, Castres.*
Galerie Wanda Reiff, Maastricht.

1989
"Mes enluminures," Galerie Crousel-Robelin Bama, Paris.
"Annette Messager—Mes ouvrages," Church of Saint-Martin-du-Méjean, Arles.*
"Annette Messager—Comédie Tragédie 1971–1989," Musée de Peinture et de Sculpture, Grenoble.**
Festival de la Sorcellerie, Centre d'Art Contemporain, Castres.

1990
"Annette Messager—Comédie Tragédie 1971–1989," Bonner Kunstverein, Bonn; Musée de la Roche-sur-Yon; Kunstverein für die Rheinlande und Westfalen, Düsseldorf.
"Contes d'été," (with Christian Boltanski), Musée Départemental d'Art Contemporain de la Haute-Vienne, Château de Rochechouart.*
"Faire des histoires," Galerie Crousel-Robelin Bama, Paris.
Galerie Elisabeth Kaufmann, Basel.

1991
"Annette Messager—Making Up Stories / Faire des histoires," Mercer Union, Center for Contemporary Visual Art [and] Cold City Gallery, Toronto; Contemporary Art Gallery, Vancouver.** Galerie Wanda Reiff, Maastricht.

1992
"Annette Messager—Telling Tales," Arnolfini, Bristol; Cornerhouse, Manchester; Douglas Hyde Gallery, Dublin; Camden Art Centre, London.**
Josh Baer Gallery, New York.

"Annette Messager—Mes ouvrages 1988–1992," Salzburger Kunstverein and Künstlerhaus, Salzburg.*
Monika Sprüth Galerie, Cologne.
"In Scapes—Annette Messager," The University of Iowa Museum of Art, Iowa.*
"Des hauts et des bas," 11 bis, rue Théodore-de-Banville, Paris.

1993
"Annette Messager—Faire figures," Fonds Régional d'Art Contemporain Picardie, Amiens.*
"Les Piques," Josh Baer Gallery, New York.

1994
"Die Fotografie im Werke von Annette Messager," Galerie Elisabeth Kaufmann, Basel.
"Penetration," Monica Sprüth Galerie, Cologne.
Grand Prix des Arts Plastiques, Paris.

1995
"Faire Parade," ARC-Musée d'Art Moderne de la Ville de Paris.**
Los Angeles County Museum of Art, Los Angeles.*
Galeria Foksal, Warsaw.
The Museum of Modern Art, New York.**
The Pace Roberts Foundation, San Antonio.*

1996
The Art Institute of Chicago.
"Dépendance Indépendance," Capc-Musée d'Art Contemporain, Bordeaux.*

1997
"Penetrations," Gagosian Gallery, New York.*
"Un mur à Marrakech," Institut Français, Marrakech.
"Pièce unique," Paris.
"Dépendance Indépendance," Museum of Contemporary Art, Miami.

1998
David Winton Bell Gallery, Brown University, Providence.
"C'est pas au vieux singe qu'on apprend à faire la grimace," Musée des Arts d'Afrique et d'Océanie, Paris.*
Sets for a play by Alfredo Arias, *Aimer sa mère*, Maison de la Culture, Bobigny (France).

1999
"La procesion va por dentro," Palacio de Velázquez, Madrid; Museo Nacional Centro de Arte Reina Sofia, Madrid.*
"En balance," Museo d'Arte Moderna, Buenos Aires.*
Hamburger Kunsthalle
"Les messagers de l'été," Écuries de Saint-Hugues, Cluny.*
Hamburger Kunsthalle

2000
Monika Sprüth Galerie, Cologne.
Marian Goodman Gallery, Paris.

*The asterisk * indicates that the exhibition was accompanied by a catalog.*
*A double asterisk ** indicates the catalog is available in English.*

group shows (selected)

1972
"French Window," Galerija Studenskog, Zagreb.
"Wool Art—Artistes de la Laine," Galerie Germain, Paris.

1973
"Boltanski, Le Gac, Messager," Biennale des Nuits de Bourgogne, Musée Rude, Dijon.
"Cinq musées personnels," Musée de Peinture et de Sculpture, Grenoble.

1974
"Ils collectionnent," Musée des Arts Décoratifs, Paris; Museum of Decorative Arts, Montreal.*

1975
"New Media," Konsthall, Malmö.
"Je/Nous," Musée d'Ixelles, Brussels.
Biennale di Venezia, Magazini del Sale alle Zattere, Venice.*

1976
"Boîtes," Arc-Musée d'Art Moderne de la Ville de Paris; Maison de la Culture, Rennes.*
"Identité Identification," Capc-Musée d'Art Contemporain, Bordeaux; Palais des Beaux-Arts, Brussels.*
"Foto & Idea," Galleria Communale d'Arte Moderna, Parma.
"Frauen machen Kunst," Galerie Magers, Bonn.

1977
"Bookworks," The Museum of Modern Art, New York.*
"Selbstporträt," Künstlerhaus, Stuttgart.
"Künstlerinnen International 1877–1977," Berlin.
Tenth Biennale de Paris.*
Documenta 6, Kassel.*

1978

"Couples," P.S.1, Long Island City (New York).

1979

"French Art 1979: an English Selection," Serpentine Gallery, London.*
"European Dialogue," Sydney Biennial.*
"Photography as Art," I.C.A., London.*
"Tendances de l'art en France III, 1968–1978/1979, Parti-pris autres,"
ARC-Musée d'Art Moderne de la Ville de Paris.*

1980

"Walls!" The Contemporary Arts Center, Cincinnati.
"L'Arte degli anni settanta," Biennale di Venezia, Padiglione Centrale,
Venice.*
"Ils se disent peintres, ils se disent photographes," ARC-Musée d'Art
Moderne de la Ville de Paris.

1981

"Typische Frau," Bonner Kunstverein and Galerie Magers, Bonn; Städtische
Galerie, Regensburg.
"Autoportraits photographiques 1898–1981," MNAM-Centre Georges
Pompidou, Paris.*
"For a New Art," Museum of Modern Art, Toyama (Japan).*

1982

"Gott oder Geißel: Erotik in der Kunst heute," Kunstverein, Bonn (special
issue of *Kunstforum*).*
"Façons de peindre," Maison de la Culture, Chalon-sur-Saône; Musée Rath,
Geneva; Musée Savoisien, Chambéry.*

1983

"New Art 83," Tate Gallery, London.*
"Kunst mit Fotografie," Nationalgalerie, Berlin; Kölnischer Kunstverein,
Cologne; Stadtmuseum, Munich; Kunstverein Schleswig-Holstein;
Kunsthalle, Kiel (cat. publ. Frolich & Kaufmann).*

1984

"Märchen, Mythen, Monster," Rheinisches Landesmuseum, Bonn;
Kunstmuseum, Thun (Switzerland).*
"Écritures dans la peinture," Villa Arson, Nice.*
Fifth Sydney Biennial.*

1985

"Ils collectionnent—Premier regard sur les collections privées d'art
contemporain," Musée Cantini, Marseille.*
"Biennale des Friedens—Finding a Form for Peace," Kunstverein and
Kunsthaus, Hamburg.*
"Livres d'artistes," Centre Georges Pompidou, Paris.

1986

"Luxe, calme et volupté—Aspects of French Art 1966–1986," Vancouver Art
Gallery, Expo '86, French Pavilion, Vancouver.*
"Photography as Performance: Message through Object & Pictures," The
Photographers' Gallery, London.

1987

"Exotisches Welten—Europäische Phantasien," Landesbibliothek
Baden-Württemberg.
"Wall Works," Cornerhouse, Manchester.
"Les années 70—Les années mémoire," Abbaye Saint-André, Centre
National d'Art Contemporain, Meymac (France).*
"Perspectives cavalières," École Régionale Supérieure d'Expression
Plastique, Tourcoing (France).*

1988

"Nature inconnue," Jardins de la Préfecture, Nevers (France).
"Narrative Art," Fonds Régional d'Art Contemporain Bourgogne, Dijon.
"Gran Pavese: The Flag Project," Antwerp.*
"Le Facteur Cheval et le Palais idéal," Mairie d'Hauterives.
Galerie Elisabeth Kaufmann, Basel.
"Jahresgaben 88," Kunstverein, Düsseldorf.*
"Auf Zwei Hochzeiten Tanzen," Kunsthalle, Zurich.

1989

"Une autre affaire," Espace Fonds Régional d'Art Contemporain, Dijon.
"Histoires de musées," ARC-Musée d'Art Moderne de la Ville de Paris.*
"Les 100 jours d'art contemporain de Montréal," Centre International d'Art
Contemporain, Montreal.
"Shadows of a Dream," Dark Room, Cambridge; Impressions, York; Untitled
Gallery, Sheffield.
"Simplon Express," La Galerie des Locataires (intervention in the Orient
Express).*
"L'invention d'un art," MNAM/Centre Georges Pompidou, Paris.*
"Peinture, cinéma, peinture," Centre de la Vieille-Charité, Marseille.*

1990

"Le choix des femmes," Le Consortium, Dijon.
Sydney Biennial.*
"Individualités: 14 Contemporary Artists from France," Art Gallery of Ontario,
Toronto.*
"Sarah Charlesworth, Jeanne Dunning, Annette Messager, Adrian Piper,
Laurie Simmons," Feigen Inc., Chicago.
"Stendhal Syndrome: the Cure," Andrea Rosen Gallery, New York.
"Contemporary Assemblage: the Dada and Surrealist Legacy,"
Louver Gallery, Los Angeles.
"Images in Transition: Photographic Representation in the Eighties,"
National Museum of Modern Art, Tokyo.*
"Vies d'artistes," Musée des Beaux-Arts André-Malraux, Le Havre; Usine
Fromage, Rouen; Musée de l'Ancien Évêché, Évreux.*
"Francja Dsisiaj," Muzeum Narodowe, Warsaw; Muzeum Narodowe, Cracow.

1991

"Sweet Dreams," Barbara Toll Fine Arts, New York.
"1969–1972. Une scène parisienne," Centre d'Histoire de l'Art
Contemporain, Université de Rennes II, La Criée-Hall d'Art Contemporain,
Fonds Régional d'Art Contemporain Bretagne, Rennes.
"L'excès et le retrait," XXI Bienal de São Paulo.*
"Plastic Fantastic Lover," Blum Helman Warehouse, New York.

"La collection," Musée Rochechouart.
"Constructing Images: Synapse between Photography and Sculpture,"
Lieberman Saul Gallery, New York; Tampa Museum of Art (Florida); Center
of Creative Photography, Tucson (Arizona); San José Museum of Art, San
José (California).*

1992
"Shapeshifters," Amy Lipton Gallery, New York.
"Bild, Objekt, Skulptur," Galerie Elisabeth Kaufmann, Basel.
"Parallel Visions: Modern Artists and Outsider Art," Los Angeles County
Museum of Art; Centro de Arte Reina Sofia, Madrid; Kunsthalle, Basel;
Setegaya Art Museum, Tokyo.*
"Le portrait dans l'art contemporain," Musée d'Art Moderne et
Contemporain, Nice.*
"Animals," Galerie Anne de Villepoix, Paris.
"Annette Messager / Annette Lemieux," Josh Baer Gallery, New York.
"À visage découvert," Fondation Cartier, Jouy-en-Josas.*
"Special Collections (the Photographic Order from Pop to Now),"
International Center of Photography Midtown, New York; Mary & Leigh Block
Gallery, Northwestern University (Illinois); Arizona State Art Museum, Arizona;
The Chrysler Museum (Virginia); Bass Museum of Art (Florida); The
Museum at Stony Brook, New York; Vancouver Art Gallery, Vancouver; Ansel
Adams Center, San Francisco; Sheldon Memorial Art Gallery, Nebraska.*
"Trans-Voices," American Center, Paris (posters in the métro and subway,
Paris and New York).
"Corporal Politics," MIT List Visual Arts Center, Cambridge (Massachusetts).

1993
"L'autre à Montevideo—Homenaje a Isidore Ducasse," Museo Nacional de
Artes Visuales, São Paulo.*
"Fall from Fashion," The Aldrich Museum of Contemporary Art, Ridgefield
(Connecticut).*
"De la main à la tête, l'objet théorique," Domaine de Kerguéhennec, Bihan
(France).*
"Et tous ils changent le monde," Second Biennale d'Art Contemporain, Lyon.*
"L'envers des choses," Galeries Contemporaines, Centre Georges
Pompidou, Paris.
"Anonymity & Identity—Oniric Threshold," Anderson Gallery, Richmond (Virginia).
"Multiples Images: Photographs since 1965 from the Collections,"
The Museum of Modern Art, New York.
"Trésors de voyage," Biennale di Venezia, Monastero dei Padri Mechitaristi
dell'isola di San Lazzaro degli Armeni, Venice.*
"Chambre 763," Hôtel Carlton-Montparnasse, Paris.*
"Eau de Cologne 83–93," Monika Sprüth Galerie, Cologne.
"The Uncanny, Sonsbeek 93," Arnhem (Netherlands).*
"Empty Dress: Clothing as Surrogate in Recent Art," Neuberger Museum of
Art, New York.

1994
"Les chapelles de Vence," Fondation Émile-Hugues, Château de Villeneuve,
Vence; Espace des Arts, Chalon-sur-Saône; Capc-Musée d'Art Contemporain,
Bordeaux.*
"Le saut dans le vide," House of Artists, Moscow.

"Trans," Galerie Chantal Crousel, Paris.
"On Nostalgia," The Gallery at Takashimaya, New York.
"Living in Knowledge—An Exhibition about the Questions not Asked," Duke
University Art Museum, Durham (North Carolina).

1995
"Traces, fragments, ellipses," National Gallery of Modern Art, New Delhi.
"Passions privées," Musée d'Art Moderne de la Ville de Paris.*
"Fetishism," Brighton Museum and Art Gallery, Brighton.
"45° Nord & Longitude 0," Capc-Musée d'Art Contemporain, Bordeaux.
"Masculin-Féminin—Le sexe de l'art," Centre Georges Pompidou, Paris.*

1996
"Collections-Parcours," Musée Rochechouart.
"Chacun sa chimère," Maison des Arts, Bordeaux.
"Comme un oiseau," Fondation Cartier, Paris.

1997
"Floating Images of Women in Art History," Tochigi Prefectural Museum of
Fine Arts, Tochigi (Japan).
"Deep Storage," Haus der Kunst, Munich; Nationalgalerie, Berlin.*

1999
"Passeurs de linge," Musée des Arts et Traditions Populaires, Paris.*
"Private Eye, Crime and Cases," Haus am Waldsee, Berlin.*
"Fauna," Zacheta Gallery of Contemporary Art, Warsaw.
"Dards d'art," Musée Réattu, Arles (France).*

2000
"Zeitwenden," Kunstmuseum, Bonn.*
"Ich ist etwas Anderes," Kunstsammlung, Düsseldorf.*
"La beauté," Palais des Papes, Avignon.*
"Le monde dans la tête," Musée d'Art Moderne de la Ville de Paris.*
"Die Verletzte Diva," Galerie um TaxisPalais, Innsbrück; Städtische Galerie
im Lenbachhaus, Munich; Staatliche Kunsthalle, Baden-Baden.*
"L'empire du temps—Mythes et créations," Musée du Louvre, Paris.*
"Closer to One Another," Havana Biennial.*
"Présumé innocent," Capc-Musée d'Art Contemporain, Bordeaux.*
"Partage d'exotisme," Biennale de Lyon.*
"La romance digestive d'Annette Messager," Restaurant
Le Petit Saint-Benoît, Comité Saint-Germain-des-Prés, Paris.*
Arken-Museum for moderne Kunst
"Dire Aids," Palazzo della Promotrice delle Belle Arti, Turin.*
"The Anagrammatical Body", Karlsruhe ZKM.
Biennale du Livre d'Artiste, Chateau de la Napoule.
"Voilà", Musée d'Art Moderne de la Ville de Paris.

2001
"Flash DVD", Whitechapel Art Gallery, London.
"Ma Sorcière Bien-Aimée", Musée d'Histoire de la Ville de Luxembourg,
Luxemburg.
"Do it", Perth Festival, Perth, Australia.

bibliography

Une scène parisienne 1968–1972, Rennes: Centre d'Histoire de l'Art Contemporain Fonds Régional d'Art Contemporain Bretagne, 1972.

Les Approches, Hamburg: Lebeer-Hossmann, 1973.

La Femme et ... Annette Messager truqueuse, Geneva: Écart, 1975.

Ma collection d'expressions et d'attitudes diverses par Annette Messager collectionneuse, Saarbrück: Antiquarium/Antibes: Arrocaria, 1975.

Ma collection de proverbes, par Annette Messager collectionneuse, Milan: Giancarlo Politi, 1976.

Mes enluminures, Dijon: Art & Art, 1988.

Mes ouvrages, Arles: Actes Sud, 1989.

"La Feuille de route d'Annette Messager," *Sommaire,* 22, Paris, 1993.

D'approche, Paris: Jean-Dominique Carré, Archives-Librairie, 1995.

Nos témoignages, Stuttgart: Oktagon Verlag/Hans Ulrich Obrist, 1995.

KunstSkandal, Hans-Peter Schwerfel, Dumont, Cologne, 2000.

Annette Messager, Catherine Grenier, Flammarion, Paris, 2000 (French edition).

films

Les Chimères d'Annette Messager, directed by Yves Brouty, 1983.

Annette Messager reine de la nuit, directed by Philippe Demontaut, 1986.

Annette Messager, Centre d'Art Contemporain, Castres, 1988.

La Carte du Tendre d'Annette Messager, directed by Michel Nuridsany, 1992.

Annette Messager—Interview, Centre Georges Pompidou, 1993.

Oh boy, it's a girl, directed by Brigitte Cornand, produced by Canal +/ Les Films du Siamois, 1995.

Dans les filets d'Annette Messager, directed by Brigitte Cornand, produced by Canal +/Les Films du Siamois, 2000.

Le Bestiaire amoureux de d'Annette Messager, video by Hans-Peter Schwerfel.